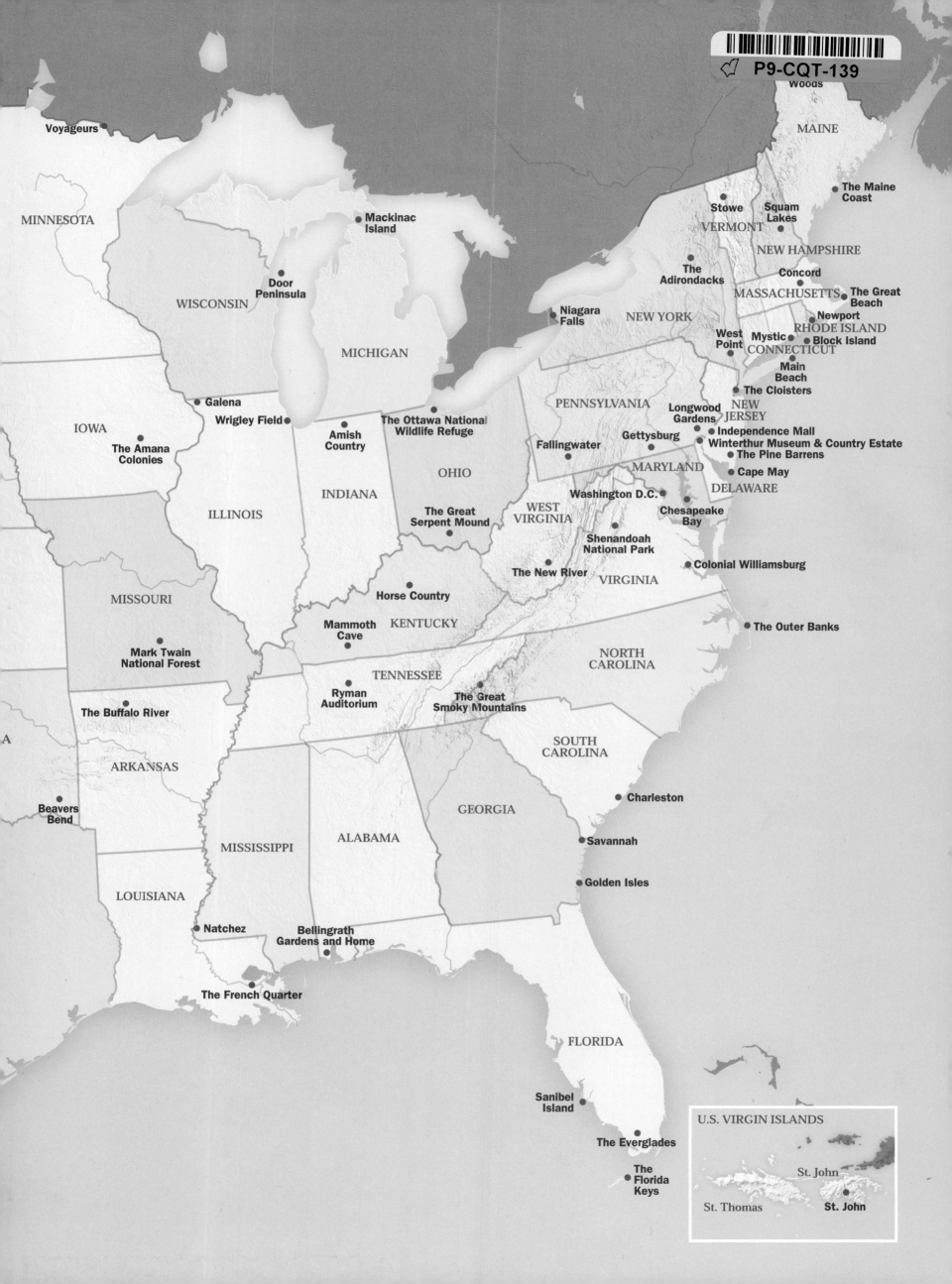

AMERICA
THE BEAUTIFUL

WHITE SANDS, NEW MEXICO

AMERICA
THE BEAUTIFUL

A PHOTOGRAPHIC JOURNEY, COAST TO COAST—AND BEYOND

ALASKA *Walruses in summer on the beach at Round Island*

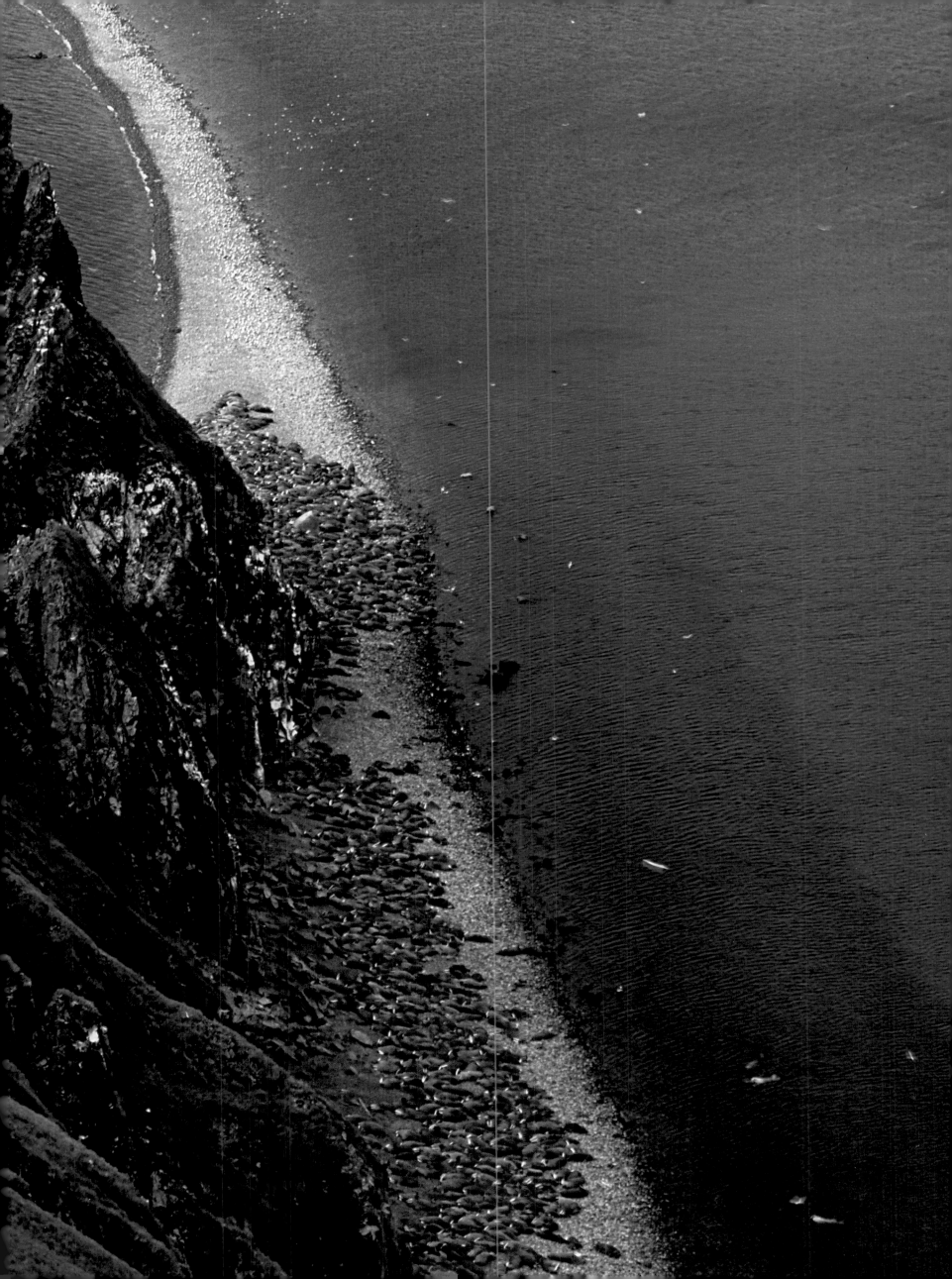

LIFE Books

Editor Robert Sullivan
Director of Photography
Barbara Baker Burrows
Creative Director Mimi Park
Deputy Picture Editor Christina Lieberman
Writer-Reporter Hildegard Anderson
Copy Lesley Gaspar (Chief), Parlan McGaw
Production Manager Michael Roseman
Photo Assistant Ryan Mesina
Consulting Picture Editors
Mimi Murphy (Rome), Tala Skari (Paris)

Special thanks to David Douglas Duncan
and Charles Rubens II

President Andrew Blau
Business Manager Roger Adler
Business Development Manager Jeff Burak
Business Analyst Ka-On Lee

Editorial Operations Richard K. Prue,
David Sloan (Directors), Richard Shaffer
(Group Manager), Burt Carnesi,
Brian Fellows, Raphael Joa,
Angel Mass, Stanley E. Moyse (Managers),
Soheila Asayesh, Keith Aurelio,
Trang Ba Chuong, Ellen Bohan,
Charlotte Coco, Osmar Escalona, Kevin Hart,
Norma Jones, Mert Kerimoglu, Rosalie Khan,
Marco Lau, Po Fung Ng, Rudi Papiri,
Barry Pribula, Carina A. Rosario,
Albert Rufino, Christopher Scala,
Diana Suryakusuma, Vaune Trachtman,
Paul Tupay, Lionel Vargas, David Weiner

Time Inc. Home Entertainment

Publisher Richard Fraiman
Financial Director Steven Sandonato
Executive Director, Marketing Services
Carol Pittard
Director, Retail & Special Sales Tom Mifsud
Director, New Product Development
Peter Harper
Assistant Director, Brand Marketing
Laura Adam
Assistant General Counsel
Dasha Smith Dwin
Book Production Manager Jonathan Polsky
Design & Prepress Manager
Anne-Michelle Gallero

Special thanks to Bozena Bannett,
Alexandra Bliss, Glenn Buonocore,
Suzanne Janso, Robert Marasco,
Brooke McGuire, Mary Sarro-Waite,
Ilene Schreinder, Adriana Tierno,
Alex Voznesenskiy

Copyright 2007
Time Inc.

Published by **LIFE** Books

Time Inc., 1271 Avenue of the Americas,
New York, NY 10020

ISBN 10: 1-933821-15-9
ISBN 13: 978-1-933821-15-3
Library of Congress Control Number:
2007902233

Printed in Singapore.

"LIFE" is a trademark of Time Inc.

We welcome your comments and
suggestions about LIFE Books.
Please write to us at:
LIFE Books, Attention: Book Editors,
PO Box 11016,
Des Moines, IA 50336-1016

If you would like to order any of our
hardcover Collector's Edition books, please
call us at 1-800-327-6388 (Monday through
Friday, 7:00 a.m.–8:00 p.m., or Saturday,
7:00 a.m.–6:00 p.m., Central Time).

Please visit us, and sample past editions
of LIFE, at www.LIFE.com. Classic images
from the pages and covers of LIFE are now
available. Posters can be ordered at
www.LIFEposters.com.

Fine art prints from the LIFE Picture
Collection and the LIFE Gallery of
Photography can be viewed at
www.LIFEphotographs.com.

Contents

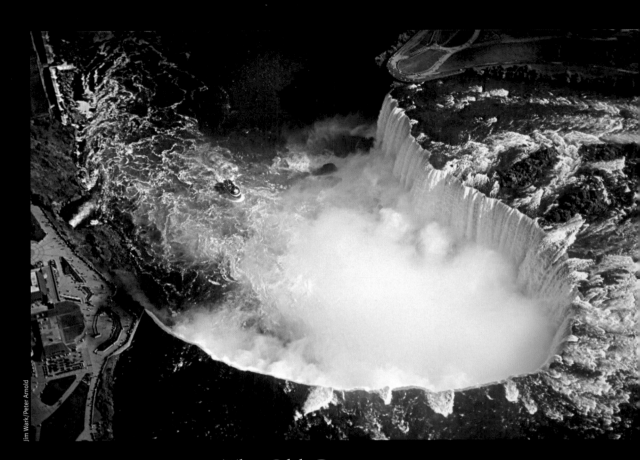

Jim Wark/Peter Arnold

The Old Country
FROM THE ATLANTIC TO THE MISSISSIPPI
page 8

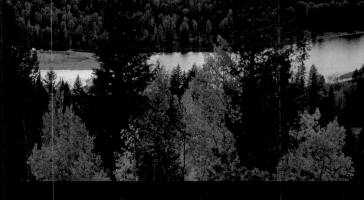

Chad Ehlers/Getty

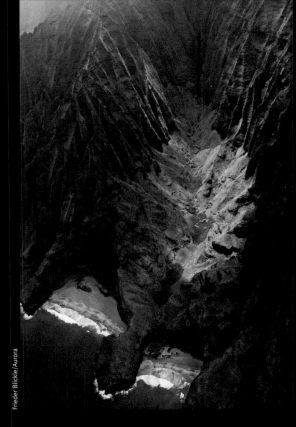

Frieder Blickle/Aurora

Westward, Ho
PUSHING TOWARDS THE PACIFIC
page 68

Out There
THE GREATS BEYOND THE LOWER 48
page 128

And the Best Place of All Is . . .

Whenever we do one of these "Top 50" or "Top 100" books, there's a temptation to make a claim for the top of the tops—the best 10, best five, best one of all. We have, in the past, boldly declared Elvis over the Beatles as the sine qua non rock act of all time, and Hank Williams as the eternal King of Country. We picked the 100 most important people and events of the last millennium (Thomas Edison topped one list, and Gutenberg's book printing beat Columbus' voyage on the other), and we even, in one LIFE volume, brazenly offered our list of the 25 greatest American heroes of all time—in order. Honest Abe stood tallest.

But with places and things—natural or man-made wonders—the listing gets trickier. This has everything to do with subjectivity. While all of us might be in rough accord that Abraham Lincoln was a titanic figure in our country's history, we would surely debate the aesthetic pleasures of a forest of California redwoods versus those of Maine's North Woods. Some folks would prefer the quietude of New Hampshire's Squam Lakes to the thunderous mountains and ferocious winds in Alaska's Gates of the Arctic National Park. While some people are transported by a lush garden or a sublime museum or a baseball game at Wrigley Field, there are others who might consider these things . . . well . . . *boring*.

No accounting for taste, is there?

Now, then: When you approach a book called *America the Beautiful*, you know you're going to get glimpses of, to name but a few, Yosemite and Yellowstone, probably Niagara Falls and a sublime city like Savannah or San Francisco. There are certain givens, and rest assured they are in this book.

But there are surprises here, too. Of all of New York City's many marvels, why does LIFE choose to highlight a strange reliquary from medieval Europe called the Cloisters? We hope you're eager to find out. What are the beguiling mysteries underlying Ohio's Great Serpent Mound, or those of the ruins out West where once dwelled a native people called the Anasazi? The theories, as well as the pictures, will fascinate.

How might you, the reader, best use this book? Well, first, for sheer and immediate pleasure. Herein are beautiful photographs of beautiful locales, accompanied by descriptions that try to convey something about the soul of the place—the essential and poetic otherness that makes it special. To contemplate these photographs is to travel in the mind to these wondrous sites. It is to visit—not only visually, but emotionally.

And then the book can, of course, be used as a life list. What LIFE is urging here is that there are places in this great land of ours that we all might consider experiencing—physically—in our lifetimes. There are sets and subsets within the list of a hundred. As said, a baseball stadium might not be for everyone. Perhaps gardens are your thing. Isn't it time to plan those pilgrimages to Winterthur and Longwood and Bellingrath? History buffs will surely want to visit Concord, Mass., as well as West Point, N.Y., and those who collect great beaches will be pointed, here, to the best ones for walking, for swimming and even for collecting shells. There are, as you would imagine, several of the country's great parks included here, as well as several places that we hope arrive out of the blue. Why should we visit New Jersey's Pine Barrens? What is the Pine Barrens, anyway? Read on.

Now for a little fun. Having already stated that it's impossible to objectively put in order the 100 places in America that we all simply must experience, LIFE is nevertheless going to offer, now, its Top 10. We just can't resist.

Here, in reverse order, are the recommendations. In choosing these 10, we've tried to make certain that any and everyone might enjoy them, whether traveling to them by foot or car.

So, do yourself a favor and go to:

The Great Beach at Cape Cod. In the off-season, it's not just a beach. It's a natural retreat from the wider world, and has been since Thoreau walked this way.

Yosemite. The naturalist John Muir often compared this valley and the mountains surrounding it to a cathedral, and any who visit would agree that nature is represented here at its holiest.

The French Quarter. This New Orleans neighborhood has regained much of its vibrancy and once again defines the term "nightlife." Its music is as lively and flavorful as its food. Plus: New Orleans needs you.

The Grand Canyon. Of the many tremendous natural carvings in the American West, the one created by the Colorado River is preeminent. If you're able, raft it. If not, take in the grandeur from the rim.

Big Sur. Driving the Maine Coast can be inspiring; driving this stretch of the central California coastline on the opposite side of the continent can seem spiritual.

Gettysburg. This consecrated ground is where the Civil War pivoted and the country found its future. It should be seen because of what it commemorates, and also because it is in a lovely and serene part of Pennsylvania.

The Florida Keys. The southernmost tip of the Lower 48 is accessible by car and surrounded by blue waters. Key West is the quintessential—the ultimate—getaway.

Hawaii's Volcanoes. By going to see the Big Island's natural pyrotechnics, which will be remembered forever as a once-in-a-lifetime show, you find yourself delivered, as a bonus, to paradise. People who long for Alaska should try to visit Alaska. Everyone should think about a trip to Hawaii.

Yellowstone. One of the country's weirdest, most wondrous settings. Yellowstone was decreed the world's very first national park by President Ulysses S. Grant in 1872. There are good reasons why.

And the winner is . . . **Washington, D.C.** Do not think of a trip to the nation's capital as a duty, even if it can be considered that. Think of it as a journey—a fun, exciting one—to the heart and soul of America. In Washington, we learn about our country, and we learn to be proud.

So that's it, LIFE's much debatable Top Ten. What's yours?

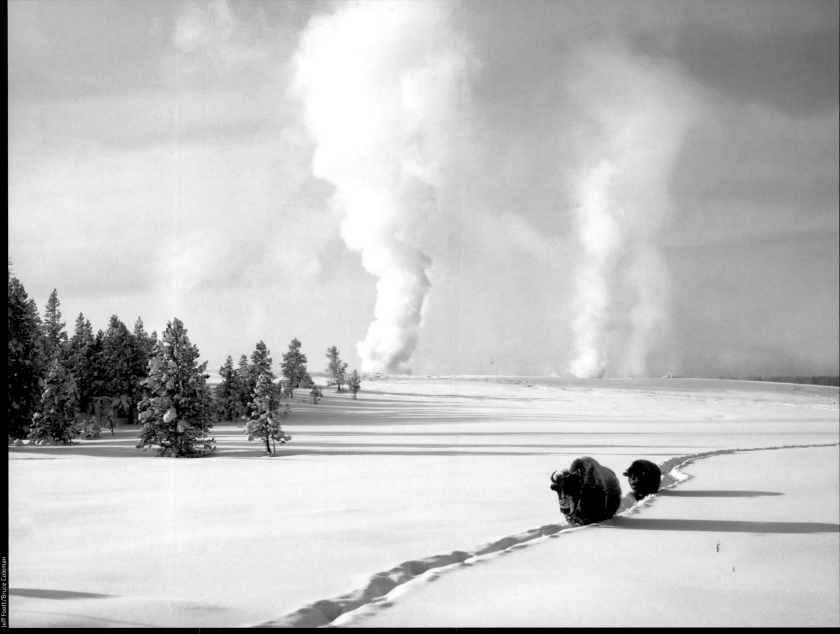

(ABOVE) A NATURAL WONDER: YELLOWSTONE (BELOW) MADE BY MAN: WASHINGTON, D.C.

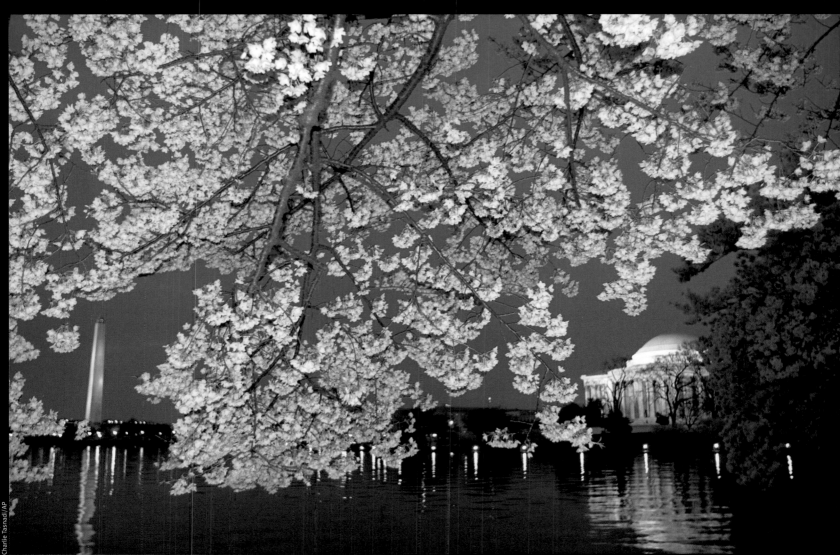

The Old Country

FROM THE ATLANTIC TO THE MISSISSIPPI

All things to all New Englanders, this often rocky, sometimes sandy stretch along the Atlantic means a walk along the Marginal Way in Ogunquit, a lobster roll in a grove of pines in Kittery, a bracing dip off Ocean Point near Boothbay Harbor or a stunning sunrise viewed from the summit of Cadillac Mountain. It is the quaint and authentic village of Castine, and the imagined but very real Dunnett in Sarah Orne Jewett's *The Country of the Pointed Firs*. It is an all-grades schoolhouse on isolated Isle au Haut and an elegant four-course meal at the White Barn Inn in Kennebunkport. It is the saltwater farm where Wilbur the radiant pig lived. It is a thousand lighthouses . . . and a thousand different memories.

THE Maine Coast
MAINE

THE North Woods
MAINE

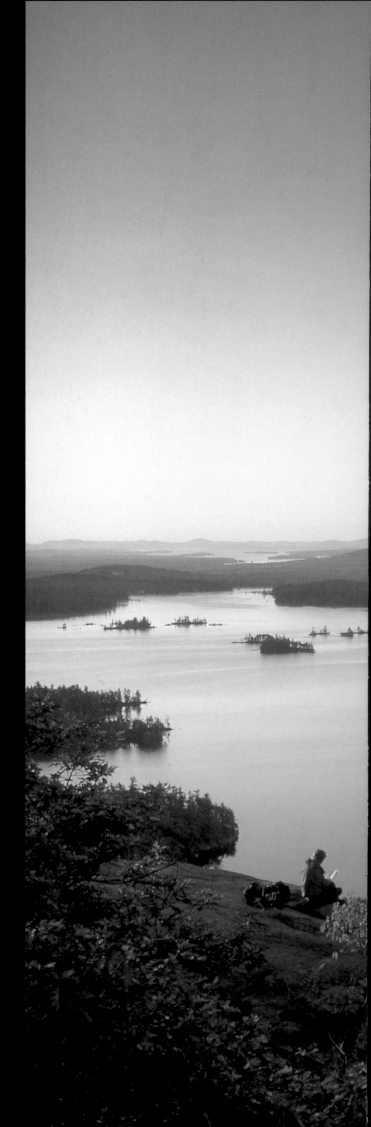

I t is a place way, way up and way, way in—a land of trees and wild rivers (the St. John and the Allagash), a 3.5-million-acre outback of bears and moose and many birds and fish, and hunters and canoeists and timber-company loggers. It isn't, anywhere in its shadowy confines, a national or state park; there are no lifeguards on these lakes. It is a world away, and it is the way the world once looked. In getting to the remote North Woods, the old Downeast adage—*ya can't get they-uh from he-ah*—might seem to apply, but any effort is worth the reward.

Squam Lakes
NEW HAMPSHIRE

"The loons. The loons. They are welcoming us back." Thus did Katharine Hepburn alert Henry Fonda to the call of visiting wildlife in the film version of *On Golden Pond*. In reality, those loons were a few of the many that nest on one of New Hampshire's two, interconnected Squam Lakes, where the movie was made. Life slows down at the Squams, which remain remarkably pristine in the present day. Century-old camps and cottages are set back amidst the pines, and most of the 65 miles of shoreline seems, when viewed from a boat, as natural as when the Abenaki Indians called the area home. And you will want to view it from a boat; a Chris-Craft, a kayak, a canoe—doesn't matter. Perhaps no other body of water in America so exalts the proposition from *The Wind in the Willows* that "there is Nothing—absolutely nothing—half so much worth doing as simply messing about in boats." You rise at dawn, depart the cottage, walk down to the dock, paddle into the village of Holderness to pick up the paper and see how the Red Sox fared . . . And thus begins another slow, blissful day on the Squams.

They are all worth visiting, certainly—all of the charming villages in Vermont that look like they were designed with Currier and Ives calendars in mind. But there is only one Stowe, a place that has resisted the pressures that tourism imposes and has remained the quintessence of an idyllic north-country hamlet. There are streams and meadows and the oft-photographed church spire, all set in relief against Mount Mansfield, Vermont's highest peak and home to some of the most storied (and sensational) skiing in the country. Just how alluring are the alpenglow attractions of Stowe? Well, it hardly seems an accident that the intrepid von Trapps, they who escaped the Nazis and inspired *The Sound of Music,* found their way to Stowe. Today, the Trapp Family Lodge is a local institution on the order of the ski area itself, and rich melodies pour forth from it, particularly during summer's Vermont Mozart Festival. The spring melt and bloom is joyous in Stowe, the fall foliage is riotous. Beauty is the watchword here, in any and all seasons.

Stowe
VERMONT

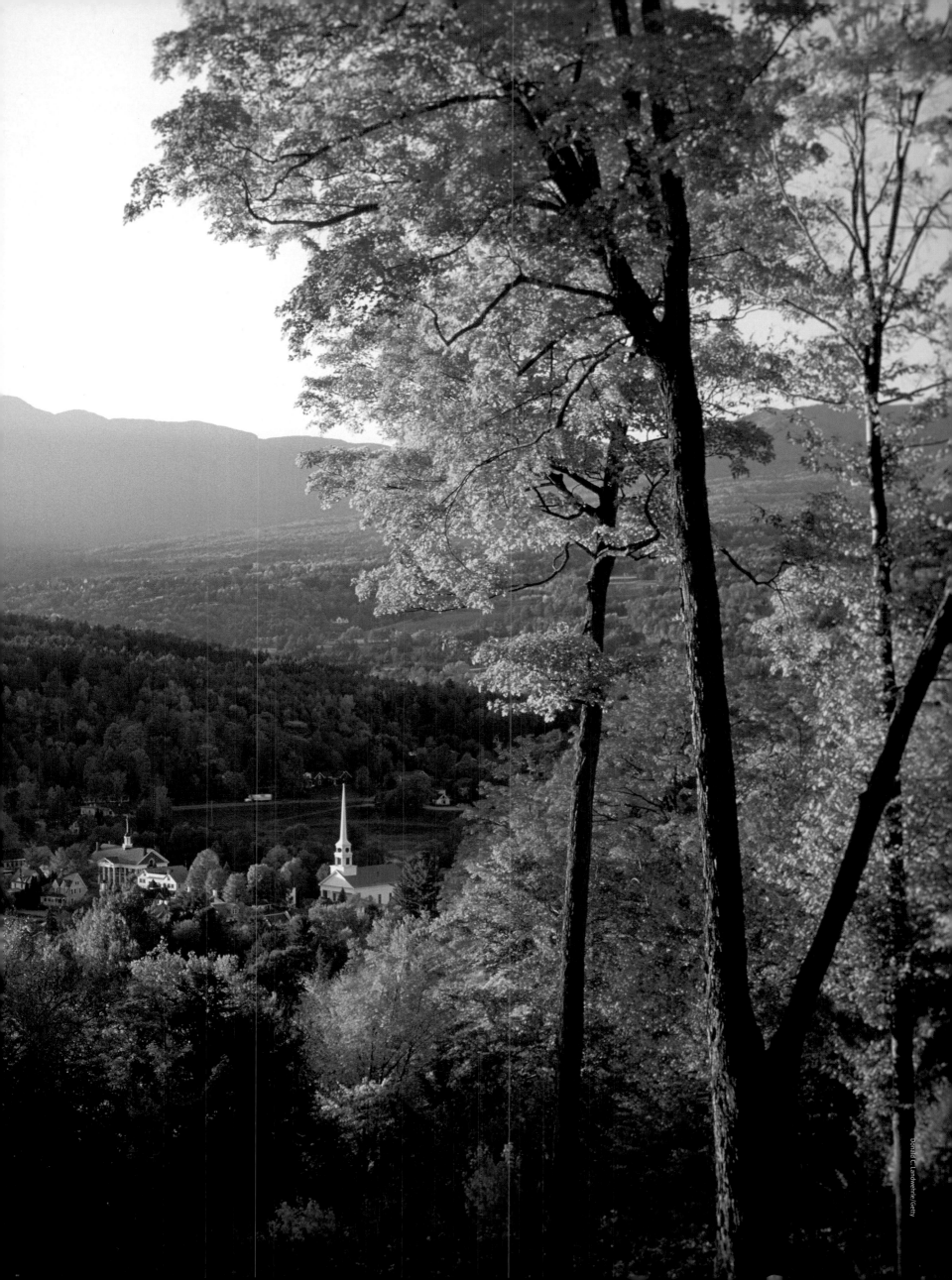

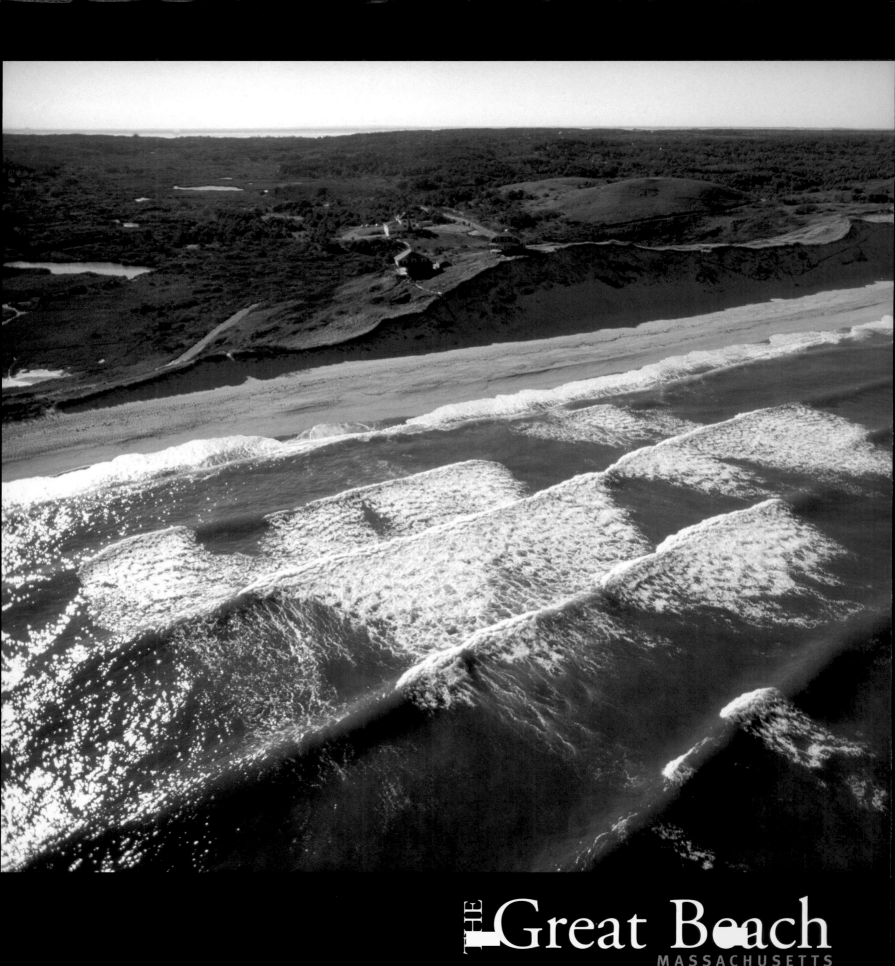

THE Great Beach
MASSACHUSETTS

In this small, peaceful, leafy New England town, history dwells—history of many kinds. On the fateful day of April 19, 1775, British Redcoats marched to Concord to destroy munitions rumored to be stashed there by rebellious colonists. They were met at Concord's North Bridge by Minutemen from various towns, and the Shot Heard Round the World rang out; two British soldiers were killed in that battle and by day's end, after six more hours of fighting along the Battle Road, the Revolutionary War was well and truly joined. That revolution succeeded, of course, and in the 19th century Concord was a hothouse for what would come to be seen as freshly and uniquely American ideas and ideals. While studying at Harvard, Henry David Thoreau once lived at what is now called the Colonial Inn, and he also famously lived for a while across town in a cabin that he built beside Walden Pond. Ralph Waldo Emerson, Nathaniel Hawthorne and the Alcotts all were of Concord, too, and their houses still stand—as does the inn, as does the pond, as does the bridge (well, actually, a fine replica, seen below). With attractive New England modesty, Concord is unassuming about its past, and allows you to walk at your own pace in the footsteps of titanic Americans.

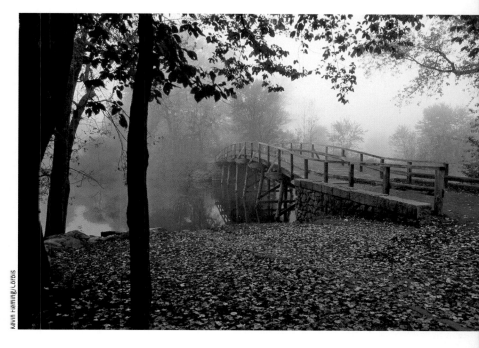

Concord
MASSACHUSETTS

It was Henry David Thoreau who, upon confronting this miles-long stretch of cliffs and sand fronting the Atlantic, first called it The Great Beach. Today, well-known parts go by other names—Coast Guard Beach, the Outer Beach (above)—but on a lonely off-season afternoon, little else seems to have changed since Thoreau walked this way. The dunes hunker against the winds, which can blow fierce, and the breakers crash unremittingly upon the shore. This is not a placid place; more than 3,000 ships have wrecked on the outer beach, or backside, of the Cape since the *Sparrowhawk* did so in 1626. (A seafaring footnote: In 1620, the Pilgrims' ship *Mayflower* made its first New World landfall at what is now Coast Guard Beach, not further north at Plymouth.) The writer Henry Beston, author of the 1928 classic *The Outermost House*, once put it eloquently and simply: "A first glimpse of the great outer beach of Cape Cod is one of the most memorable experiences in all America."

Newport
RHODE ISLAND

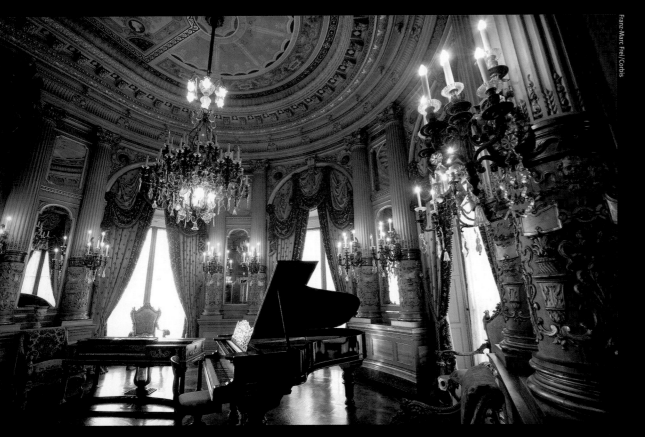

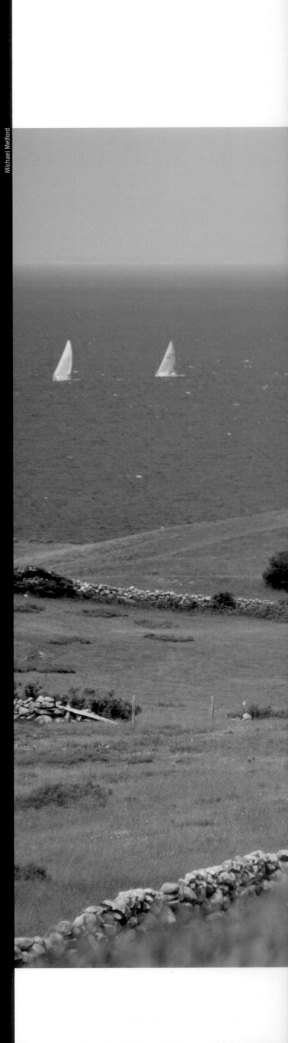

B efore there were the Hamptons, before there was Malibu, there was Newport—a coastal summer playground of the hyper-rich, to which they could repair to consort among themselves and, not least, to show off. The Rhode Island seaport's Gilded Age began circa 1850, when word got 'round the boardroom that Newport was the only acceptable place to ensconce come the Fourth of July. Up went enormous stone homes, filled with priceless antiques from Europe and called by their owners "cottages" (har, har). Consider just one: Cornelius Vanderbilt's The Breakers (above), named for its view of waves crashing on the rocks below. It was patterned after an Italian Renaissance palazzo, with a central covered courtyard and 70 rooms, 33 of which were servants' quarters. Its stone facade was embellished with Corinthian columns and its dazzling interior was decorated with gilt cornices, rare marble, "wedding cake" painted ceilings and opulent furnishings. Gardens, too, were a source of pride. Today, the splendor—or obscenity—of Newport's bygone era is still on display at 11 historic sites. If you need some fresh air after inhaling this extraordinary opulence, a stroll along the famous Cliff Walk by Narragansett Bay should be just the thing.

Block Island
RHODE ISLAND

Less famous than its offshore Massachusetts cousins Nantucket and Martha's Vineyard, this pear-shaped isle off the southern coast of Rhode Island is what they once were: an unassuming retreat from the Sturm und Drang of the mainland. Long stretches of beach, bridging in some places a gap between the sea and dramatic cliffs, are ideal for swimming, sunning, lolling and, in the cool of the evening, building a clambake. There are cars here, but bikes are a better way to visit the island's two historic lighthouses, wildlife refuge, 350 freshwater ponds, shingled Victorian farmhouses and old stone walls covered with rambling roses and honeysuckle. Clean air and clear, star-filled nights, constant breezes and the pounding surf, sitting on the veranda telling ghost stories of bygone shipwrecks or playing badminton on the lawn: This is Block Island.

Mystic
CONNECTICUT

This Connecticut town is all about the sea and always has been. Situated on a protected tidal river, Mystic was once a thriving 19th-century port, and today it celebrates that heritage in a variety of ways. The sights, sounds, smells and feel of the sea linger over the cobblestone streets and brick buildings of Mystic Seaport and the downtown area known as Olde Mistick Village. In the Seaport there are an 1841 three-masted whaling bark, tall ships and a museum where unfolds the story of whalers, sealers, fishermen and explorers who once set out from Mystic. The finder of the *Titanic*, Robert Ballard, is affiliated with the world-class Mystic Aquarium, and there's a permanent exhibition of his artifacts here, as well as many sea mammals. You can do much in Mystic, but what you can't do is get Julia Roberts to warm you a slice of pizza—although, yes, this is the place where her breakthrough 1988 movie, *Mystic Pizza*, was set and filmed. The pizzeria, which opened in 1973, is still at its West Main Street locale, but Julia has moved on.

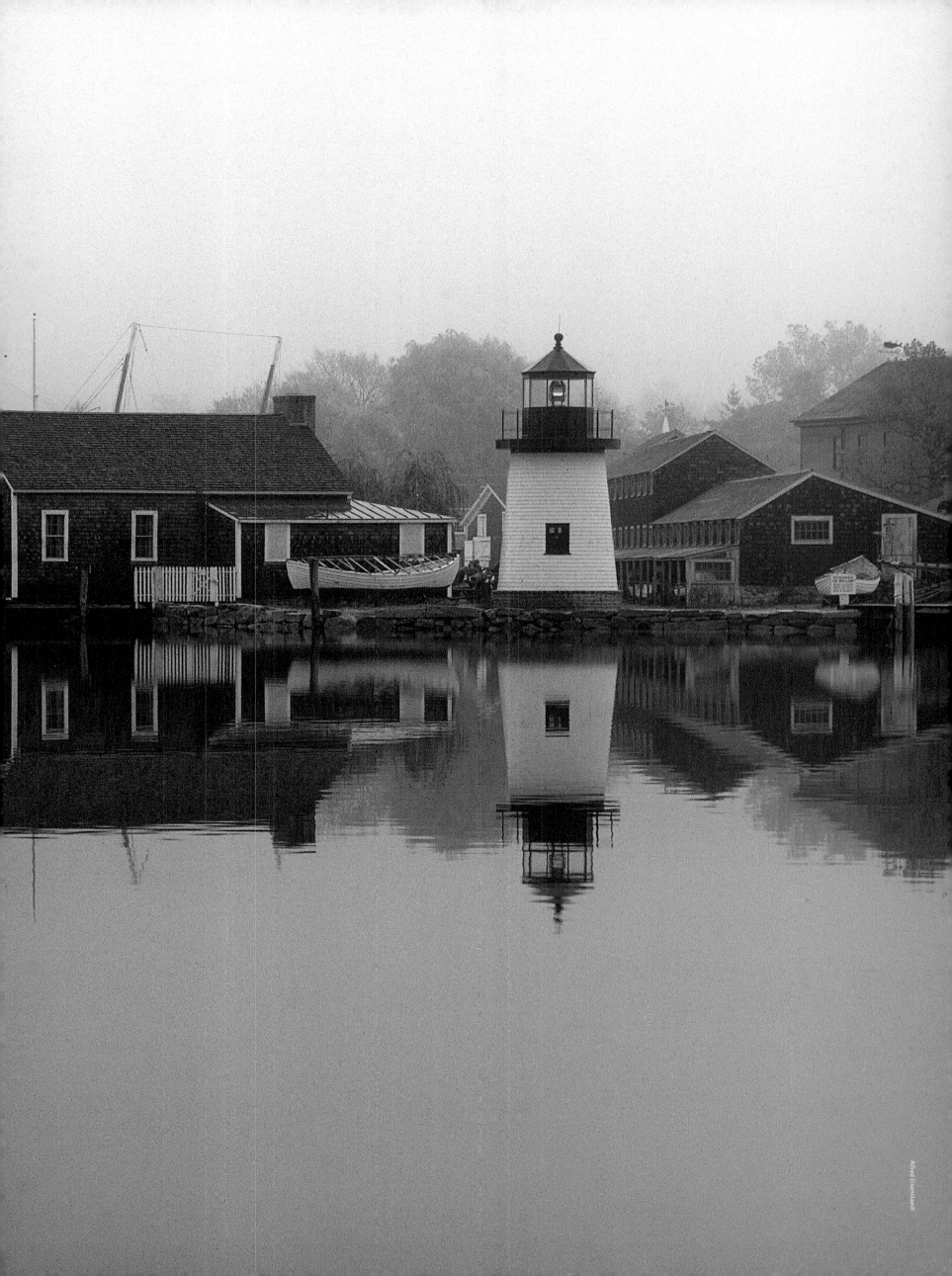

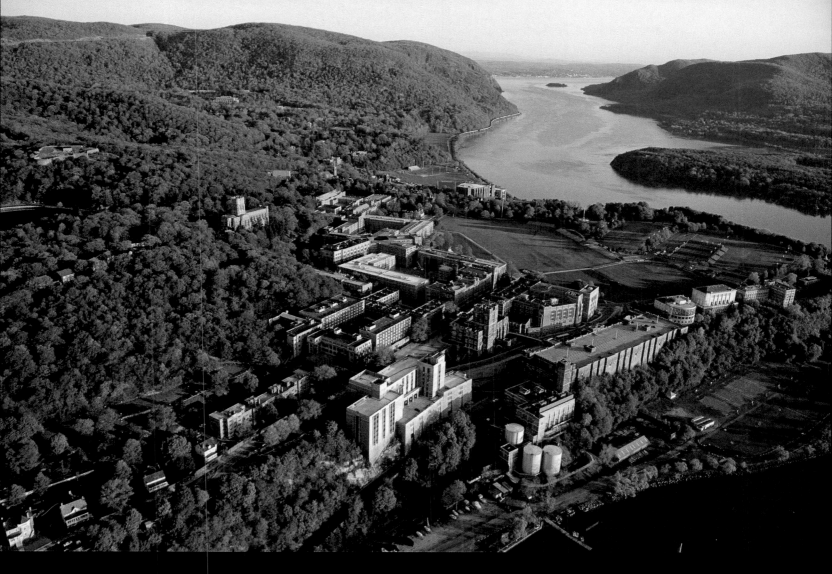

Long before Europeans spotted these mountains, the Algonquin and Iroquois were here. Did the Iroquois inadvertently give the region its modern name when they insulted a nearby Algonquin tribe as "Ha-De-Ron-Dah" or "bark-eaters," who ate pine bark when food got scarce? If so, the Algonquin probably had good reason. This is a land of harsh extremes: Winters can get as cold as 40° below, with three feet of snowfall in a single storm. Life is not easy here. Even today, only 130,000 people call it home. But there is a lot of room. About the size of Vermont, this unique mixture of private and public land constitutes the largest park in the Lower 48. And it is beautiful. It has thousands of peaks, with lakes, ponds and 31,000 miles of rivers and streams below. Here there be wild things: bobcats, coyotes, eagles, falcons, loons and bears. And because of New York's constitution, which reads in part, "The lands of the State . . . shall be forever kept as wild forest lands," the park should remain fine, with 2.6 million acres of Forest Preserve now protected so all can canoe, hike, fish and dream.

The women and men who bravely depart the United States Military Academy for some of the world's worst trouble spots are faced with an especially cruel irony: They are leaving behind one of the most scenically sublime environments that their homeland has to offer. For strategic rather than aesthetic reasons, the original fort that became West Point was situated here because of its commanding views of the Hudson River. None other than George Washington picked the spot, high atop the cliffs at a bend in the river, so that the Revolutionary Army could control British travel on the Hudson. Washington feared the British Army could sunder the colonies if they ever took West Point, and his concerns were nearly given a trial when the treasonous commander Benedict Arnold tried to sell the fort to the British. It was President Thomas Jefferson who established the U.S. Military Academy in 1802, and today the institution is not only the oldest continually occupied military post in the land, but at more than 16,000 mostly splendid acres, it is one of the largest campuses in the world. To visit here, amidst the pomp, circumstance and glory of the Corps of Cadets, is to be inspired. The views? As fine as ever, if somewhat less crucial to the nation's well-being.

THE Adirondacks
NEW YORK

"Then, when I felt how near to my Creator I was standing, the first effect, and the enduring one—instant and lasting—of the tremendous spectacle, was Peace. Peace of Mind, tranquility, calm . . . Niagara was at once stamped upon my heart, an Image of Beauty; to remain there, changeless and indelible, until its pulses cease to beat, for ever." So wrote Charles Dickens in 1842, and so have felt millions of others who have viewed the three great falls on the Niagara River from either the American or Canadian side. The falls each drop about 170 feet, and the widths of American and Horseshoe Falls are truly extraordinary: Horseshoe, seen here, is a half-mile wide. The falls have attracted, through the decades, not only honeymooners and other romantics, but plunging daredevils (many of whom have died), tightrope-walking acrobats and Hollywood filmmakers (Marilyn Monroe's 1953 *Niagara* being Exhibit A). The falls do not appear today as they did to Dickens—upriver power plants can and do control the flow-rates at all times, for instance. But they still look grand and mighty, a spectacle to behold.

Niagara Falls
NEW YORK

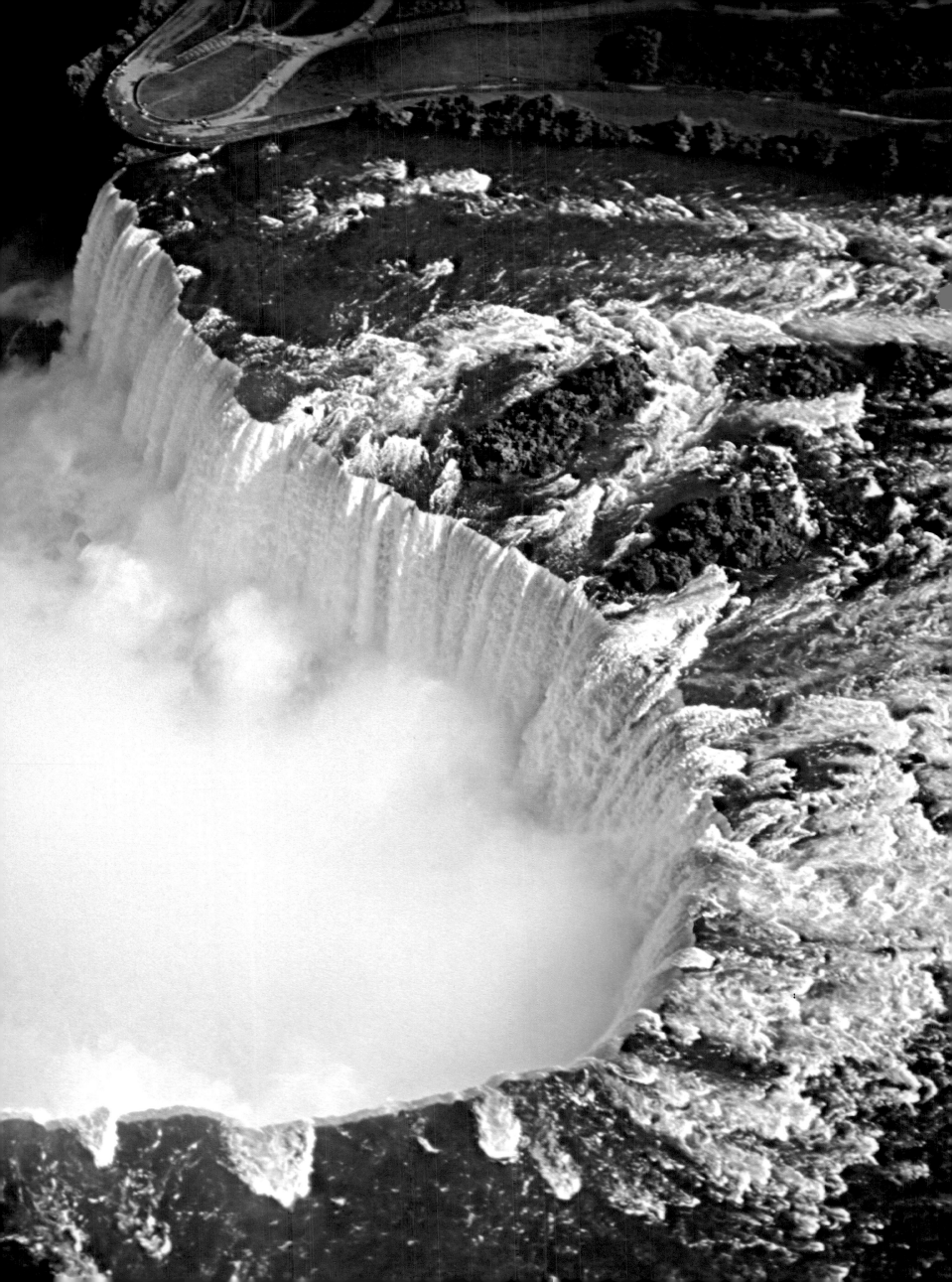

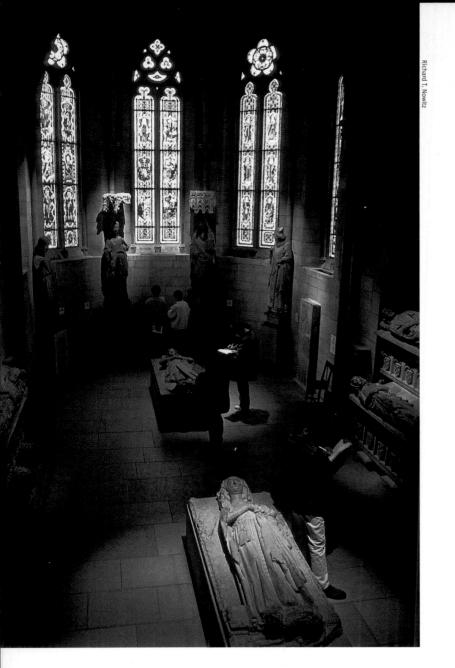

THE Cloisters
NEW YORK

New York City is a place of a thousand entrancing or entertaining delights, from the Statue of Liberty in the harbor to Yankee Stadium in the Bronx. And then there is the Cloisters, a wonderful, somewhat unusual institution tucked away in the glades of a Hudson River clifftop in northern Manhattan. The Cloisters exists due to the beneficence of John D. Rockefeller Jr., who in the 1920s bought a magnificent collection of medieval art for the Metropolitan Museum of Art. He also purchased 66.5 acres on which to situate a suitable building to house these new acquisitions as well as some of his own masterpieces, including the storied set of tapestries depicting "The Hunt of the Unicorn." By 1938, rooms from five medieval cloisters had been brought from France to be reassembled in New York. Et voilà, the Cloisters. Rockefeller had seen to everything, even unto the purchase of several hundred acres of pristine land across the river in New Jersey, so the view from the Cloisters would be forever undisturbed. In a city where hustle and bustle are the order of the day, the Cloisters offers a wonderful respite—a place of art and sometimes music, a spot where contemplation akin to that exercised long ago within these walls remains possible. The Cloisters represents, according to none other than Germain Bazin, former director of the Louvre in Paris, "the crowning achievement of American museology."

Main Beach
NEW YORK

Here's the East Hampton we're not talking about: J.Lo, Jay-Z, Spielberg, Martha, Diddy, velvet ropes, $200 entrées, no reservations, traffic jams. We're not talking about boutiques and $1,000 handbags. We're not even talking, here, about the pleasures of a walk through Northwest Woods, or of reading a good book in the shade of an enormous elm down by Town Pond. What we're talking about here is the beach, a truly great beach by any judgment, one of the finest walking and swimming beaches in the world. It is broad, for starters, very broad, so your perspective of the ocean has an illusory quality. You walk past the rim of grass-stitched sand dunes and onto that flat stretch of sand (do this off-season, and the pleasure is trebled). The sound of the waves rises from echo to rumble as you move towards the water. If it's a good day for a swim, you're in for unparalleled bodysurfing. Or just take a stroll. The enormous wealth that underlies East Hampton makes this quite an experience, for on your left is the beautiful sea, while on your right are magnificent mansions and estates. Winslow Homer painted this beach more than a century ago because it was beautiful. It's beautiful still.

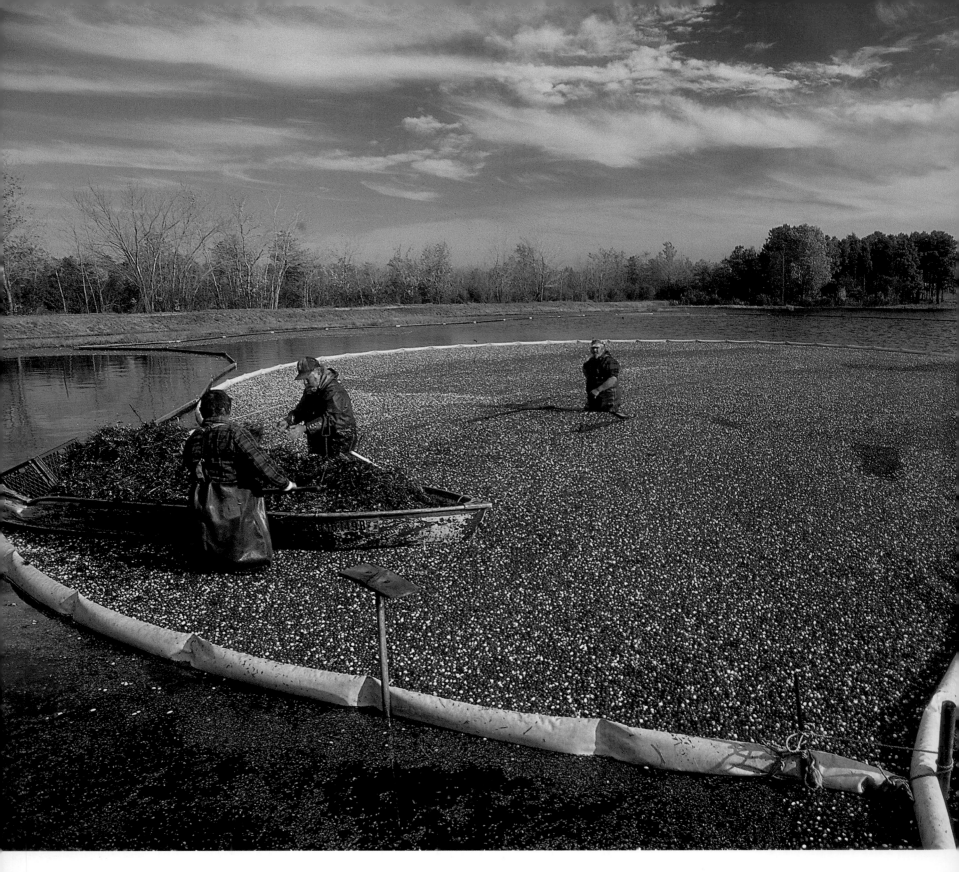

THE Pine Barrens
NEW JERSEY

It is a place that stirs our imagination and piques our curiosity. What is it, exactly? Well, it's the largest parcel of open space between Massachusetts and Virginia. It is a coastal plain of more than a million acres covered largely by dense forest. There are hamlets within it, a 49.5-mile hiking trail right through it, mountains with scenic vistas. Wetlands of all sorts are paradise for birders or canoeists. Interesting things grow in the Pine Barrens: pygmy pitch pines, carnivorous plants, orchids, blueberries— the country's first cultivated blueberries were harvested here in 1916, and today blueberry farms proliferate. In the bogs, there are cranberries; New Jersey ranks third among all states in cranberry production, thanks to the Pine Barrens. This region has distinctions both esteemed and odd. In 1978, it became our nation's first National Reserve; in 1938, humans battled aliens here in Orson Welles's sensational radio broadcast of *The War of the Worlds*; in 2001, it was the place where Tony Soprano's mobsters got lost while chasing a Russian gangster. The Pine Barrens is all this, and there's nothing else quite like it.

Michael Melford

Cape May
NEW JERSEY

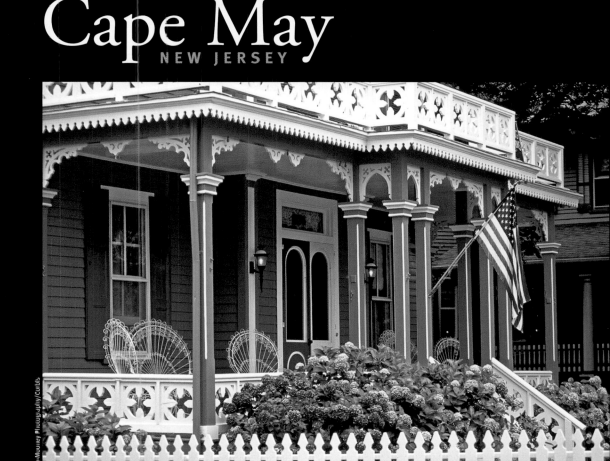

Kelly-Mooney Photography/Corbis

There's a peninsula extending between the Delaware Bay and the Atlantic Ocean, and at its end sits Cape May, southernmost New Jersey's colorful celebration of Victoriana. The city's slogan is "The Nation's Oldest Seashore Resort," and the claim is that Philadelphia vacationers, traveling by stagecoach or schooner, first started arriving here for rest and relaxation in 1766. But it is not Colonial-era architecture that, today, is the calling card of Cape May. It is the abundance of well-preserved gingerbread houses; no city in the United States, save San Francisco, has more Victorian-era homes. As with many places that own substantial histories, Cape May, for the longest time, didn't know what it had. In fact, some urban leaders of the late 20th century fought against listing the town on the National Register of Historic Places and against efforts to preserve and renovate the grand Emlen Physick Mansion on Washington Street. But preservationists carried the day, the listing was secured, the Physick Estate was saved from the wrecker's ball (it is today a museum with an extensive collection of Victorian furnishings and artifacts), and Cape May gathered unstoppable momentum towards its destiny as a pretty-as-a-postcard city by the sea.

Longwood Gardens

Gardens, in the ideal, are places of beauty, pleasure and tranquility. If they offer these three things and nothing further, they are fulfilling their mission. Longwood Gardens, west of Philadelphia in the historic Brandywine Valley, is an exemplar. The statistics do go far in telling Longwood's tale: Here are 1,050 acres of gardens, woodlands and meadows adorned with more than 11,000 varieties of exquisite flowers, blooming trees, delicate ferns and exotic plants. It's a floral kaleidoscope on a grand scale. Longwood's design incorporates an intellectually and aesthetically inspiring blend of French, Italian and English landscapes, each cultivated to perfection and evoking a different flavor and mood. Sparkling fountains, an Orchid House and an indoor Cascade Garden with more than 15 waterfalls and lush tropical plants are highlights. A day at Longwood is as enriching as it can be therapeutic.

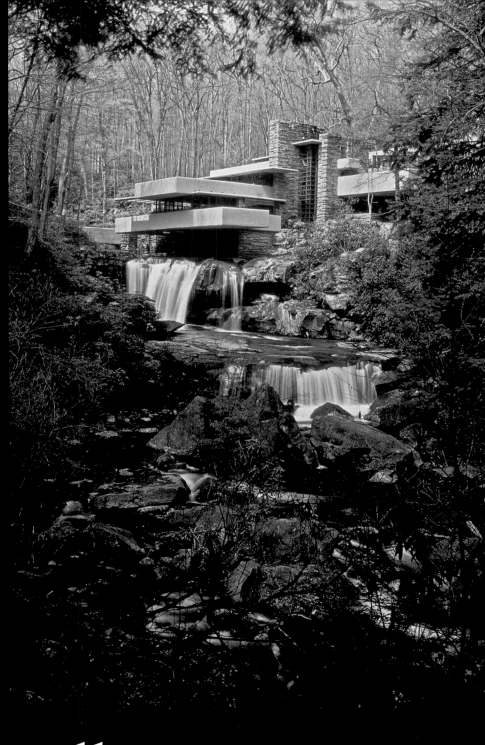

Fallingwater
PENNSYLVANIA

Most children play in tree houses or wish they could. Or
they dream of castles in the sky or underwater homes.
As adults, we usually put such dreams aside, but not
always and not all of us. In 1934 architect Frank Lloyd Wright,
already in his mid-sixties but far from the end of his prolific career,
was asked by Edgar J. Kaufmann, a Pittsburgh businessman, to
design a vacation home next to a waterfall in the southwestern
Pennsylvania town of Mill Run. Kaufmann expected a house with a
view of the falls and was surprised when Wright suggested that it
be built right over the water. The finished building seemed to grow
out of the bones of the stream and was an instant masterpiece.
But it also immediately began to crack and sag and, after years, it
became apparent that Fallingwater might fall down. Typically,
Wright's imagination had exceeded his engineering skills. But the

Independence
Mall PENNSYLVANIA

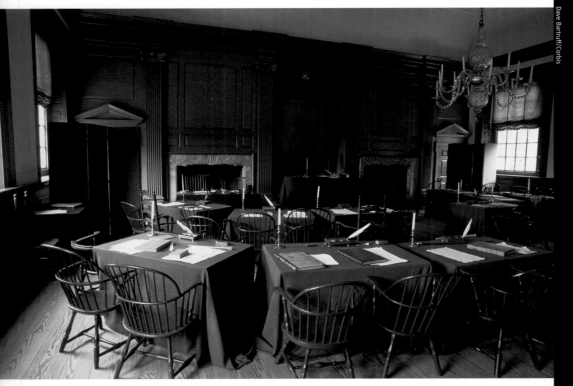

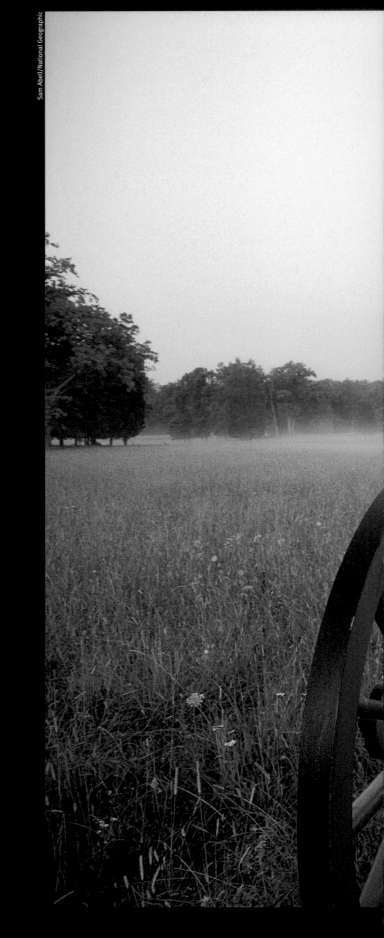

I f Boston's Faneuil Hall, where John Hancock, Samuel Adams,
Paul Revere and other Colonial firebrands plotted against
the British, is known as the Cradle of Liberty, then this section
of Philadelphia can be seen as Liberty's School—the campus
where it learned to think, developed a spine and decided
it could stand on its own two feet. The cast of characters this
time included George Washington, John Adams, Thomas Jefferson
and Benjamin Franklin. Franklin had come from Boston and
become a great man of Philadelphia even before the stirring events
of 1775 and '76; he was an esteemed publisher, philosopher and
inventor, and to this day he remains Philly's favorite son.
Deliberations by the Second Continental Congress in various
buildings on what is now known as the Mall led to the crucial
decisions of the American Revolution, including the appointment
of Washington to command the military and that of Jefferson
(with Adams and Franklin looking over his shoulder) to draft
the Declaration of Independence. (Above is the Assembly Room in
Independence Hall, where delegates adopted the Declaration.)
And there is, of course, the Liberty Bell—the very one that was
rung on July 8 when the Declaration was read to the public.

In July of 1863 Gen. Robert E. Lee and his Army of Northern Virginia launched their second invasion of the North, and Lee surely realized that the fate of the Confederate cause lay in the outcome. It was in Gettysburg that Lee's troops met those of Gen. George Meade, and fought them savagely for three days. Finally, Lee lost the battle and was forced to retreat to Virginia. That was the death knell for the Confederacy's hopes of becoming a new nation. Left behind in the small Pennsylvania crossroads town was a landscape of ravaged farmers' fields that were now being used as graveyards; homes and schools that were now pressed into service as hospitals (during the three days there were 23,000 Union and 20,000 Confederate casualties); and a horrific mass of memories. President Abraham Lincoln went to Gettysburg to dedicate the cemetery there on November 19, 1863, and delivered a two-minute oration that is one of the most eloquent, moving and inspirational in the annals of public speech. All of this can still be felt at the Gettysburg National Military Park; you can still visit the farmhouse of the widow Lydia Leister, where General Meade set up his headquarters. This is where, in a frightful way, our country was preserved.

Gettysburg
PENNSYLVANIA

Winterthur
Museum & Country Estate
DELAWARE

As with Newport, this is a glimpse into the lives of the rich and once-famous. Unlike Newport, awesomeness (some would say overt ostentation) is not the principal rule of the day. Situated amidst rolling hills, streams, meadows and exquisitely landscaped gardens, this ancestral estate of the du Pont family is a repository of choice American antiques dating from 1640 to 1860. The 175 period rooms are filled with some 85,000 historic objects, including furniture, clocks, silver, paintings, Oriental rugs and much more, which Henry Francis du Pont started to collect in the 1920s from all over the world. (Yes, sure, that sounds pretty awesome—but it's still not Newport!) Winterthur's 60 acres of gardens contain rare botanical plants and were designed so that there would be flowers blooming continuously from February to November. The Azalea Woods are a palette of pinks, whites, lavenders and reds, while the Enchanted Woods offer a fairy-tale setting for children to explore. Du Pont converted his family treasure into a museum in 1951, and families ever since have thanked him. This picture shows the Duck Pond, and the bird is a mute swan that lives year-round at the estate.

Chesapeake Bay
MARYLAND

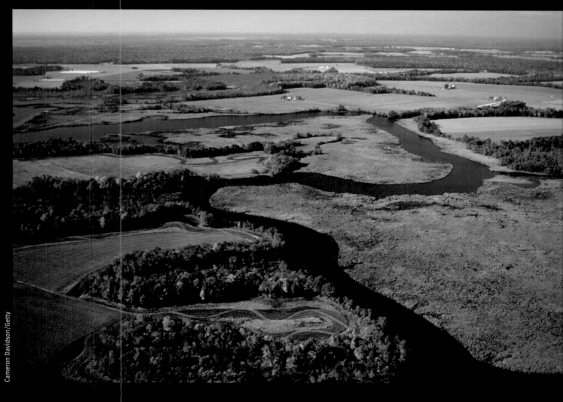

Cameron Davidson/Getty

The inclusion of this entry is a poignant one, for although Chesapeake Bay, the country's largest estuary, is something still worth experiencing, decades of environmental degradation and overfishing have imperiled it— and today, it is but a shadow of its once-teeming self. Chesapeake Bay's unique combination of characteristics fed its glory and, later, helped exacerbate its decline. It is, first of all, immense—the watershed encompasses nearly 65,000 square miles—but the bay is shallow, averaging less than 30 feet in depth. (This is because the bay is, essentially, the sloping valley of the Susquehanna River, which has been slowly covered by the rising waters of the Atlantic.) Under one translation, the Algonquin Indian word *Chesepiooc* means "Great Shellfish Bay," and in the Native American experience, it certainly was that. Clams, oysters and blue crabs were bounteous; striped bass and an enormous population of eels thrived. Now all of that is threatened, if not yet obliterated. Chesapeake Bay is fed by seven major rivers besides the Susquehanna, and each of them has brought pollutants. Algae blooms fed by the waste have become a plague. Foreign species have forced out the native.

There is no one thing in the nation's capital that is, in and of itself, a must above the others. All of it is part of an essential experience in the life of any American citizen. There is the White House and there's the U.S. Capitol and the Supreme Court, each representing a crucial element in our system of checks and balances that constitutes this working democracy—and ensures our liberty. There are the inspiring monuments: Washington's, stunning in its height; Lincoln's, seen here, powerful in its large but graceful solidity; those to the wars, humbling. The silence in the air as veterans and their families run fingers over the names on architect Maya Lin's masterwork, the Vietnam Veterans Memorial, is palpable. A similar frisson can be felt while strolling through Arlington National Cemetery, where so many who have sacrificed for our freedom now rest. Then there are all of the cultural and artistic riches on display in the Smithsonian's various museums, and in nearby Virginia the grand homes of Washington and Jefferson to be visited. Do not miss a trip to the National Zoo, or the opportunity to be inspired by the immensity of the Washington National Cathedral. Washington, D.C., built on what once was a swamp, is today one of the world's great cities. In it is the heartbeat of America.

Washington, D.C.

This might be the greatest misnomer in natural history. The New River is in fact very, very old. How old is uncertain, since it's just about impossible to date a river with any precision, but some geologists have speculated that the New is the oldest on the continent and among the two or three oldest in the world, right up there with the Nile. This speculation has something to do with the fact that the 320-mile river, which begins in North Carolina and continues through Virginia into West Virginia, is generally a north-flowing river, which may indicate that the river existed before the landscape surrounding it took its present form. In any event, the New River is probably somewhere between 10 million and 360 million years old—that's a wide range, certainly, but pretty old even on the young end. The New River is in places wide and meandering, and elsewhere a froth of white water; during the spring melt in the surrounding Appalachians, rafters can experience a Class VI thrill. For fishermen, there are trout, walleye, muskie, bluegill, channel catfish and bass to be caught. On the third Saturday in October each year, more far-out sportsmen take to the New River. That's when BASE (Building, Antenna, Span and Earth) jumpers convene at the New River Gorge Bridge for a day-long saturnalia of parachuting down to the waters below.

THE New River
WEST VIRGINIA

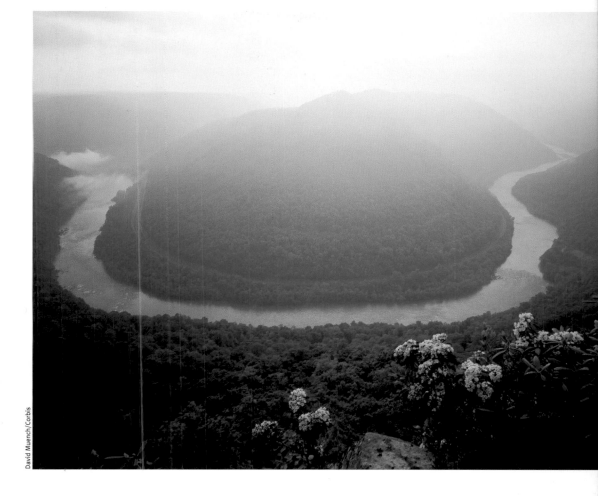

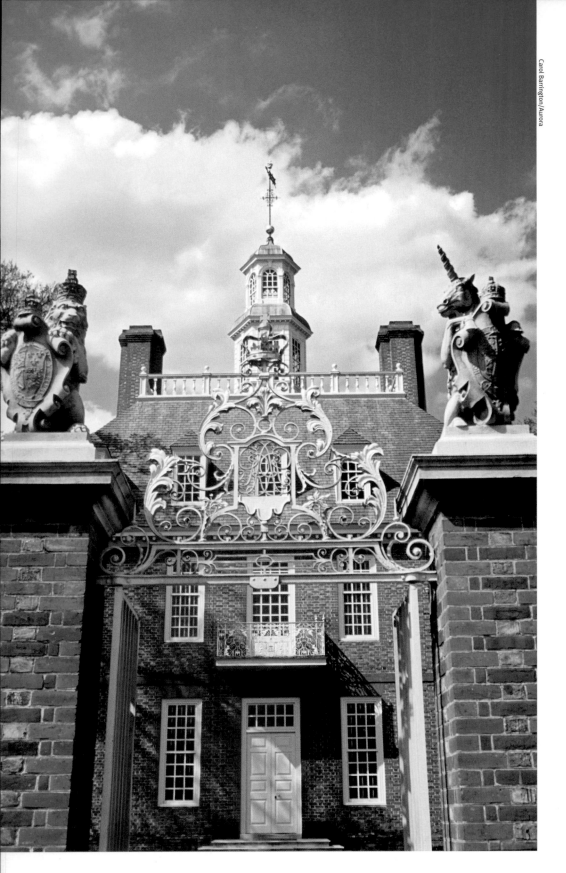

Shenandoah National Park
VIRGINIA

Just over a hundred miles in length, the highway from Front Royal south to Rock Fish Gap is the ne plus ultra of a species of mid-Atlantic ridge-running roadway that offers the driver frequent and stunning views of and from the Blue Ridge Mountains (which continue, beautifully, down into the Carolinas). Spreading out splendidly to the west of the Virginia drive is the Shenandoah Valley with its eponymous river, while the foothills falling eastward are equally captivating. Were one driving foolishly, one could execute this trip in three hours. But with caverns to visit and so many overlooks to enjoy, each of them affording a more soul-stirring experience than the last, who would be so foolish? And as for the mountains themselves, they are soft and rolling and blue and tree-topped: pure Appalachian romance. Just as Laurel and Hardy, no less, observed when they sang "The Trail of the Lonesome Pine" in their film *Way Out West*:

In the Blue Ridge Mountains of Virginia,
On the trail of the lonesome pine,
In the pale moonshine,
 our hearts entwined,
Where she carved her name
 and I carved mine.
Oh June, like the mountains I'm blue.
Like the pine, I am lonesome for you.

Colonial
Williamsburg
VIRGINIA

This is not Walt Disney World; there is an authenticity here that is hard to describe. The town has been re-created to look just as it did in the 1770s, when it served as Virginia's first capital. So, yes, in that sense it's fake. But stroll from the capitol building at the east end of Duke of Gloucester Street to the Wren Building of the College of William and Mary (the nation's second-oldest college) at the western end, and you have taken a very real walk into America's past. The Governor's Palace, seen here, was completed in 1722; the taverns along the way serve authentic Colonial cuisine; the shops of the blacksmith and the wigmaker are operative; at the Bruton Parish Church, candlelight organ recitals feature period music. Life can get strange in Williamsburg. You realize there's artifice afoot, but it feels like artifact.

THE Outer Banks
NORTH CAROLINA

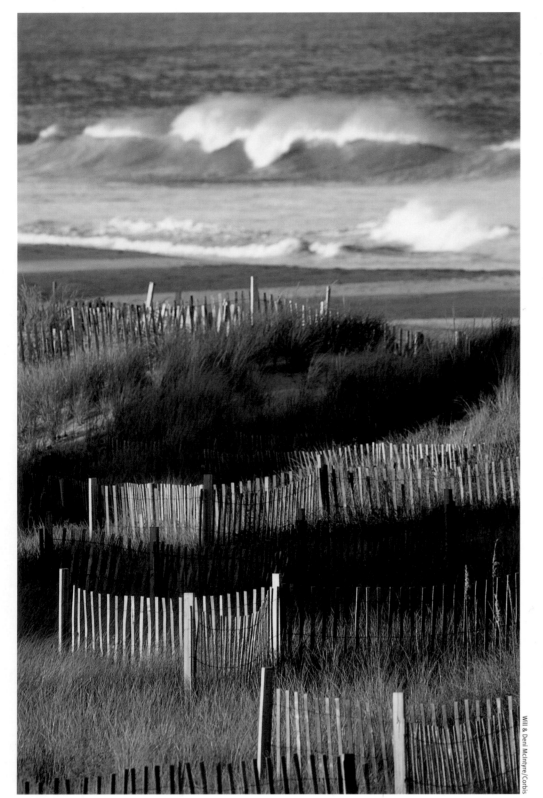

Will & Deni McIntyre/Corbis

David Muench/Corbis

Shakespeare's *The Tempest* employed Bermuda as its model, but it could have been set on this slender chain of barrier islands off the coast of North Carolina, isles that are renowned for natural beauty and dramatic history. It was here that, in Shakespeare's very day, the English made their initial, unsuccessful attempt to put down roots in America. The Lost Colony still haunts, four centuries later. The first white child in America, Virginia Dare, was born here. The infamous pirate Blackbeard pillaged here, and met his death here. Much more recently (but still more than a century ago), the Wright Brothers proved here that man could fly. As the Wrights well knew, water and wind have etched wide sandy beaches along an underdeveloped seashore. These days, that translates into tourism. There is no better place on the Eastern Seaboard to swim, sail, surf and shell than on the Outer Banks. Or to birdwatch: Egrets, herons and other migratory birds stop here to rest on their journey along the Great Atlantic Flyway. Lighthouses dot the coastline; the one at Cape Hatteras, at 208 feet, is the nation's tallest. For decades, it has thrust out a beacon from this rough-hewn place into the tempest.

Charleston
SOUTH CAROLINA

A place of "genial grace" and "slow charm" was how Rhett Butler described Charleston. The city, though bigger today (and a mite faster-moving), has somehow preserved a gracious elegance. It has a well-preserved historic district of double-galleried antebellum houses, historic churches and exquisite gardens, some of which are open in springtime during Charleston's Festival of Houses & Gardens. South Carolina's sunny, benign climate lets flowers bloom year-round, and the air is perpetually redolent with the aroma of wisteria and jasmine. Beginning in January, the city and nearby Magnolia and Middleton Place

red camellias, azaleas and oleander, which have been planted against a backdrop of native magnolias, live oaks and palmettos. Above is the great oak at Drayton Hall, another famous estate. Laid out in 1680 on a peninsula between the Ashley and Cooper rivers, Charleston was once a busy port, deriving its wealth from exports of rice, indigo and cotton. Today, there is still old-world charm, but also modern hotels, chic shops and five-star restaurants serving local delicacies such as she-crab soup. The Catfish Row of *Porgy and Bess* is here, and so is the annual world-class Spoleto arts festival. Charleston is young and old, provincial and wordly—yet never,

There are more than 100 (all gorgeous) tidal and barrier islands in the Atlantic between the Carolinas and Florida, but here we are referencing the several major ones that hug the Georgian coast. Now, then: how to visit them? Well, let's say you were going to drive from storied Jekyll Island, where Rockefellers lunched with Vanderbilts in the Gilded Age, up to that Athens of the antebellum South, Savannah. You could hop over to Interstate 95 and make the trip in less than two hours. Or you could meander 81 miles north on 17, with a little detour through the town of Meridian on 99, and thereby bathe yourself in the lush, rich atmosphere of what the locals call the Gold Coast. The collection of barely offshore islands that includes Jekyll, St. Simons, Little St. Simons, Cumberland and Sea Island is known hereabouts as the Golden Isles—a very discerning appellation. No less alluring are the estuaries and marshlands (the salt grasses in the Marshes of Glynn are mesmerizing) and the miles of pine forest that exist gently inland. It is an intoxicating locale.

Golden Isles
GEORGIA

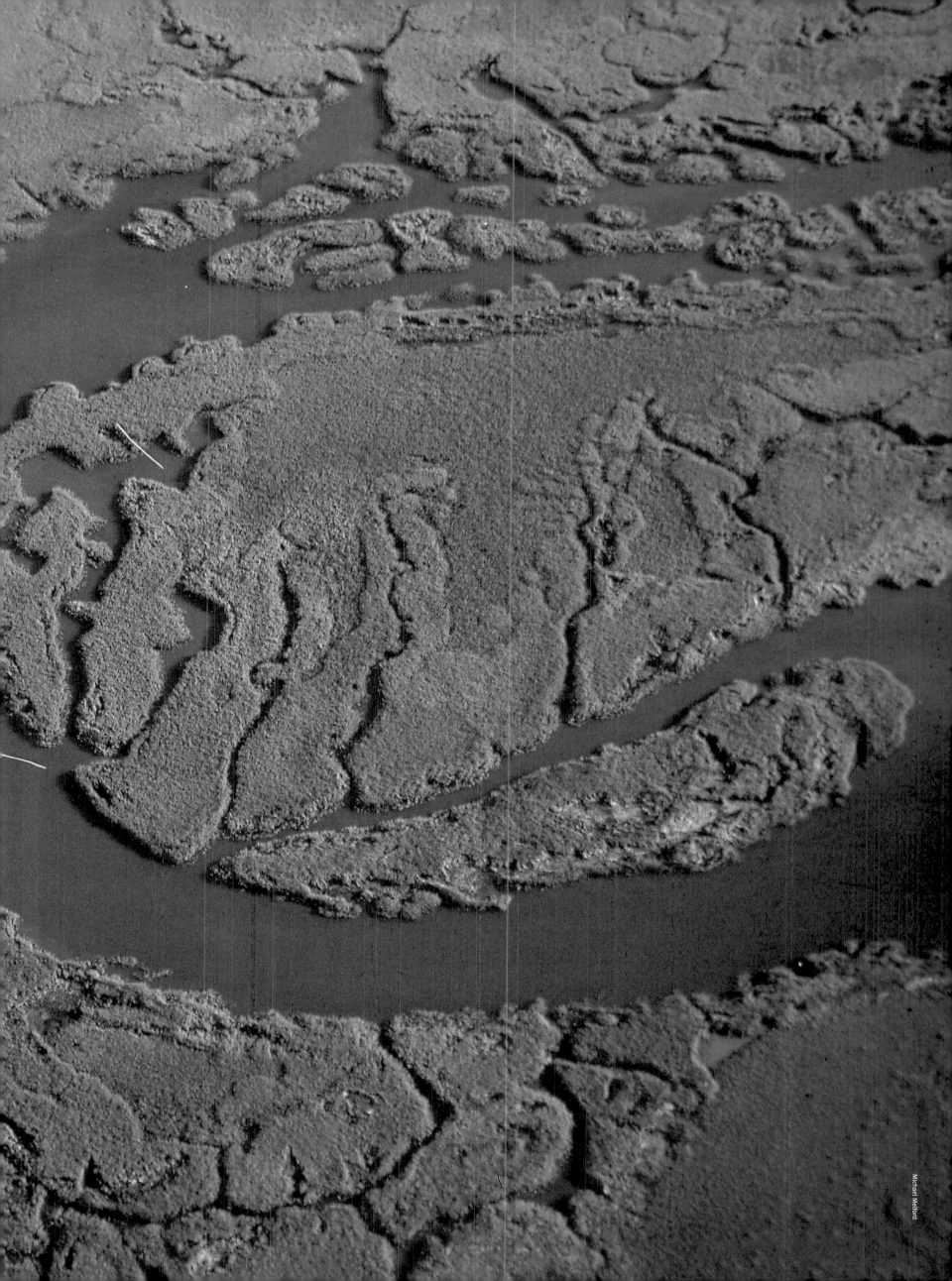

S avannah, one of the nation's loveliest cities, is graced with southern gentility, unhurried tempo and old-fashioned ambience. It is also graced with a little strangeness, as *Midnight in the Garden of Good and Evil* revealed for us all. That book shone a light on a part of Savannah that had previously been dark, but made the place all the more interesting—and human. To skim the surface of Savannah, travel the Historic Landmark District, the largest such area in the country. It still reflects the plan that Gen. James Oglethorpe laid out in 1733—a grid of squares (small parks today) surrounded by antebellum mansions interlaced with spacious streets and quaint, quiet alleyways. The city was once a prosperous river port, and still remains famous for the wrought-iron grillwork that embellishes gates, balconies and window seats in the handsome estates. More than 5,000 magnolias, palmettos and oak trees trailing Spanish moss keep Savannah green and shady, while blooming azaleas and dogwood turn the town pink in early spring. All very lovely . . . and then the sun goes down.

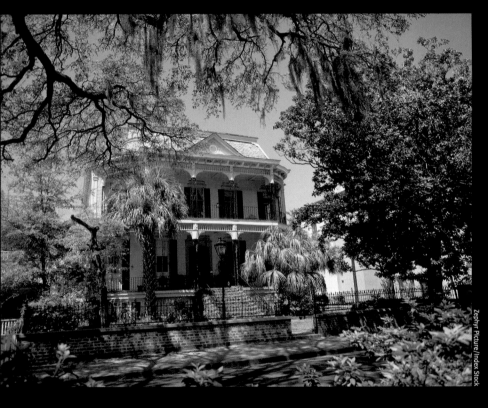

Zephyr Picture/Index Stock

Savannah
GEORGIA

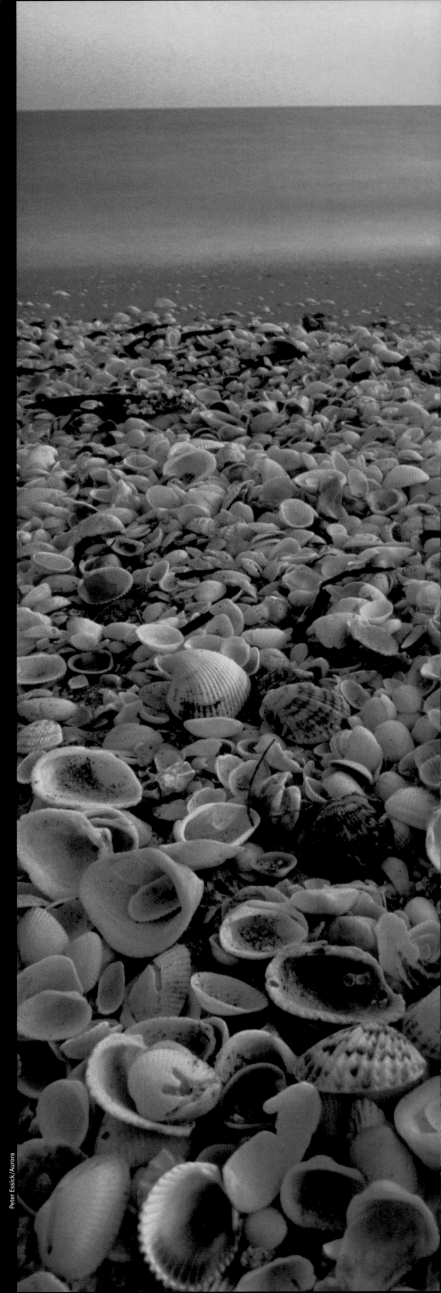

Peter Essick/Aurora

I t's hard to think of a more warming family enterprise than walking the shoreline to look for seashells. The children are full of eagerness and wonder, the parents are brimming with love and also reminiscence—*this is me, when I was that age.* There's simply nothing else like shelling; it is the most casual of pastimes, and yet somehow one of the most profound. It's Exhibit A for that clichéd proposition: Memories are made of this. Now, some places are better than others for finding a wide array of lovely seashells, but few are better than the white-sand beaches of Sanibel Island. Just off Florida's western coast in the Gulf of Mexico, Sanibel has an unusual east-west orientation, and so acts as a scoop for shells moving north on the prevailing current. At low tide or after a storm, the picking is easy. (But remember not to take any live shells, starfish or sand dollars. Return them to the ocean so they can continue to breed and so you can avoid a hefty fine.) Sanibel, not a large island but with 17 miles of alluring beaches, is connected by a bridge to the equally captivating Captiva. Both isles have an abundance of wildlife and are home to legions of shorebirds, they have fine restaurants, they have spectacular sunsets over the Gulf, they have lively pirate lore attached to them . . . But what they have more of are those shells—makers of memories.

Sanibel Island
FLORIDA

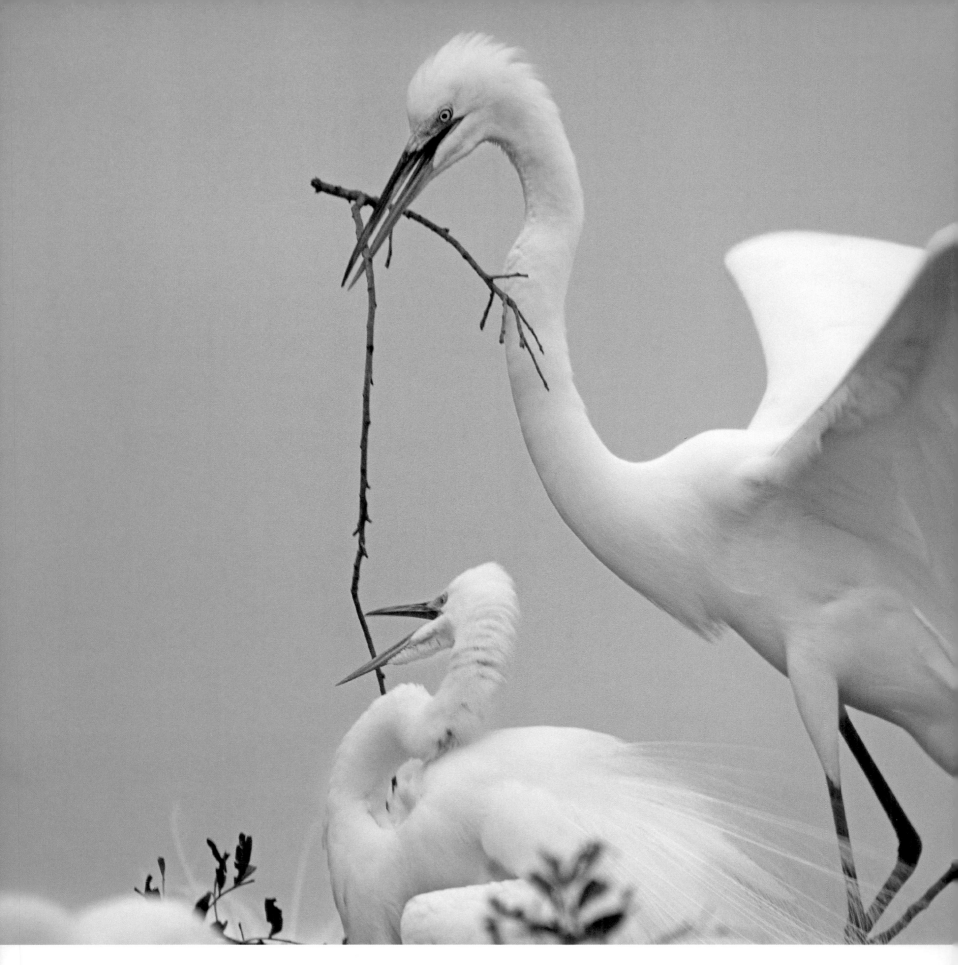

‖Everglades
FLORIDA

There's nothing else remotely like it in America. It's difficult, even, to get your mind around just what the Everglades *is*. By definition, Florida's Everglades National Park is the largest subtropical wilderness in the U.S. More descriptive of what's at the heart of the unique Everglades ecosystem is the often-applied term "river of grass." Yes, it is that, a slow-flowing river some 50 miles long and not more than knee-deep, winding through 1.5 million water-soaked acres of shimmering saw grass, mangrove swamps, pinelands and hardwood stands. The river is the lifeblood of the Everglades, creating a teeming paradise for wading birds (egrets, above), fish, alligators and hundreds of lesser-known animals and plants that have adapted to this special environment. Their magical realm is under constant siege by development in the Sunshine State, but for now, the Everglades remains a wonder of the natural world.

T hey represent not just Hemingwayesque bonefishing or Jimmy Buffett's Margaritaville, although they are both of those things in select spots. What they are is this: separate but interrelated islands—including Key Largo, Islamorada, Marathon, Big Pine Key, Long Key, and Key West—unspooling to the southwest from the tip of continental Florida as if cast by some great angler in the sky. They have attracted loners and drifters in days of yore, and just-passing-through tourists and sportsmen in modern times. Is the snorkeling off Key Largo superior to the sport fishing off Islamorada? Impossible to say. Are Marathon's resorts more comfortable than the still-scruffy, laid-back hostelries of Big Pine Key? Depends what you like. And then there's Key West, the Last Resort, the southern terminus of the continental U.S., a place where you can find a secluded guesthouse or party down on Duval Street. There's so much that's so different, why not go see it all? A drive from Florida City to Key West on the 127-mile, 42-bridge Route 1 is an oceangoing voyage unlike any other.

THE Florida Keys
FLORIDA

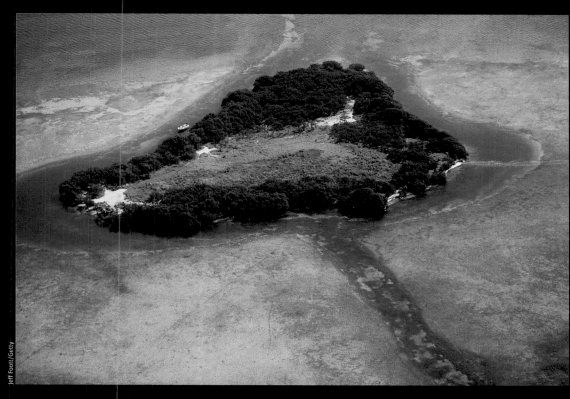

Tim Fitzharris

Jeff Foott/Getty

Walter Bellingrath, who made his first fortune with a vastly successful Coca-Cola bottling franchise in Mobile, also had a green thumb and a winning way with a metaphor: He once likened the creation of the fabulous gardens on his 65-acre estate to a beautiful woman wearing a different dress every week of the year. Indeed, the Gardens does change its beguiling look with regularity, as 250,000 delicate spring flowers are on display in March and April, one of the nation's outstanding rose gardens takes pride of place in summer, 80,000 chrysanthemums show their colors in the fall and a scarlet blaze of poinsettias ushers in the Christmas holidays. The Asian-American area of the estate features a teahouse and a lake where snow-white swans swim before a backdrop of weeping cherry trees. Flagstone walks wander past fountains and waterfalls, and a conservatory is home to orchids and exotic plants. The 15-room mansion is filled with antiques and objets d'art, and an adjacent gallery houses the porcelain sculptures of Edward Marshall Boehm. In short: A feast of flowers and fragrances awaits in Bellingrath Gardens, which Walter and his wife, the former Bessie Mae Morse of Mobile, first opened to the public in 1934. A lovely postscript for a place so lovely is that the Gardens' supremacy is the product of a love story. When Bessie Mae died in 1943, Walter pledged to dedicate the remainder of his life to working with the grounds. "These Gardens were my wife's dream," he said, "and I want to see that dream come true."

Philip Gould/Corbis

Peter Frischmuth/Peter Arnold

Bellingrath Gardens and Home
ALABAMA

Next to the word *antebellum* in the dictionary they could offer a photograph of historic Natchez, where pillared houses and estates stand grandly on land atop a bluff, which runs down to the eastern bank of the Mississippi. Natchez, population just about 20,000 today, is one of the oldest cities on the river, having been founded as a fort in 1716. Even before that the site had been employed as the ceremonial village of the Natchez Indians, who fell into conflict with—and were eventually wiped out by—the encroaching French. Natchez was

controlled subsequently by the Spanish and British before being ceded to the United States towards the end of the 18th century. Just before the Civil War erupted, Natchez was considered one of the very wealthiest cities in the country, as plantation owners chose to build their luxurious private homes there. Many of those mansions still exist as Natchez, occupied beginning in 1863 by Union forces, was spared the ravages suffered by other Southern cities. Natchez's good fortune back then is the reason that, today, it stands as the very definition of the Old South.

THE Great Smoky Mountains

This land used to belong to the Cherokee, who farmed here and established villages in the forests and foothills. In the 1830s they were violently pushed out, their famous Trail of Tears eventually finding its end in Oklahoma. The rural settlers who replaced them built small communities and started traditions of hunting, farming, worship and music that became hallmarks of Appalachian culture. Then, in the early 20th century, came the loggers, and life in the Great Smoky Mountains was simple no more. The hills were being rapidly denuded by the lumberman's saw, and only in the very nick of time was the lovely mountain range we know today as the Smokies, which runs along the border between North Carolina and Tennessee, saved. In 1934 Great Smoky Mountains National Park was established to preserve what natural beauty remained. As a consequence of the formation of the park, more than 1,200 people had to give up their homesteads and relocate. Empty log cabins, barns, mills—even schools and churches—were left behind; several dozen of them are still maintained by the park service, and color a visitor's experience. So does 6,642-foot Clingmans Dome, the highest point in Tennessee; so does a fantastically diverse collection of plants and animals, from a million tiny wildflowers to some 1,600 bears; so does the signature blue haze that hangs above the hills, a product of hydrocarbons from trees and other plants commingling with the humid air. It all adds up to the Smokies of today— and of yesteryear, miraculously preserved.

Ryman
Auditorium
TENNESSEE

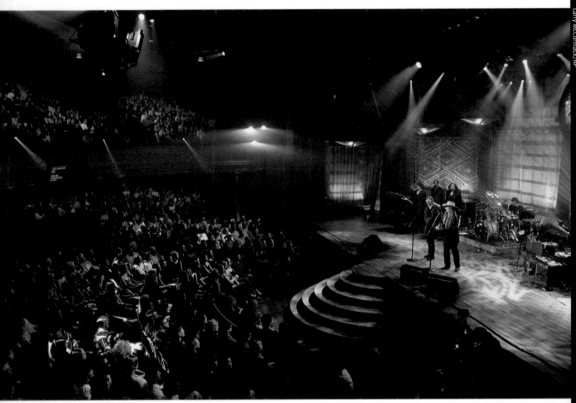

Larry McCormack/AP

Bob Krist/Corbis

Since 1974 the Grand Ole Opry has made its home in Opryland, the mega resort/golf course complex on the outskirts of Nashville. But from 1943 till '74, it broadcast every Saturday night from the stage of this hallowed concert hall downtown, a place that stands in regard to Opryland as Johnny Cash would to the latest hat act. Acoustically in a league with Symphony Hall in Boston or the Salt Lake Tabernacle, stylistically a Gilded Age marvel, the Ryman is truly, as it claims of itself, the Mother Church of Country Music. But it's more than that, too. Opened in 1892 by the riverboat captain Thomas G. Ryman as the Union Gospel Tabernacle, the building has always been ecumenical in its reach. Hank Williams and Patsy Cline performed here, surely, but so did Enrico Caruso, Sarah Bernhardt and Nijinsky with the Ballet Russe. Loretta Lynn, Willie Nelson (above, right), of course, but also Bob Hope, James Brown, the Byrds and Rob Thomas (also above, with Willie). All the stars have come to the Ryman, and the Ryman itself, so lovely to behold, has starred—in the movies *Nashville, Coal Miner's Daughter* and *Sweet Dreams*. After the Ryman was spurned by the Opry, it stood unused and forlorn for two decades. But it came blazing back to life after a 1994 renovation, and today it, like Opryland, is where the country music pilgrim to Nashville simply must go.

Horse Country
KENTUCKY

Y ou don't have to be a horse—or even a horse lover—to appreciate this green, serene, altogether lush and luscious part of the country. Also known as the bluegrass region and encompassing parts of 15 counties in the heart of central Kentucky, this landscape has elegant farm after elegant farm, charming mile after charming mile between Lexington and Louisville—and, oh yes, lots of very handsome horses. The hills roll to the horizon behind miles of white-plank fences that glisten in the midday sun. And there grazing, or getting their exercise, or being rubbed down, are the magnificent thoroughbreds—rivaling the scenery itself in beauty. You can tour the storied, 800-acre Calumet Farm outside of Lexington, where were bred Triple Crown winners Whirlaway and Citation, as well as nine other Kentucky Derby champions. Nearby is Kentucky Horse Park, where you can pay respects to Man O' War, who's buried on the grounds, and also meet living legends such as John Henry, stabled in the Hall of Champions. There is no prettier racetrack in the land than Lexington's Keeneland, and no prettier farm than that town's Manchester (below). But, again, let's say horses aren't your thing. A drive through Kentucky's horse country still remains a sensory exercise in rest and relaxation not to be missed.

Mammoth Cave

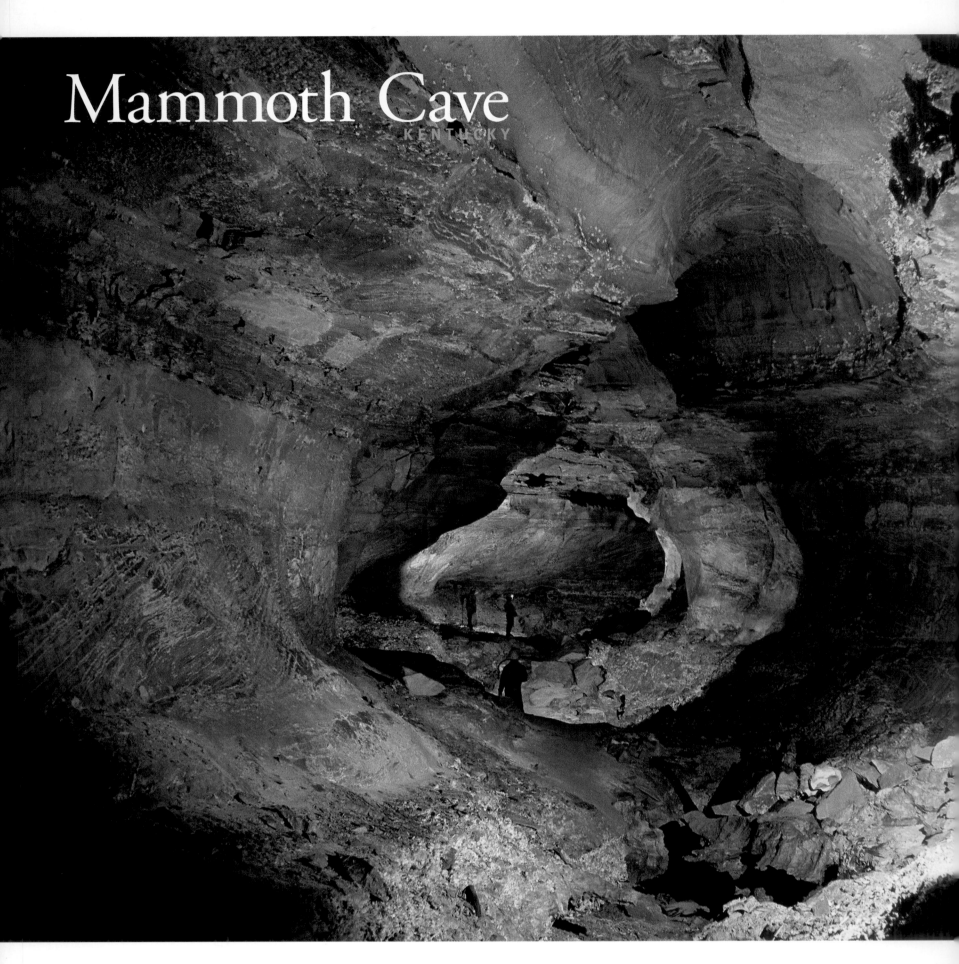

"A grand, gloomy and peculiar place," said Stephen Bishop, capturing succinctly a few of Mammoth Cave's particular charms. He was a slave who had come to be employed as a guide in the cave during several breakthrough years (some of the breakthroughs were his; he was the first to cross Bottomless Pit, which led to everything else) in the mid-19th century. (Above is the New Discovery Bore Hole, which was found in 1939.) Little could Bishop have known that "grand" would one day come to mean "the world's longest cave system." It certainly is that, with 365 miles explored, and it certainly is, in places, gloomy and peculiar as well. But it is most often sensational—and intriguing. Explored by Native Americans since time immemorial and by Europeans since the 1700s, Mammoth Cave is now largely protected as a national park, and attracts 2 million visitors a year. Those guests enter a world of limestone wonder beyond compare, a world peculiar, sometimes gloomy, but regularly grand.

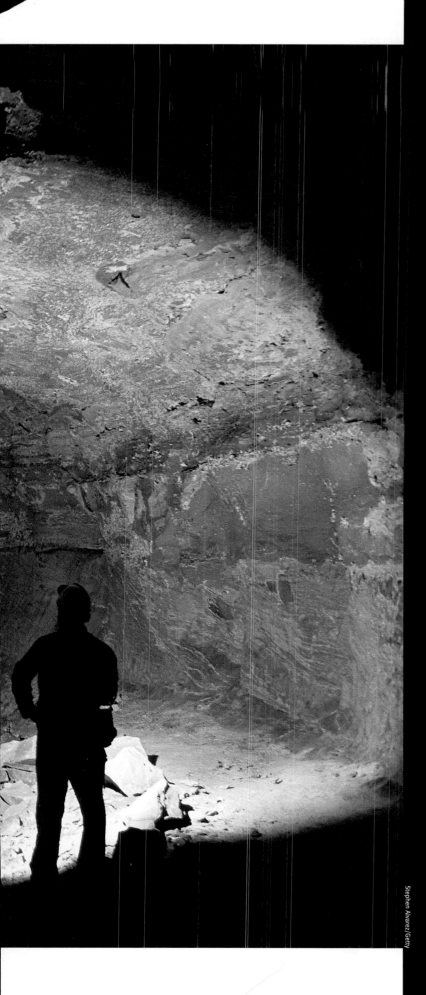

Stephen Alvarez/Getty

One of the great, too often unsung American recreations is birding. Millions upon millions of us are birders, delighting in the quiet pastime of simply looking at a natural, beautiful living creature in its native habitat. The Ottawa National Wildlife Refuge Complex is comprised of three refuges lying on (and in the case of West Sister Island, just off) the southern shore of Lake Erie. In all, there are 9,000 acres protected—marsh, open water, wetlands, grasslands, shrublands, croplands and an open estuary—and if the protections have a principal aim above others, it is to preserve a major feeding, nesting and resting area for migratory birds. There are shorebirds, warblers, wading birds, all manner of waterfowl and raptors in Ottawa National. In springtime, songbirds flock here from the South and set a spell, before continuing their migration north. This is a small bit of Eden for the birds, and for those of us who would come to gaze at them.

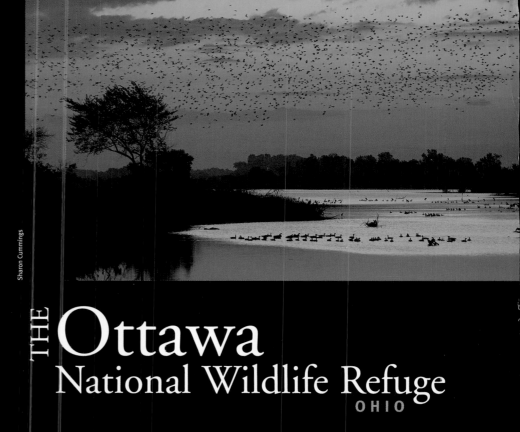

Sharon Cummings

THE Ottawa
National Wildlife Refuge
OHIO

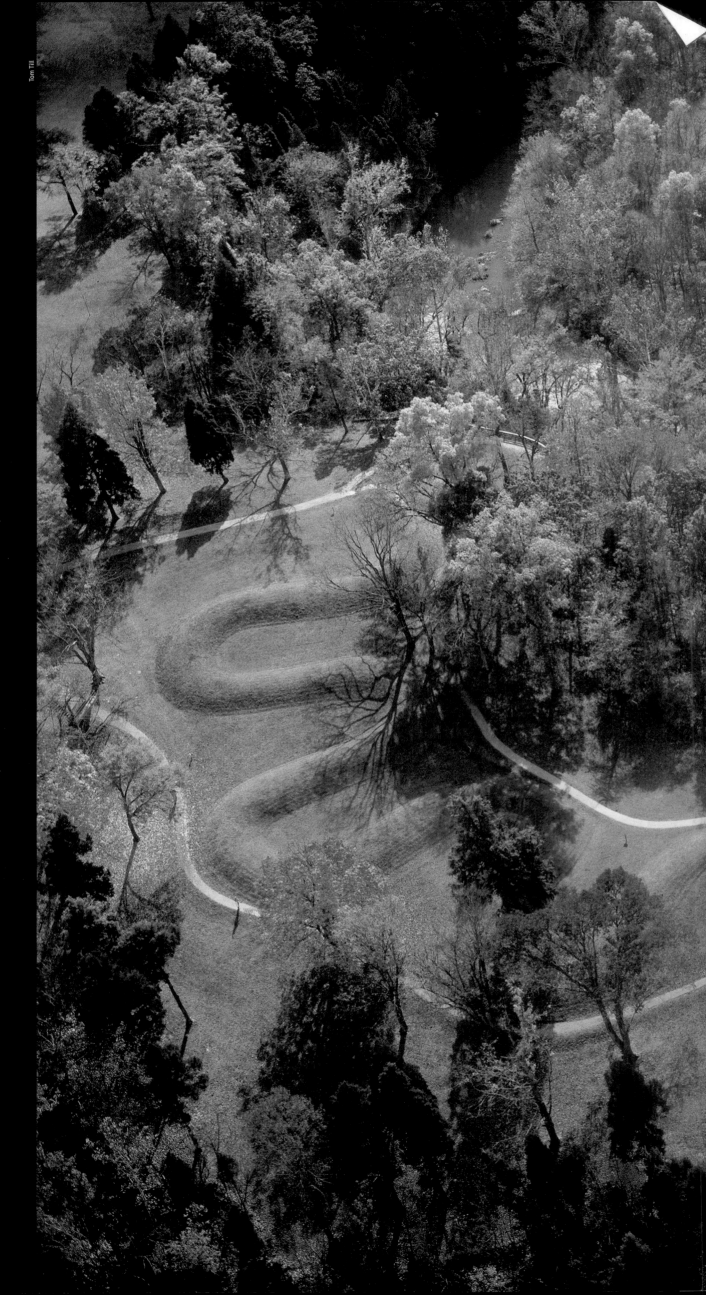

Tom Till

While American history is well documented, America's prehistory is too often ignored. The facts are, humans were firmly established in the New World thousands of years before the white man's arrival. They built civilizations from Alaska to Georgia. Eventually, the early Indians' hunter-gatherer lifestyle grew in sophistication, as evidenced by found tools, artifacts and earthworks. Most spectacular among the legacies are thousands of mounds throughout the U.S. Some were burial places, some marked sacred sites. The Great Serpent Mound near Hillsboro, Ohio, is the largest effigy mound in the world, averaging 20 feet wide by five feet high and running a quarter mile from tip to tail. It is not certain beyond doubt who created the mound, when it was created, or what it was created for, but the Adena culture began building elaborate earthworks around 700 B.C. and is often mentioned first in conjunction with the mound. It is not a burial site, and because of various alignments in the design nodding to solstice sunrises, it is thought by some to reference astrological events. Whatever the answers to the Serpent Mound's many mysteries, it is as wondrous to behold as it is fascinating to ponder.

THE Great Serpent Mound
OHIO

Mackinac Island MICHIGAN

It depends upon when you go. It is a wonderful summertime vacation in full flight, or in winter—well, it is a trip back in time. There are no private cars allowed on Mackinac, which lies several miles offshore in Lake Huron, and that changes many equations. In summer, when the weather is constantly splendid, swarms of tourists walk and bike the 3.7 square miles of Mackinac, and the island indeed feels small. In winter, the island's somehow more extensive 70 miles of road are snow-covered; many of those miles are groomed for skiers. The sounds of winter on Mackinac are hushed: hoofbeats on snow, a quietly crackling fire, the *schuuush* of cross-country skis. Even deliveries come by horse-drawn cart. A small cluster of hotels and restaurants remains open year-round, and the 500 or so locals warmly welcome off-season visitors. The Village Inn (but of course that is its name) is the island's social hub on cold evenings, and it is a great spot for steaks, chops, burgers and its signature dessert, Mackinac Island fudge cake. Plus the island's signature feature, summer or winter: Mackinac Island warmth.

Amish Country
INDIANA

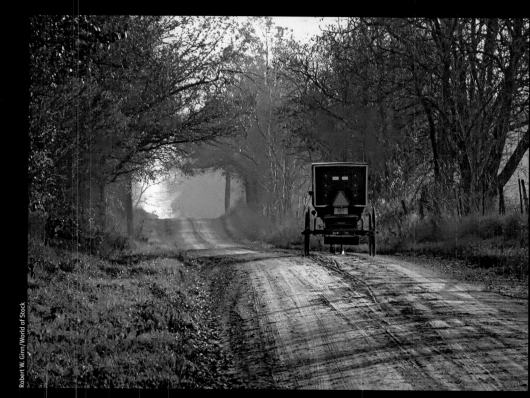

Robert W. Ginn/World of Stock

Layne Kennedy/Corbis

If there is a voyeuristic aspect to taking an auto tour through a community of people whose religion asks them to forgo cars (as well as other modern amenities including telephones and electricity), it is nonetheless true that this is a splendid way to drink in the rhythms of life among the Amish. And if you feel in need of sanction, consider this: The visit-by-car is precisely what's recommended at the Elkhart County Visitors Center, where you can obtain the Heritage Trail Tour CD or cassette, a 90-minute recording that will assist you as you travel east. The history of the region and the Amish who began settling here in the 1840s is detailed, as are local attractions. You'll see children in straw hats and bonnets throughout these communities, and as you make your way through the village of Middlebury and past Amish farms that dot Crystal Valley between there and Shipshewana, drive very carefully: Just over the next hill may be a horse and buggy heading for market. Do not think of yourself as a voyeur or even a tourist here, but rather as a guest.

Galena

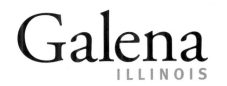

ILLINOIS

<div style="text-align:right">Gerald Brimacombe</div>

The word *galena* is the technical term for sulphide of lead, and on this less than poetic fact rests the considerable history of a city that, today, is pure poetry. Beneath the rolling hills of northwestern Illinois there have long been lead deposits in considerable quantity. Indians first mined the ore, and of course the white man did too. In the early 1800s the U.S. Congress established the Upper Mississippi Lead Mine District in the region, and in 1826 Galena was born. By mid-century, this city on the Galena River was the busiest port between St. Paul and St. Louis, and rivaled Chicago in population, while greatly outstripping it in wealth per capita. The grand DeSoto House Hotel was a focal point—candidates Abraham Lincoln and Stephen A. Douglas both addressed the citizens of Galena from its balcony—and the mansions along Prospect Street were alluring during a Sunday promenade. Ultimately, though, the lead-mining industry yielded to the California Gold Rush and other market forces, and Galena's own golden age came to a close. But the homes, hotels, banks and churches remained. Showing great prescience, city leaders saw a future in these edifices, and today, 85 percent of Galena's buildings are in the National Register of Historic Places. The DeSoto House still thrives, for Galena has become a mecca for those who choose a taste of bygone elegance.

Jim Sugar/Corbis

When we ask to be taken out to the ball game, taken out to the crowd, it is to a stadium like Fenway in Boston or Chicago's Wrigley that we want to be transported. This is where we want to enjoy our peanuts and Cracker Jack, this is the arena from which we don't ever want to return. We may root, root, root for the home team, or we may just sit on our hands and drink in the aesthetic pleasures of the sights and sounds that are baseball: the crisp clack of bat on ball, the impossible greenness of the real-grass field, the elegance of a center fielder tracking down a long fly. At Wrigley, the glories are unending. First, crucially, you can often get a ticket—something that's beyond difficult at Fenway. And, as opposed to most Major League teams, who play the great preponderance of their games under lights, the Cubs remain dedicated to the proposition that baseball is a sport best enjoyed in the daytime. (Below, for contrast's sake, we see the first-ever Wrigley night game, staged in 1988.) Wrigley, which opened in 1914, is a lovely antique, with brick walls and, in the outfield, a vast garden of ivy clinging to those walls—growing denser as the summer wanes, counting the days of the baseball season right along with the rest of us.

Wrigley Field
ILLINOIS

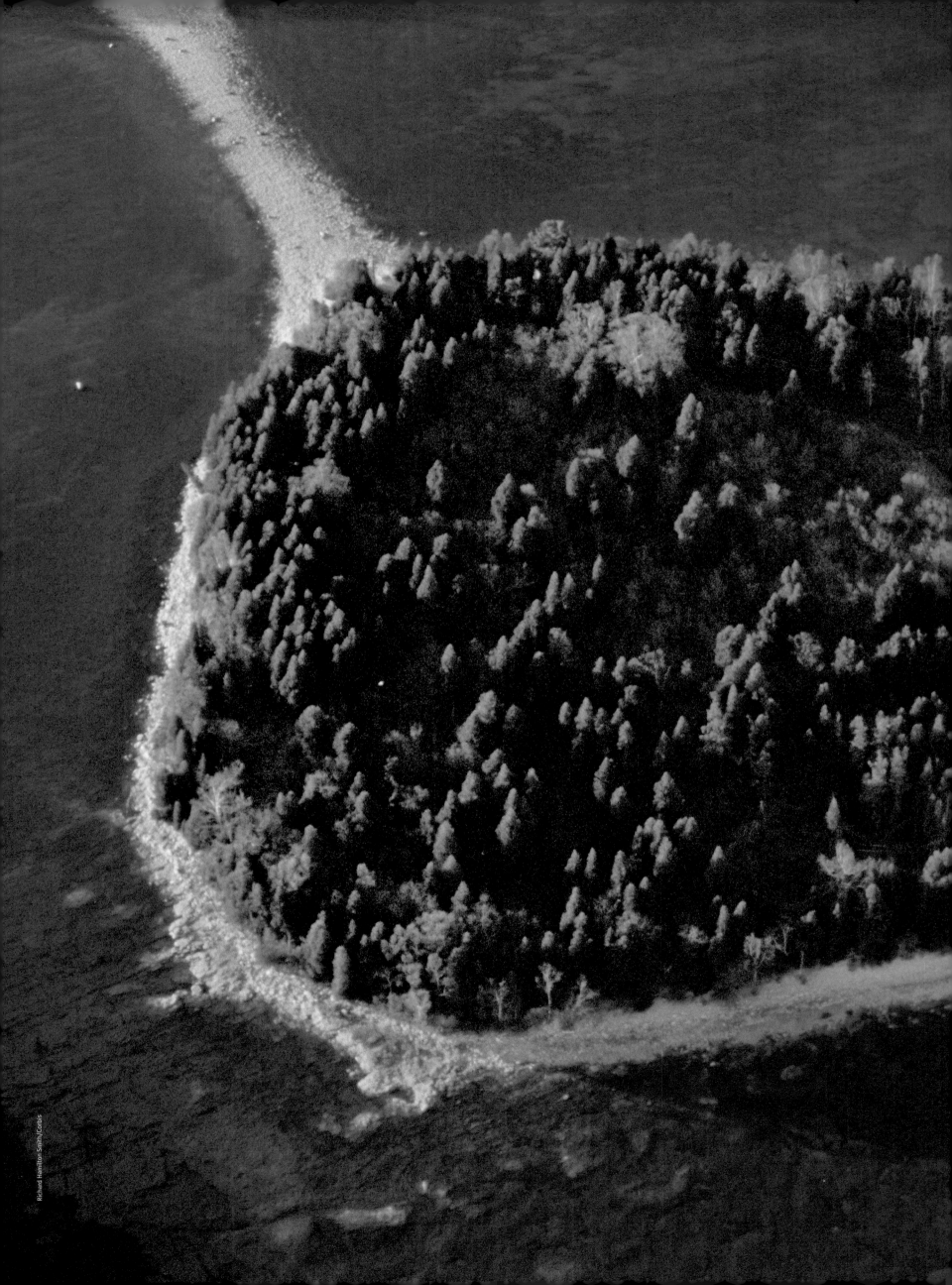

When we ask to be taken out to the ball game, taken out to the crowd, it is to a stadium like Fenway in Boston or Chicago's Wrigley that we want to be transported. This is where we want to enjoy our peanuts and Cracker Jack, this is the arena from which we don't ever want to return. We may root, root, root for the home team, or we may just sit on our hands and drink in the aesthetic pleasures of the sights and sounds that are baseball: the crisp clack of bat on ball, the impossible greenness of the real-grass field, the elegance of a center fielder tracking down a long fly. At Wrigley, the glories are unending. First, crucially, you can often get a ticket—something that's beyond difficult at Fenway. And, as opposed to most Major League teams, who play the great preponderance of their games under lights, the Cubs remain dedicated to the proposition that baseball is a sport best enjoyed in the daytime. (Below, for contrast's sake, we see the first-ever Wrigley night game, staged in 1988.) Wrigley, which opened in 1914, is a lovely antique, with brick walls and, in the outfield, a vast garden of ivy clinging to those walls—growing denser as the summer wanes, counting the days of the baseball season right along with the rest of us.

Wrigley Field
ILLINOIS

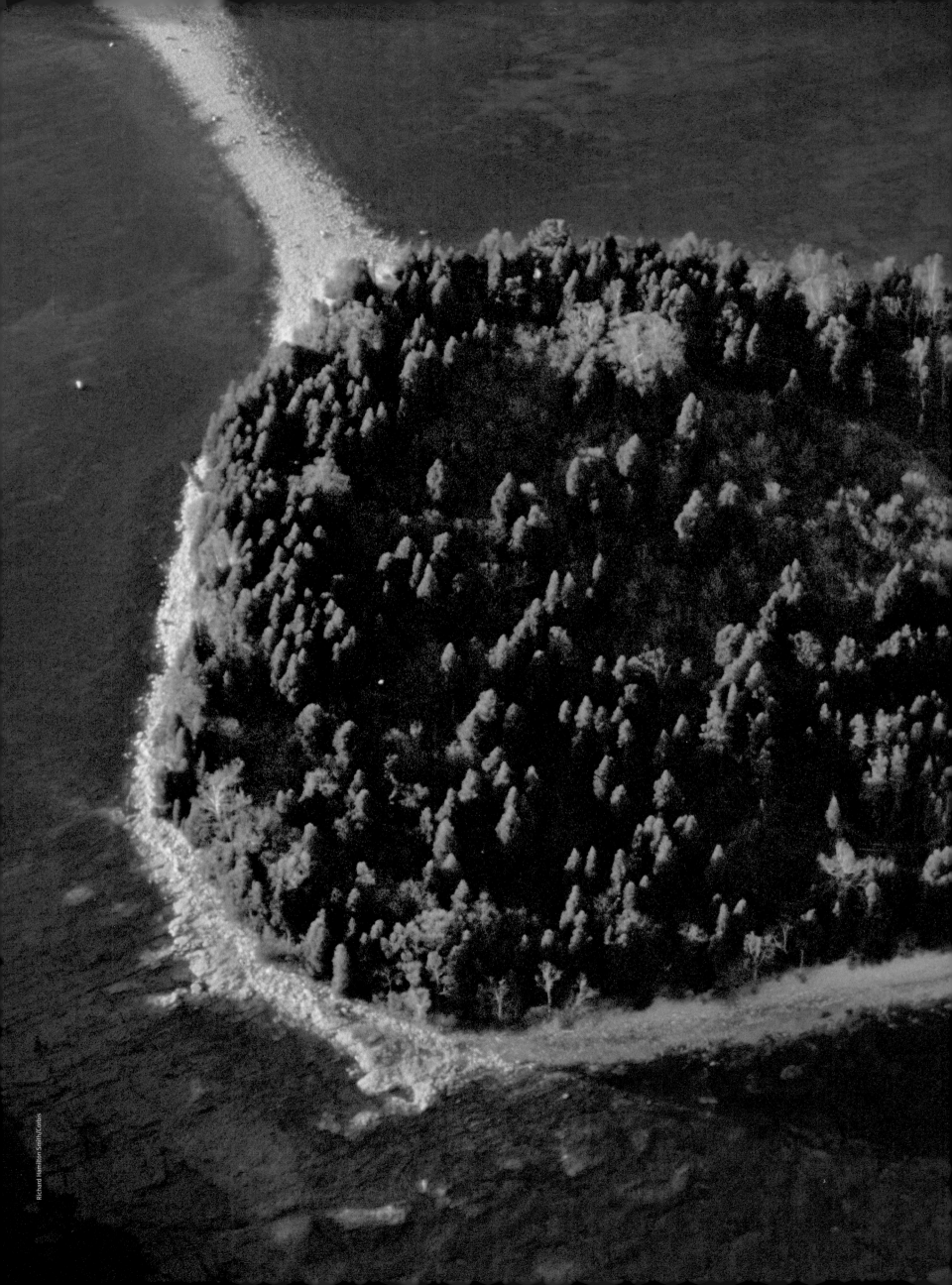

Door Peninsula

This is the attached-to-the-mainland (sort-of) version of Mackinac Island. While summer escapees from Chicago and Milwaukee have made its summertime famous, the Door swings open year-round for outdoor fun. What it is: a 75-mile-long spike thrusting into Lake Michigan that was severed from the eastern Wisconsin mainland by a ship canal 125 years ago; many of the tidy villages that dot its western shore date from that period. In warm weather, the peninsula is packed—but never so fully as to be less than fun. In winter, there's magic at work. You go down to the Cookery in Fish Creek and breakfast on buttermilk pancakes in that thick sauce made from local cherries. Then, even on the coldest days, you have options. Take Door County Trolley's winery tour—horse-drawn sleigh ride included. Or for those who want some exercise, kick and glide on miles of groomed cross-country ski trails in 3,700-acre Peninsula State Park. Or go sledding. Or even ice fish for perch or northern pike in Green Bay (Packers tickets not included). At day's end, bed down at the Whistling Swan, a fine hotel that was transported across frozen lake waters a century ago. You, too, will be transported.

Joel Meyerowitz

CAPE COD

CERTAIN PHOTOGRAPHERS SHOOT A PLACE so often and so well, their vision of that place becomes ours. We come to "know" the place through their eyes, their lenses. In this book we will highlight the work of three of these fine photographers—Michael Melford, the legendary Ansel Adams and, here, Joel Meyerowitz—not just to prove that point, but to dazzle you with the fruits of their photographic talents and efforts.

Meyerowitz is known for chaotic urban photos among other things—and then there are these stately images of his beloved Cape, most of them made with an 8 x 10 view camera. Why? "Cape Cod is a one-story place," Meyerowitz once said. "Everything sits against the horizon. Everything is in human scale. It allows me to make formal photographs. The camera itself is formal. We're like a bride and groom. When I stand in front of a place with that camera, I'm at attention, the camera is standing at attention, the buildings are standing at attention. Everything is having its portrait taken."

Think of these, then, as portraits of Cape Cod, expressive of mood and feeling, not just as pictures. Another time he said: "Who knows what's going to leave us spellbound at any given moment. Everything has power—even the most common object: a fencepost, a picket fence, a street lamp." Or a lone kayak, a bicycle, a hammock asway in the breeze: portraits from Cape Cod, equaling a portrait of Cape Cod.

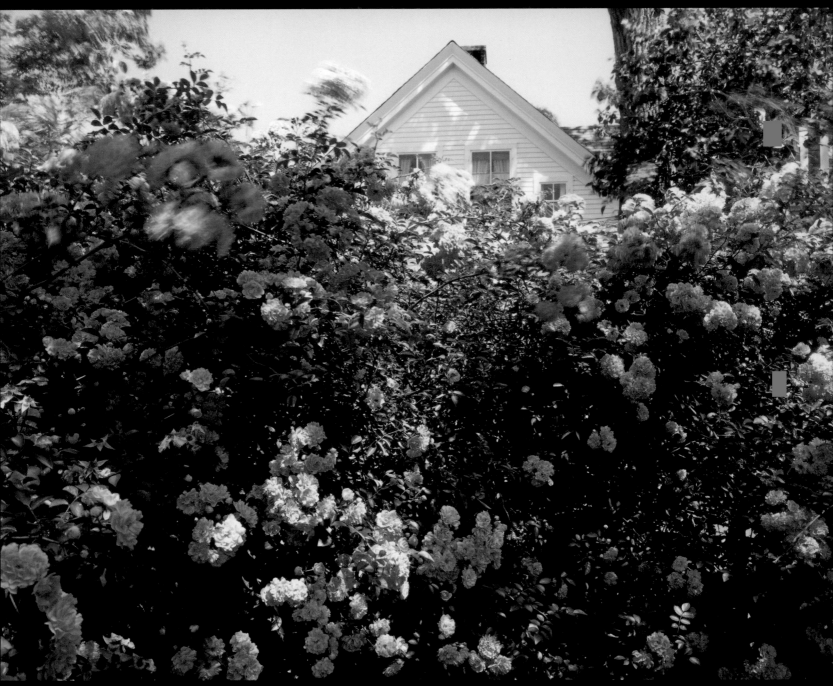

ROSES AFLAME BEFORE A COTTAGE

A SEA KAYAK BY CAPE COD BAY

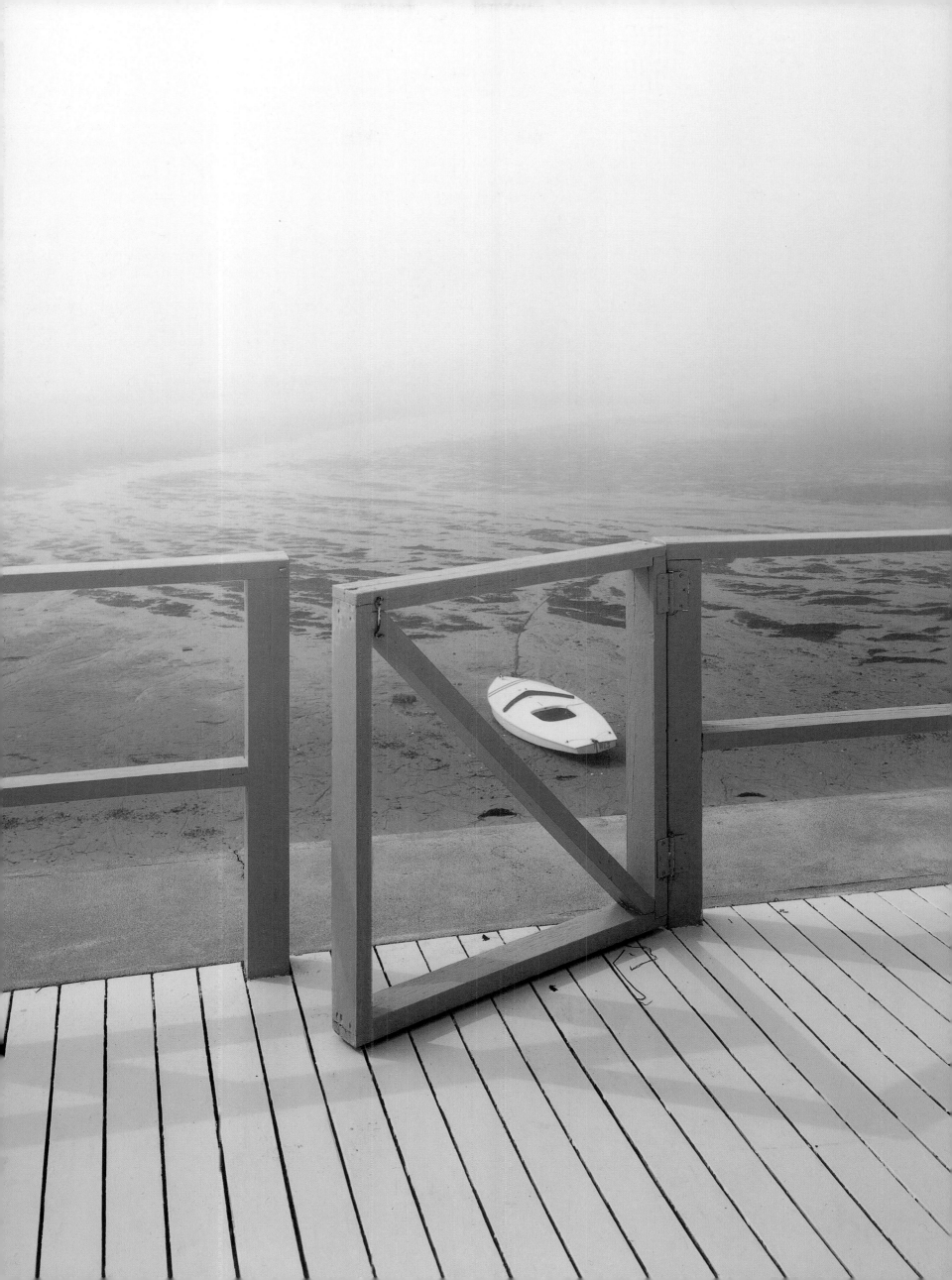

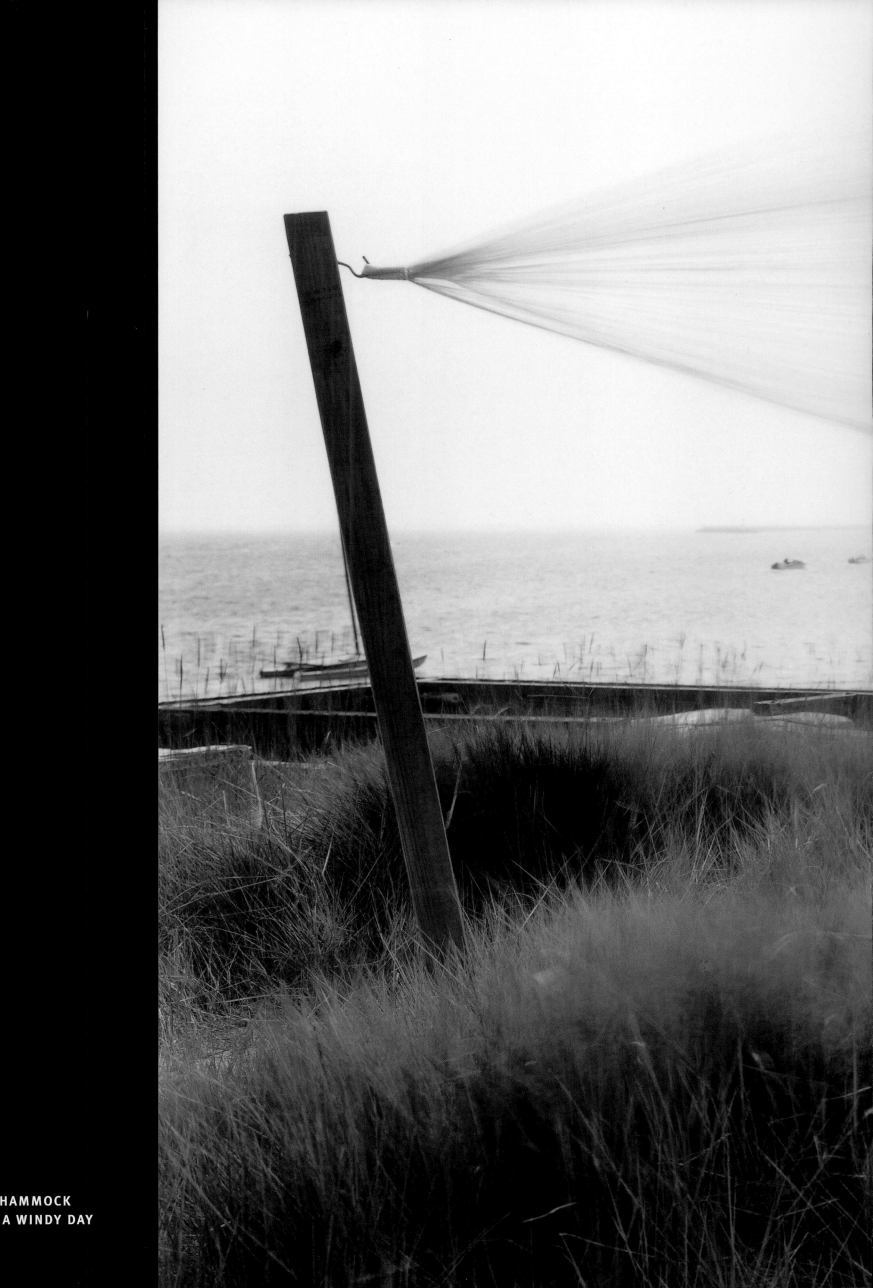

HAMMOCK
A WINDY DAY

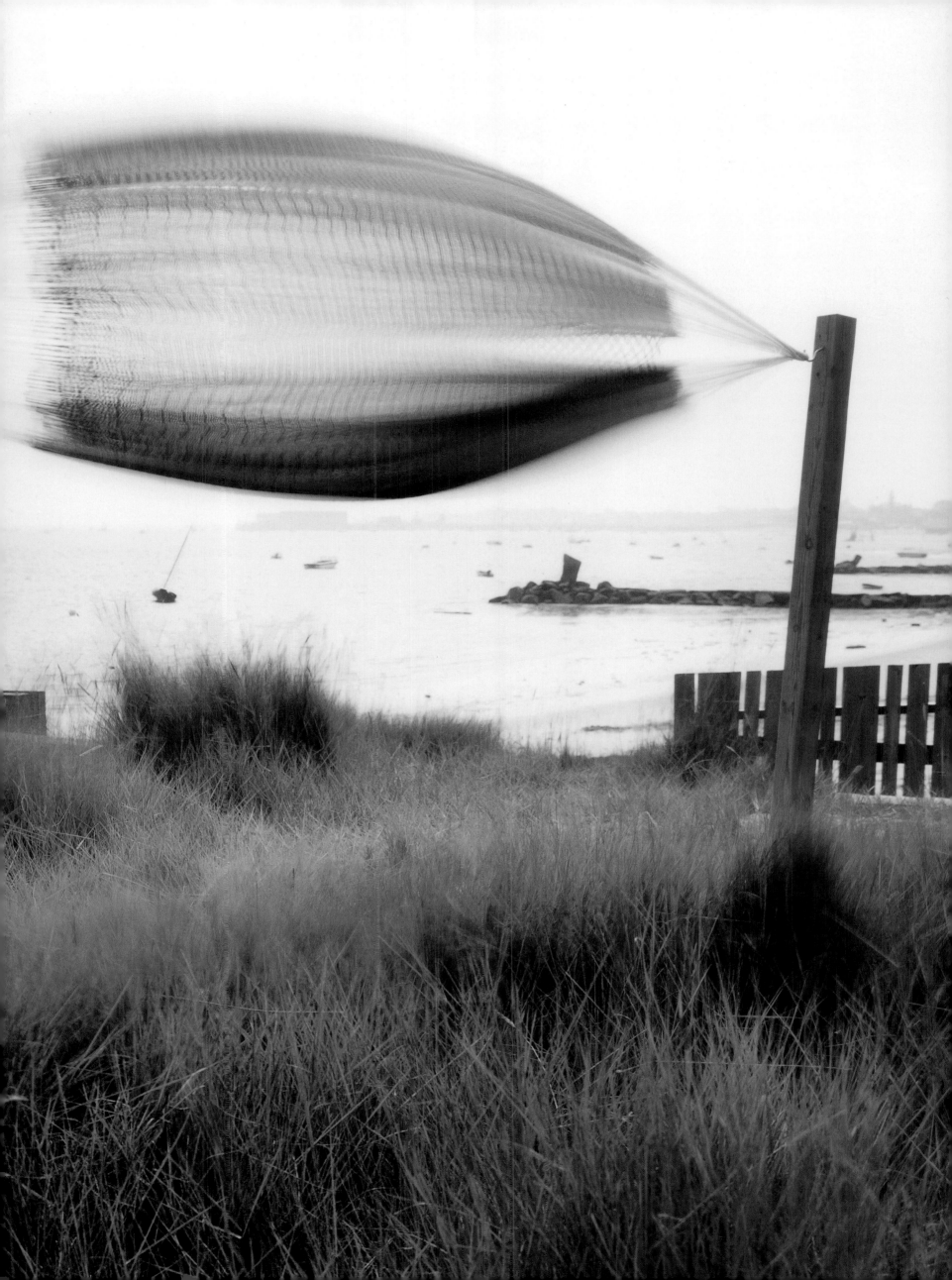

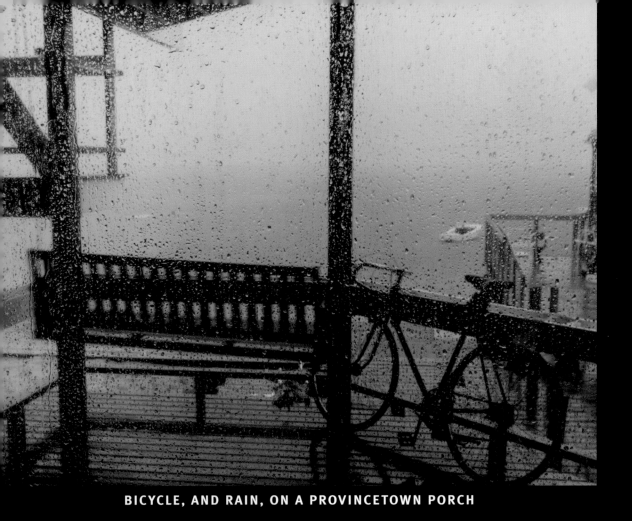

BICYCLE, AND RAIN, ON A PROVINCETOWN PORCH

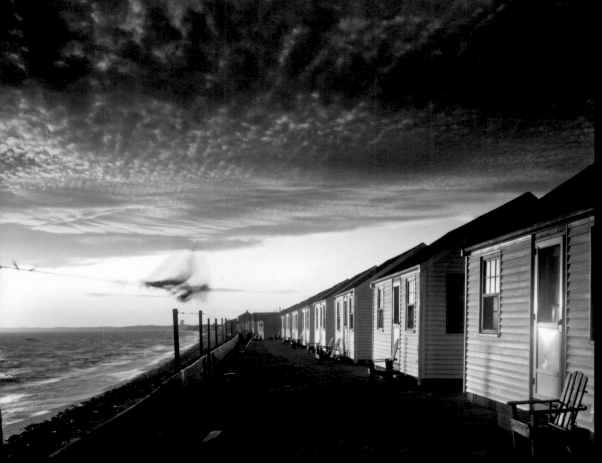

COTTAGES IN PROVINCETOWN

HOUSES AT TRURO AS A STORM ROLLS IN

Westward Ho

PUSHING TOWARDS THE PACIFIC

Voyageurs
MINNESOTA

This is a watery world, a place of lakes within the forest. It is also an old world, both geologically and in terms of human history. The glaciers made their final retreat from northern Minnesota approximately 10,000 years ago, leaving exposed on the land's surface rocks that are among the earth's most ancient. Almost as soon as the ice was gone, people of the Paleo-Indian Period came to occupy the area, as the waters of glacial Lake Agassiz—which once covered 110,000 square miles in Minnesota, North Dakota and parts of Canada—receded. For many millennia the lands that are now designated as Voyageurs National Park were home to none but the natives, and then, in 1688, French explorer Jacques de Noyon scouted the Rainy River. Arriving subsequently were French-Canadian trappers and traders traveling in birch-bark canoes; these were "the voyageurs," shuttling back and forth between the forests and markets in Montreal and the Canadian northwest. Today, people who love the outdoors paddle in their wake—in kayaks as well as canoes. There are motorboats and houseboats too, and in winter, snowmobiles. But, as it was long ago, Voyageurs is best experienced quietly, the only sound that of the distant wolf

THE Amana Colonies
IOWA

Joan Liffring-Zug Bourret

Mark Twain National Forest
MISSOURI

David Muench/Corbis

One of the principal attractions of a free country such as ours is the right to pursue and exercise religious or philosophical beliefs that might be beyond the mainstream. This has given rise at various times to what have been termed "utopian communities"—small societies of like-thinkers who band together and live by their own rules (while adhering to the laws of the land). Beginning just before the Civil War, a group of German-speaking immigrants belonging to a religious group called the Community of True Inspiration established several villages in the hills of the Iowa River Valley: the Amana Colonies. These were self-sustaining townships, each featuring a communal kitchen that could accommodate 30 to 40 people during meals; a general store; a school; such establishments as bakeries and blacksmith shops; and certainly a church, which back in the day hosted 11 religious services a week. That day lasted a long time—from 1855 to 1932—and the Amana Colonies represent one of the longest-lasting communal experiments in history. Thirty-one sites in the seven villages in east central Iowa are today listed on the National Register of Historic Places. They can be visited, and you can drive past the surrounding farmland, which remains lovely—even, yes, utopian.

When Samuel Clemens was born in 1835, this 1.5-million-acre section of the Ozark Plateau in his home state was dense with forest. With its steep-sloped hills, many crystalline streams and countless really good hiding places, it was just the kind of natural wonderland where Tom Sawyer or Huck Finn might cook up some serious mischief. By the time Samuel Clemens, by then much better known as Mark Twain, died in 1910, he would not have recognized these Missouri woods. Ferocious lumbering had stripped the hills of their trees, and what was once a paradise had become a wasteland.

Conservationists saw a need to try and bring the forest back, and over time they succeeded. Then came the protections: The Mark Twain was declared a National Forest in 1939, and there are now seven federally designated wilderness areas, covering 63,000 acres, within it. This is premium hiking land, as a climb into the St. Francois Mountains, one of the oldest igneous ranges in North America, proves. There are also 350 miles of floatable streams, including the Eleven Point River (below). And if Huck were alive today, surely he would be a mountain biker, bombing the Noblett Lake Loop on his knobby tires.

THE Buffalo River
ARKANSAS

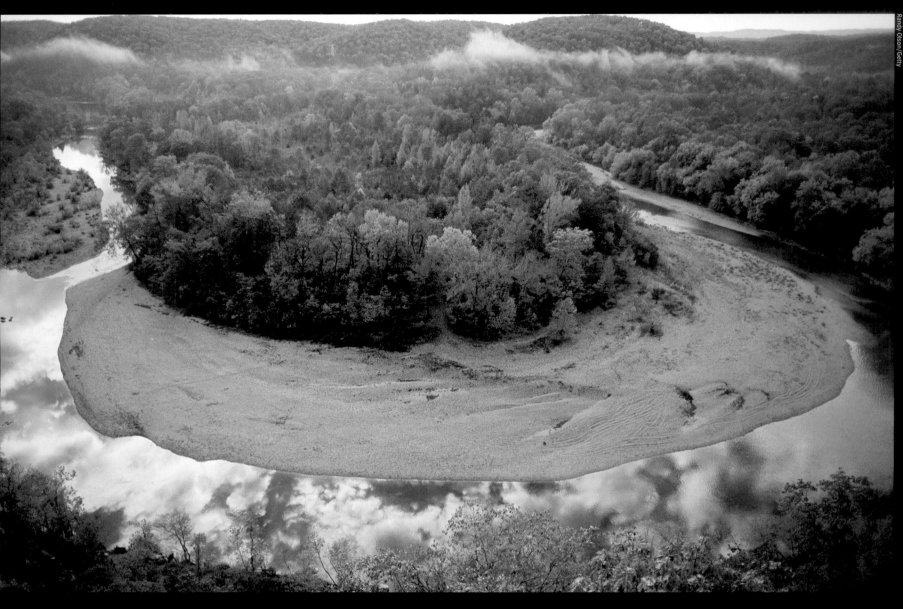

Randy Olson/Getty

There are National Parks, National Forests, National Wildlife Refuges and, yes, National Rivers—and the Buffalo was the very first, so designated by Congress on March 1, 1972. It is also unique in that it is one of the few remaining major rivers of some length that runs its entire course—in this case, 150 miles—free of dams. The Buffalo originates in the high and rough Boston Mountains of the Ozarks, and soon there are stretches of the river that, in a good year, offer fine, frothing white water. Lost Valley, an impressive canyon between Boxley and Ponca, is something that should be experienced, as is the ghost town of Rush. In its heyday, which was in the early decades of the 20th century, this was a zinc-mining boomtown of some 5,000 people, with stores, a hotel and a local movie house. But the closing of even the post office sounded the death knell for Rush in the 1950s, and a few deserted buildings and mines are all that remain. Back on the water, high bluffs and hardwood forests continue to border the widening river, which now runs at a rate perfect for a relaxing float. The Buffalo is a popular river, too popular for some. But caught early in the day or late, or in a season other than summer, it is a gem.

New Orleans is still struggling to recover from the ravages of—the *horrors* of—Hurricane Katrina; there is no escape from that fact. And yet the untamed heart of this vibrant city, the French Quarter, where the good times roll day and night, is largely back on its feet. The French Quarter is not just a section or a few city blocks, like New York's Times Square, but an entire neighborhood, 13 blocks long by six wide, first laid out in 1718 by French Canadian naval officer Jean-Baptiste Le Moyne and now home to a few thousand residents (and hundreds of thousands of transient revelers). It has a singular style, smell and flavor all its own, and yet is a melting pot, with French, Cajun, Creole, African American and Spanish influences. The music pouring forth from the open-shuttered bars could be jazz, yes, but it might just as well be zydeco or funk or blues. The cuisine you enjoy in one of the Quarter's 200 restaurants may well be Cajun, but in recent years innovative Nawlins chefs following in the path of Prudhomme and Lagasse have cast off labels in favor of whatever constitutes fine food. Bourbon Street, where every night seems like Mardi Gras, can be seen as a blast or a bore depending upon one's point of view. But there is so much more to the Quarter, including charming art galleries, antiques shops and small cafes for a morning cup of good, strong coffee. The French Quarter is back, and we can all celebrate.

THE French Quarter

LOUISIANA

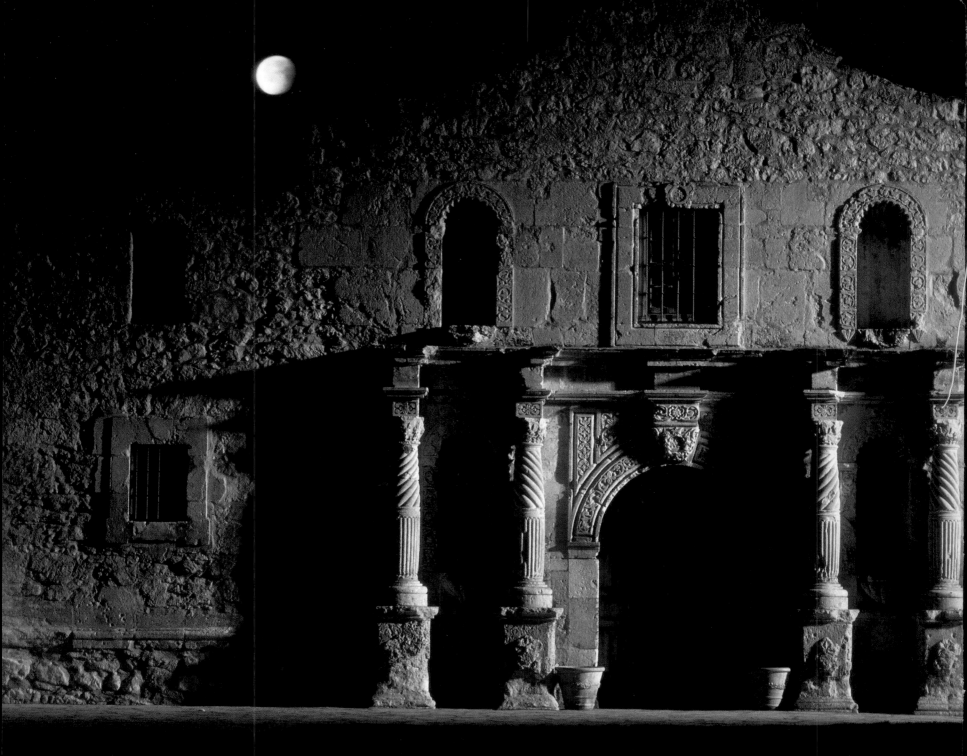

At dawn on March 6, 1836, after a 13-day siege, 1,800 Mexican troops commanded by Gen. Antonio López de Santa Anna assaulted San Antonio's Alamo, a former Franciscan mission being used as a fortress by a volunteer militia fighting for Texan independence from Mexico. While a band played a Spanish battle march, Santa Anna's men made several attempts to scale the wall but met resistance from the Texans and their 18 cannon. Finally the Mexicans were able to get over the wall and began to engage in hand-to-hand combat, overwhelming the outnumbered defenders. At the end of the day, 189 of them lay dead, including Davy Crockett and Jim Bowie, who had defiantly proclaimed, "We will rather die in these ditches than give it up to the enemy." They did so, but, weeks later, others rose up to salute them. On April 21, Gen. Sam Houston shouted "Remember the Alamo!" and led another band of Texans to victory at the Battle of San Jacinto. Independence was won. Today, the Alamo, situated on 4.2 acres in the heart of San Antonio, is a treasure—a shrine of sorts, a spiritual touchstone for the Lone Star State.

THE Alamo
TEXAS

Lindsay Hebberd/Woodfin Camp

Beavers Bend

OKLAHOMA

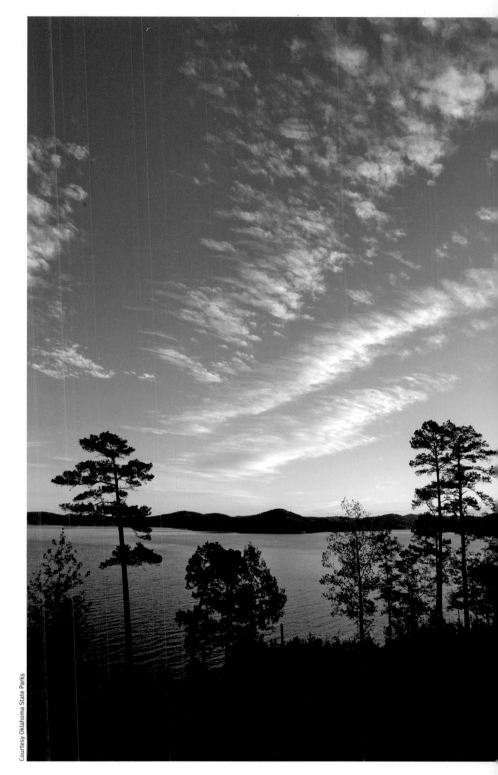

Courtesy Oklahoma State Parks

In the southeastern corner of Oklahoma there is an unusual but beguiling area nicknamed by the locals "the Little Smokies." This implies that the place is un-Oklahoman, and it's true that, in its principal attractions, it seems to fly in the face of a wide-open, dusty, Big Sky image. But the Beavers Bend/Broken Bow region is in no way unnatural or tricked-up. On the contrary, it is what it is: a lovely park (Beavers Bend State Park) with ample and spectacular opportunities for hiking or horseback riding, a grand hotel (the Lakeview Lodge) and a fabulous lake. Two hundred feet above Beavers Bend lies Broken Bow Lake (above), with 180 miles of shoreline—nearly 14,500 surface acres in all—extending towards the Ouachita Mountains. Dense fir forests rise along the shoreline, and there are few more picturesque settings for superb boating or bass fishing. The water is shimmering and clear, and the lake has long been a favorite of divers as well. The Beavers Bend area may not look like what you think of when you think "Oklahoma," but it looks just fine—as Oklahomans know.

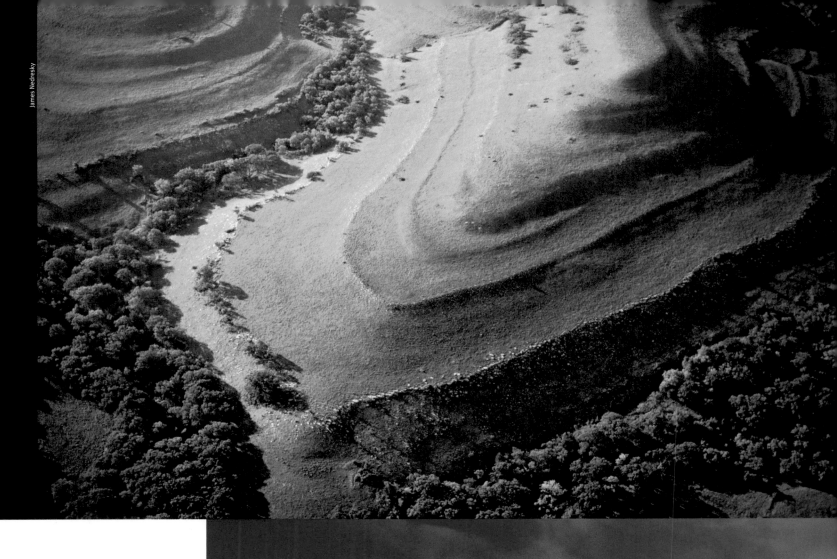

James Nedresky

Jeff Gnass

Chimney Rock
NEBRASKA

To pioneers trudging westward across the continent, Chimney Rock rose mystically in the distance like a sentinel—or like a beacon, calling them onward. A clay and sandstone spire resembling a factory chimney and rooted in Nebraska's North Platte Valley, it seemed eerie to some, exceedingly odd to others, otherwordly to more than a few. Chimney Rock, mentioned more than any other landmark in pioneer diaries, was likened by one settler to "a pyramid standing alone." Elisha Perkins got right up near it in 1849: "No conception can be formed of the magnitude of this grand work of nature until you stand at its base & look up. If a man does not feel like an insect then I don't know when he should." If fearsome in countenance, Chimney Rock nevertheless proved welcoming to weary travelers on the Oregon Trail. They knew from previous accounts that now, by reaching the rock, they had finished more than a third of their arduous journey to the Pacific.

THE Flint Hills
KANSAS

Kansas is flat as a pancake, right? Well, take a drive through the Flint Hills and you'll realize otherwise. In fact, the thought may well arise, as it did with Dorothy, "We're not in Kansas anymore." But you are, in an undulating expanse 200 miles long by 50 wide, with that enormous Kansas sky but, on the horizon, green and ochre hills rather than a level plain. Once, this landscape was a waving sea of bluestem grass, and still today the country's largest tract of tallgrass prairie perseveres in the hills. Vibrant wildflowers add a dash of color to the hues. The wagon trains came this way, as can well be imagined, and the town of Council Grove was once a bustling point of rendezvous on the Santa Fe Trail. Today it is a charming, welcoming hamlet with 24 registered historical sites commemorating its pioneer past. Want to taste that past? The Hays House restaurant used to feed cowboys and settlers back in the 1800s, and it will feed you in much the same homey style today.

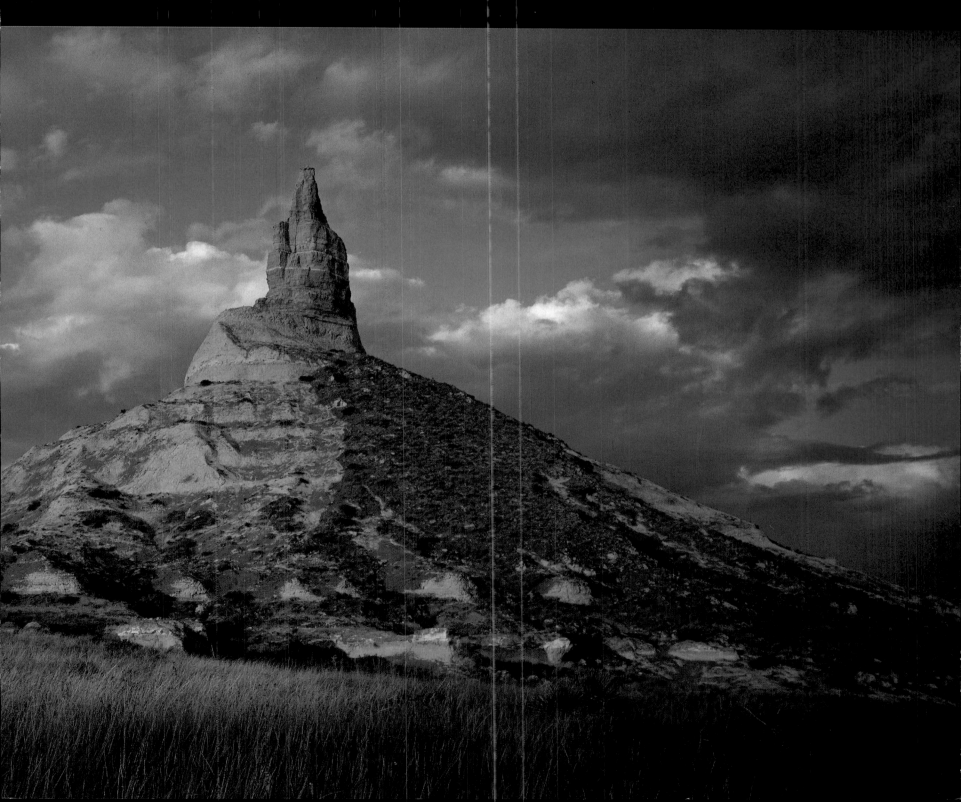

Crazy Horse Memorial

The sculptor Korczak Ziolkowski was one of the many who worked on the massive Mount Rushmore National Memorial honoring four U.S. Presidents, and he heard that many Indians thought it only fair to have a hero of their own saluted in a similar fashion. In 1948 Ziolkowski set to work, only eight miles away from the Rushmore site in South Dakota's Black Hills, on an even more enormous depiction of the Lakota Sioux warrior Crazy Horse. Ziolkowski died in 1982 and the project was taken up by his family; the face of Crazy Horse was completed in 1998, but work on the rest of the memorial continues today. When the carving of Thunderhead Mountain is finished, the sculpture, which shows the chief in full flight atop his horse, will be 641 feet wide and 563 feet high. Crazy Horse's head alone will be 87 feet high; by contrast, the Presidents' heads on Rushmore are 60 feet high. Work on the Crazy Horse Memorial is obviously labor informed by passion, but there are passionate critics of the project as well. Lame Deer, a Lakota medicine man, wrote in his memoir, "The whole idea of making a beautiful wild mountain into a statue of him is a pollution of the landscape. It is against the spirit of Crazy Horse." What the great warrior would think, we cannot know.

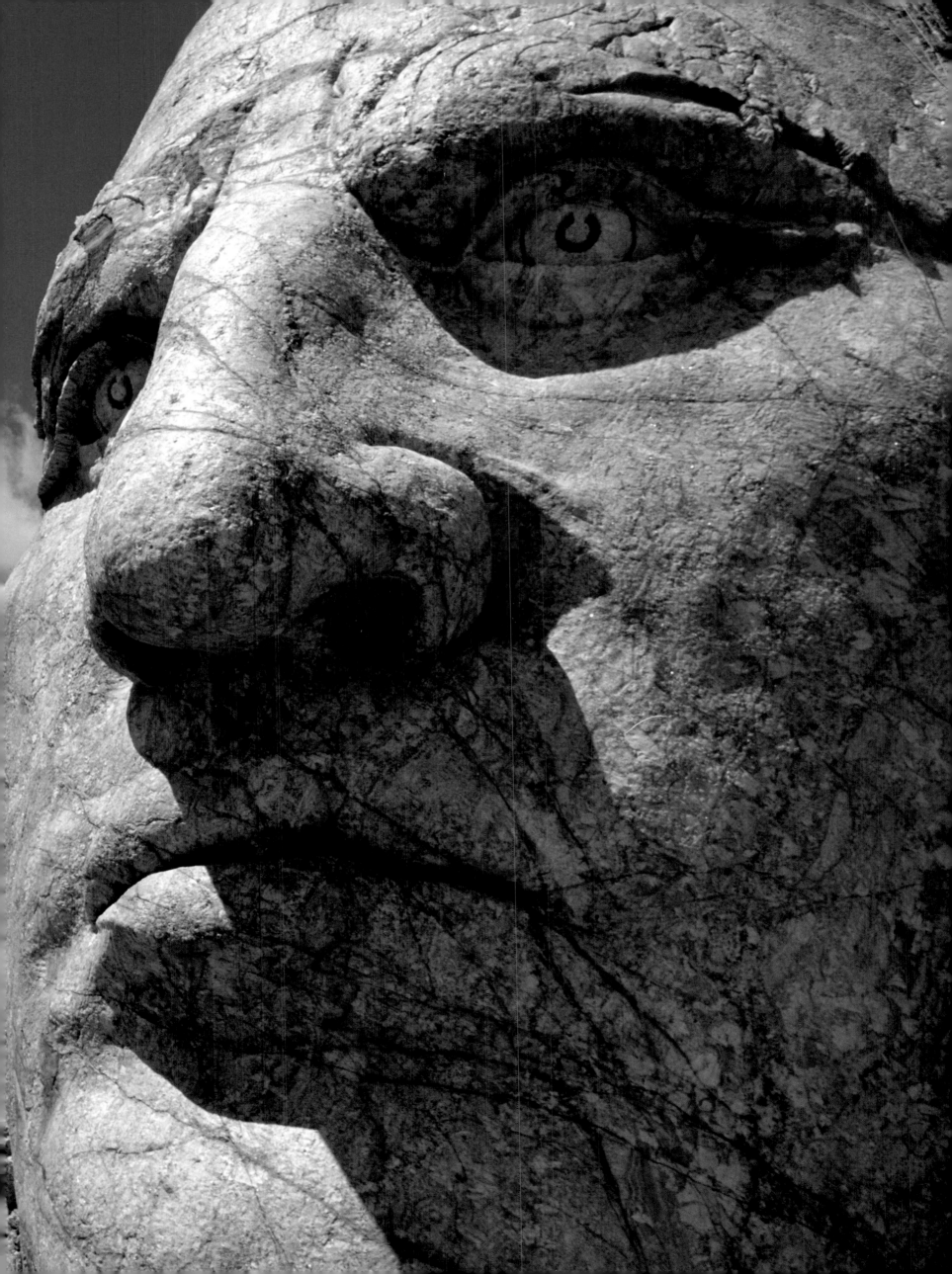

Bill Clinton and Dwight Eisenhower had their golf, Jack Kennedy had his touch football and Harry Truman had his daily constitutionals, but Teddy Roosevelt claimed the whole outdoors—to hunt in, ride horses in, generally revel in. He was by far the greatest naturalist among our Presidents, and for his accomplishments in protecting public lands, boosting the National Park Service and establishing the National Forest Service, he will forever remain the greatest. It is altogether fitting that a 70,447-acre part of North Dakota that he knew well and loved dearly—he returned to the state soon after his first wife's death to mourn and recover—is now sanctified as the Theodore Roosevelt National Park. Within it is a 14-mile drive from the visitors' center to Oxbow Overlook that is a living evocation of TR's rough-and-ready, tough-but-gentle spirit. You are traveling through what are known as badlands, but consider the ochre rocks and the straw-brown valley floor, the longhorns and bison grazing as they did when Teddy rode the range. There is a solemn, western, cowboy poetry at play here. Said the man himself, looking back on life: "I never would have been President if it had not been for my experiences in North Dakota."

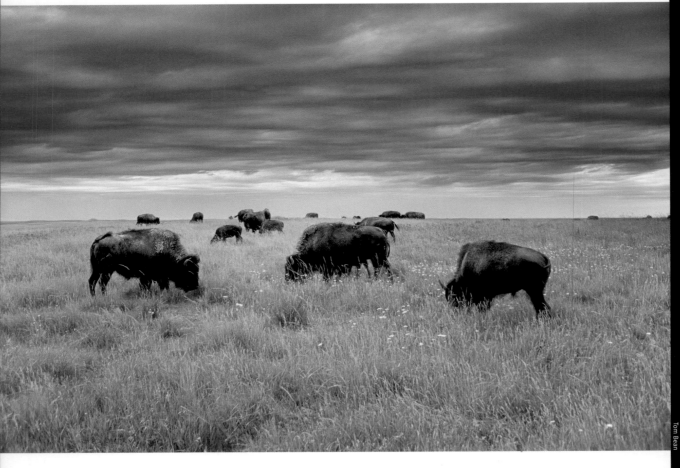

Theodore Roosevelt
National Park
NORTH DAKOTA

Glacier National Park

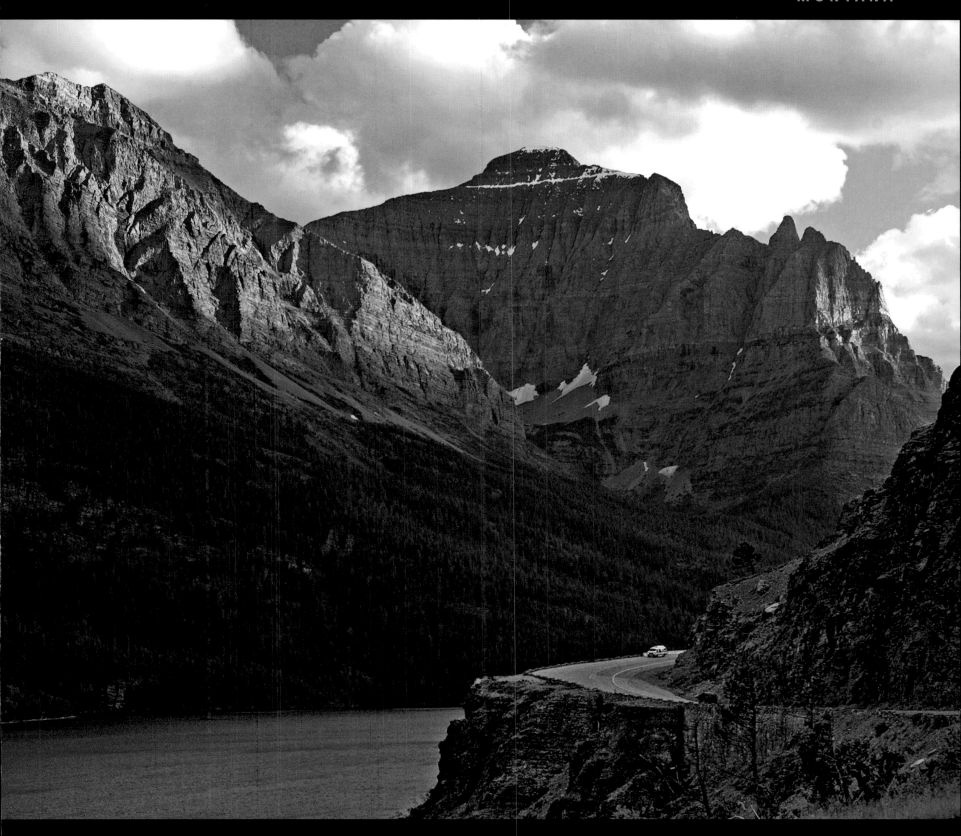

I t is something of a sleeper among the great parks, not getting the traffic of Yosemite or Yellowstone, but it is as sensational as any. Its spectacular, rugged alpine environment has led to the park's being called the Crown of the Continent; Native Americans knew it as the Backbone of the World. Its dense forests, steep mountains and large, wondrous lakes are a paradise for hikers or campers. But even motorists can avail themselves of Glacier's glories. In 1918, the National Park Service's chief engineer, George Goodwin, proposed a road through Glacier, one that would climb up and over Logan Pass on the Continental Divide. The resultant 50-mile byway, a quarter of its length carved out of mountainside, didn't open until 1933, after years of painstaking preparation and backbreaking work. Since this was a park road, all care was taken to yield the best scenery—it travels the length of Lake McDonald before heading for the pass, then the length of St. Mary Lake on its way down—while preserving the landscape. The name of the drive, Going-to-the-Sun Road, comes not from its impressive grade, but from an eponymous nearby mountain. It is a nonetheless suitable moniker, as former park superintendent J. Ross Eakin averred in 1933: "It gives the impression that in driving this road autoists will ascend to extreme heights and view sublime panoramas."

With the possible exception of Jack Kerouac, no American of the 20th century was more noted for going on the road than commentator Charles Kuralt, and it was his considered opinion that the Beartooth is, simply, "America's most beautiful road." The 68-mile stretch of Route 212 beginning in Red Lodge and ending in Cooke City at the northeastern entrance to Yellowstone National Park—having along the way dipped into Wyoming's Shoshone National Forest—was designated a National Scenic Byway in 1989. It is that in spades, as becomes evident after the quick ascent from Red Lodge onto the enormous Beartooth Plateau, at 3,000 square miles one of North America's largest land masses above 10,000 feet. There are hundreds of alpine lakes and unequaled mountain views on the drive, and there's history as well. In 1882, Civil War legend Gen. Philip Sheridan, with the aid of a local hunter, led the first successful crossing of the Beartooth Mountains along the very route that, in 1936, would become Beartooth Highway.

Beartooth Highway
MONTANA AND WYOMING

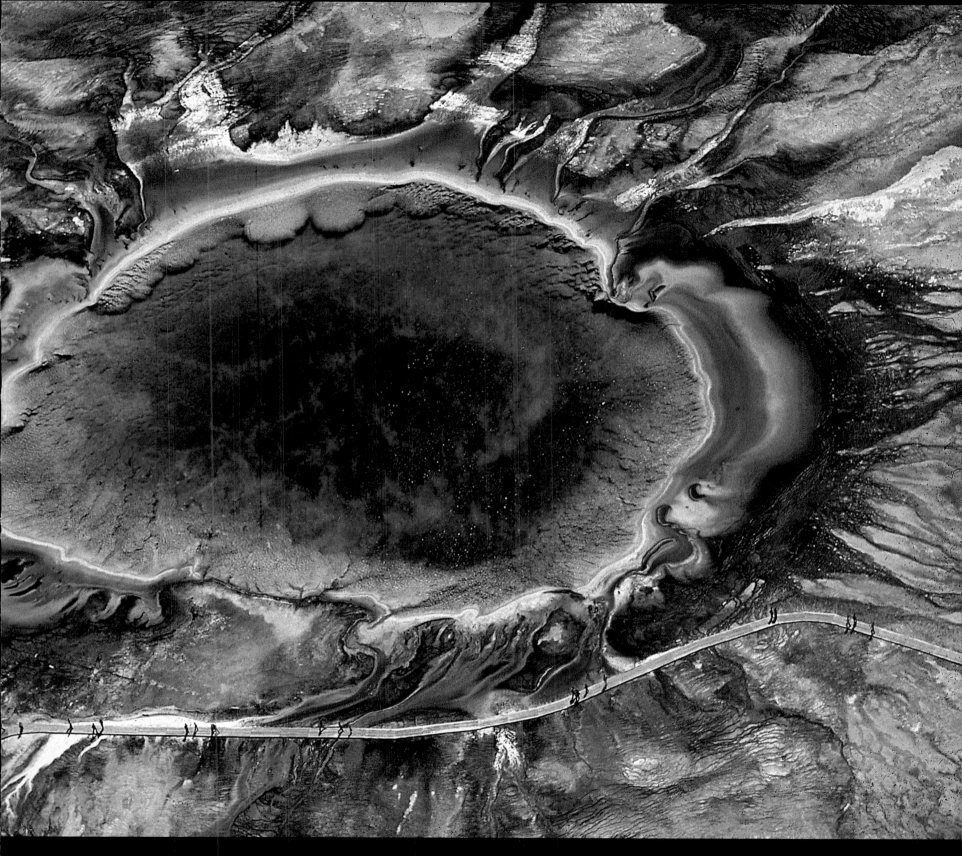

Yellowstone
WYOMING, MONTANA AND IDAHO

Today, more than 100 countries throughout the world have national parks or reserves, but in 1872, when President Ulysses S. Grant signed a bill creating a park at the headwaters of the Yellowstone River, there was only one. No one was certain what a national park was; Yellowstone would be an experiment. Few legislative initiatives have been, over the long haul, so successful: We have indeed become a society dedicated to preserving our natural wonders. The wonder of Yellowstone has to do with the bison and wolves and all that,

THE Tetons
WYOMING

These are fierce peaks, jutting nearly 7,000 feet above the valley and the headwaters of the Snake River. Spiked, snowcapped, altogether hyperbolic, they resemble nothing so much as fearsome Mount Crumpit, the cartoon crag rising above Whoville, the one down which the Grinch and his dog Max plunged on Christmas Day. In the Teton Range there is 13,770-foot-high Grand Teton, only one of a dozen peaks over 12,000 feet. There are other wonders within the range; the canyons Avalanche and Cascade are as awesome up close as the entirety of the Tetons is from the valley. And then there is that valley: the Snake River (above), one of the best fishing and white-water opportunities in North America, and Jackson Hole, a real western town with a nearby ski area that is among America's finest and, in places, most ferocious. Grand Teton National Park was established in 1929 and today is visited by 3.5 to 4 million people a year. Every one of them leaves overawed.

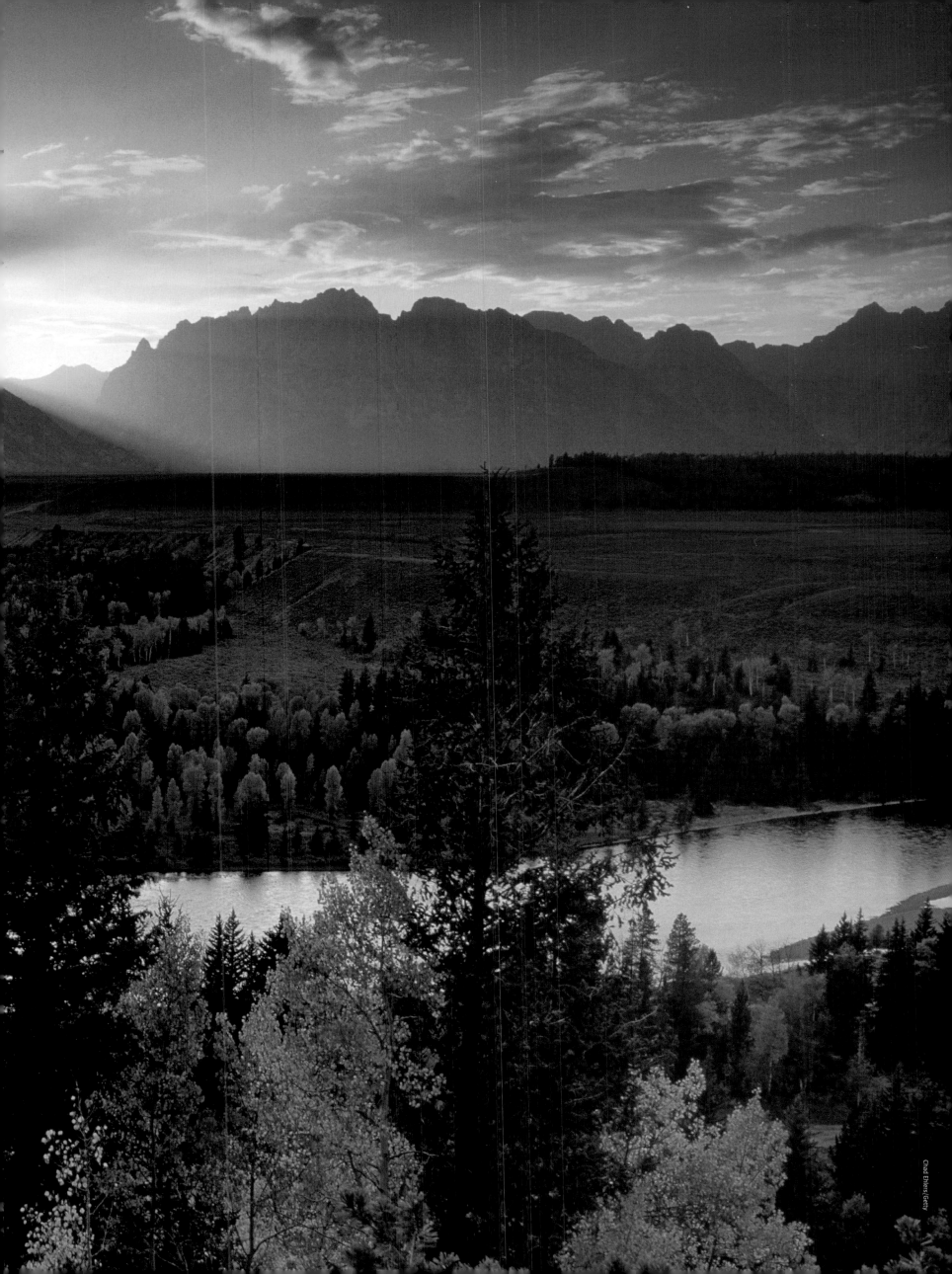

A continental divide is the ridge that separates watersheds, with one flowing one way to the sea, and the other flowing in the opposite direction towards another body of water. There are actually four such divides on our continent; Atlanta, for instance, sits atop an eastern divide that sends water towards the Atlantic or towards the Gulf of Mexico. The Great Divide is the one more commonly known as the Continental Divide, running from Alaska down along the crest of the Rocky Mountains through western Canada and the United States, into Mexico and, if you want to keep tracing, right on down to the tip of South America. From on high, standing atop any random point on such a mammoth and vertiginous divide, the world looks expansive and spectacular. In our country, efforts have been mounted by many dedicated folks to keep in good repair a trail running the ridgetops from Canada to Mexico, and hiking the 3,100-mile Continental Divide National Scenic Trail has become an outdoorsman's grail. In stretches of Colorado in the Rocky Mountain National Park, the views are otherwordly—particularly from near Grays Peak (below), at 14,270 feet the highest point anywhere along the trail.

THE Great Divide
COLORADO

David Muench/Corbis

Jim Zuckerman/Corbis

Telluride

COLORADO

The boom-and-bust-and-boom cycle of this stunning mountain village is the template for many a western civic tale, but the good news for Telluride (as opposed to many others, which are now bona fide or approximate ghost towns) is: The joint has never been more jumpin'. For the Ute Indians, Telluride represented a nice, calm summer camp. In the hands of white folk, it has always been at least a little wild. Its fate since the 1870s has largely been forged by two different substances, silver and snow. In that decade nearly a century and a half ago, the Sheridan Mine became the first of several to open. When the railroad arrived in 1890, the first boom was sounded loudly. Five thousand people of all stripes squeezed into Telluride, which blazed day and night; down at the brothel, the celebrated African American woman at the piano—she had two degrees in music, the locals bragged—could be heard at almost any hour. But silver prices slipped and so did Telluride. Fast forward to 1973 and the opening of the Telluride Ski Resort in those stunning cliffsides above the town. Athletes shouted the news, and actors and actresses followed; Telluride became a place to see and be seen, and remains so today. It has the great scenery, the great skiing, the requisite music and film festivals, and the storied past. It's got it all.

L ike Telluride, this is another western site with rich history and character that is today riding high by virtue of its natural splendor and strong reputation for art and culture. But this is a city to Telluride's town, and an altogether more laid-back and less rough-hewn community. Founded by the Spanish in 1610, it has been a seat of government ever since, and is in fact, after nearly four centuries (and today as the state capital of New Mexico), the oldest capital city in the United States. It spent its first 200 years as a Spanish and Indian trading post, and after Mexico won its freedom from Spain in 1821 Santa Fe became a hub of Mexican export to the U.S. The city was taken for the U.S. in 1846. The Santa Fe Trail to Missouri saw constant traffic for much of the 19th century until the Atchison, Topeka & Santa Fe railroad reached New Mexico in 1880, rendering the trail archaic and then obsolete. Forever and still today, Santa Fe has been a place of handsome adobe buildings and brilliant turquoise jewelry, everything in town colored by Spanish and Pueblo Indian shadings. The town's aesthetics have attracted through the years a colony of writers, artists, artisans, musicians—and today Santa Fe, which has more than 60,000 citizens, is arguably the Per Capita Arts Capital of America. It is also a very romantic place.

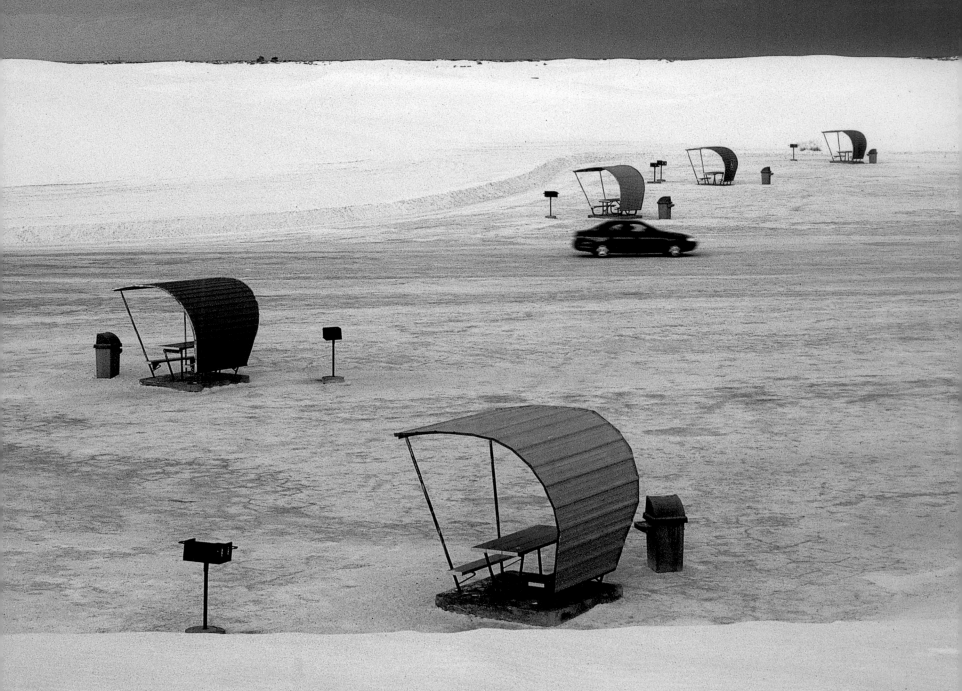

White Sands

prevailing winds have deposited pure gypsum from the nearby San Andres Mountains on the floor of the valley below, creating a dazzling sea of undulating dunes, some as tall as 60 feet. Unlike other desert sands, the powdery grains here are cool to the touch. This brilliant white sand resembles nothing so much as fallen snow, and as the winds continue to blow, the landscape is ever changing, growing and cresting. This 275-square-mile area is as ethereal as it is unique. There is calm here, even a kind of quiet joy.

THE Anasazi Ruins
COLORADO, NEW MEXICO, ARIZONA AND UTAH

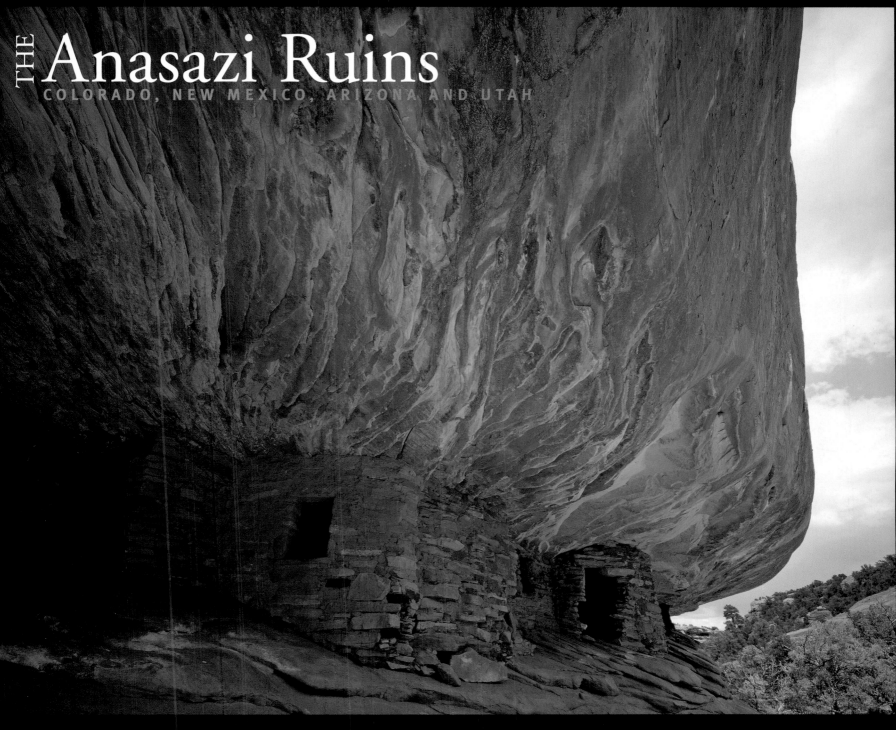

David Muench/Corbis

Catherine Karnow/Woodfin Camp

Dwellings like these in Utah's Mule Canyon were built by the Anasazi, ancestral Puebloans who were the Athenians of the Southwest and lived in abodes up to 2,000 feet above the ground during the 13th century, only to vanish mysteriously. The ruins of Anasazi communities have been found not only in Utah but in Colorado, Arizona and New Mexico as well. Petroglyphs, such as the evocative ones found on so-called Newspaper Rock in Arizona's Petrified Forest National Park, tell tales of daily life; clearly animals were important to these people as symbols as well as sources of food. The

Anasazis were cultured, productive and spiritual, but beyond the tantalizing hints in the cryptic cryptograms, there is little for us to go on. We can't even know what these early Indians were really called. The term Anasazi means "enemy ancestors" in the Navajo language; much of the scant Anasazi record comes from that tribe and other invaders. The Anasazi, for their part, eventually left or were driven from their settlements, and by 1300 had all but disappeared. It was the job of ethnographers and anthropologists to determine that this once great nation became the Pueblo Indians, who still inhabit the Southwest.

Carlsbad Caverns

NEW MEXICO

Beneath the Chihuahuan Desert and Guadalupe Mountains of southeastern New Mexico and west Texas are more than 300 limestone caves. They exist in what can be considered a fossilized reef, which was created by the enormous inland sea that covered much of America 250 to 280 million years ago. After the ocean receded, sulfuric acid ate away at the

limestone, leaving fantastic remnant stalagmites and stalactites rising from the caves' floors or clinging tightly to their ceilings. Evidence found in the caves indicates prehistoric and historic Native American presences in the most easily accessible caves, like Carlsbad Cavern itself. Local cowboy Jim White was a teenager when, in 1898, he first used his handmade wire ladder

Gates of the Arctic

ALASKA

Today, that is the name of the national park here, but well earlier that was the grandly poetic title bestowed upon this then-unbounded part of north central Alaska's Brooks Range by Bob Marshall, the restless, charismatic founder of the Wilderness Society. "Gates of the Arctic," as he envisioned and dubbed it, was the portal to an otherworldly world of arctic alpine wonder. The place was so remote, so rugged and so often cold— snow can fall in any month of the year—that a man like Marshall could be all alone here to contemplate the harrowing beauty of

our planet or, in fact, to contemplate anything at all. Many of these mountains are yet unnamed; others were named by Marshall himself; some, such as the impressive Arrigetch Peaks, go by words bestowed by those most closely native to this land (*arrigetch* means "outstretched fingers" in Nunamiut). Today, Gates of the Arctic comprises a national park, national preserve, six wild and scenic rivers and two national natural landmarks—but, really, that's all technical detail. This is virginal territory where nothing at all has changed, a radiant wilderness of glaciated valleys and heroic peaks,

Out There

THE GREATS BEYOND THE LOWER 48

It has been called the American Serengeti, and this is a useful metaphor, for it brings to life a place that too often exists in the American mind as only "an issue." The issue, now more than 25 years old, is whether Congress should open the coastal plain of the Refuge to oil drilling. Critics say such action would imperil a pristine land and the animals that inhabit it, while advocates point to American dependence on resources from the Middle East as a problem that must be solved. And, they point out further, the Refuge is so far from anything—everything—that no one goes there anyway. It is true that relatively few humans visit this vast area, nearly 20 million designated acres coming off the North Slope of the Brooks Range and extending over the tundra-covered coastal area to the sea. But those who do come up here enjoy the extraordinary opportunity to visit with an exotic Arctic menagerie in its natural habitat. Caribou herds and birds—snow geese, peregrine falcons, dolly varden, grayling and others—migrate seasonally in the Refuge, and year-round residents of the boreal forest include wolves, moose, lynx, marten, wolverines, black bears and old Mr. Grizzly. There are Dall sheep and primordial musk oxen here: altogether fabulous animals. One species not to be found in profusion, at least not yet, is the oilman.

THE Arctic
National Wildlife Refuge
ALASKA

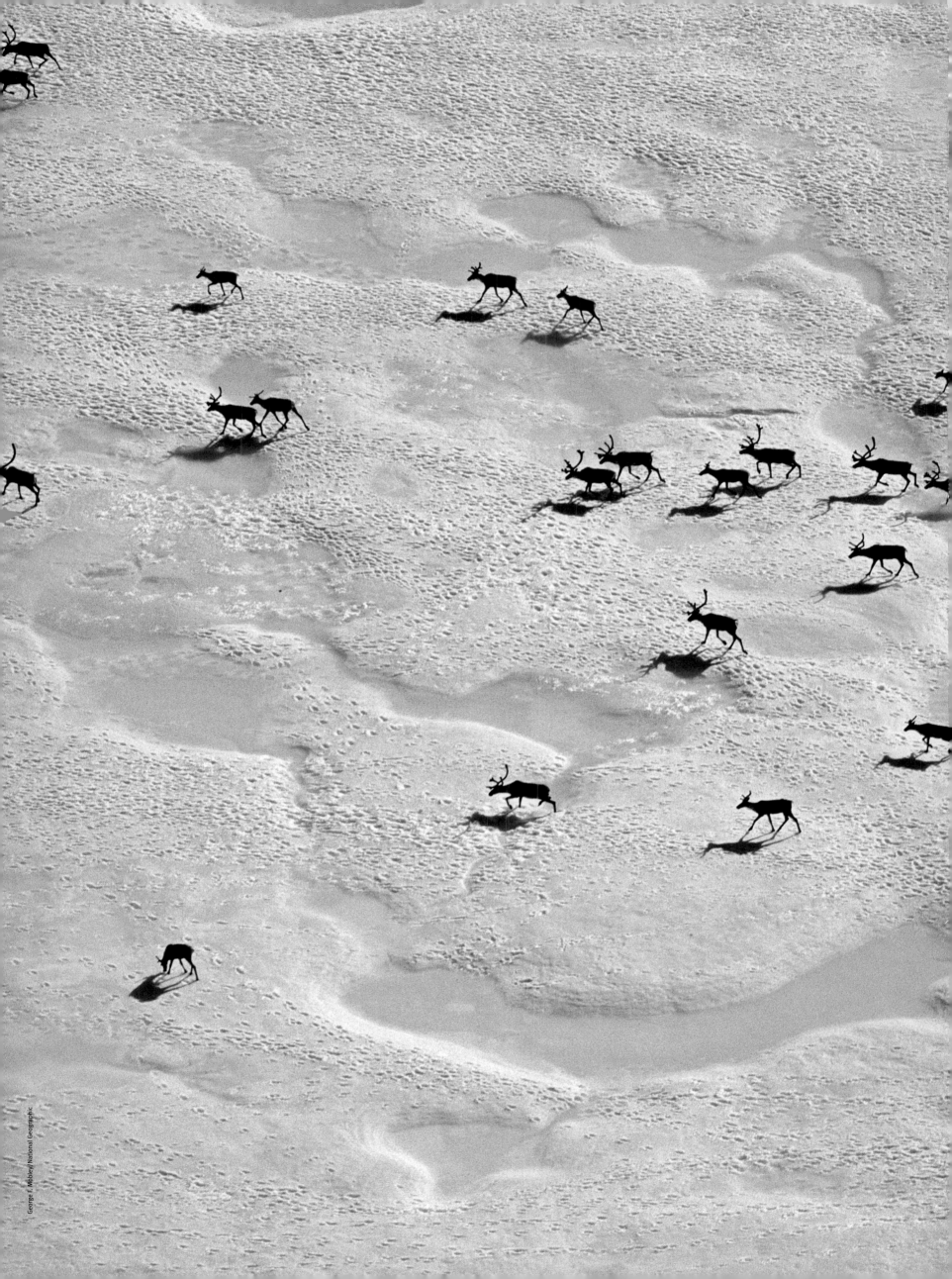

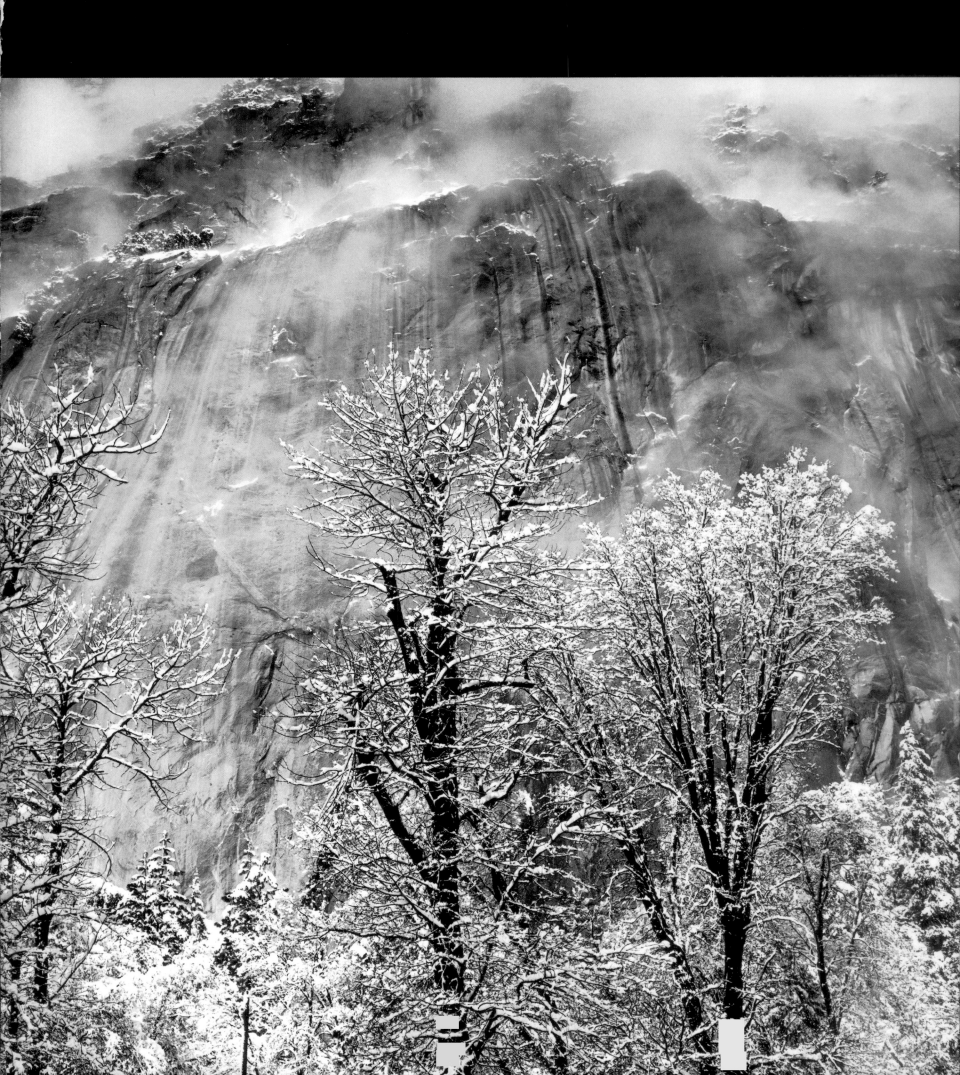

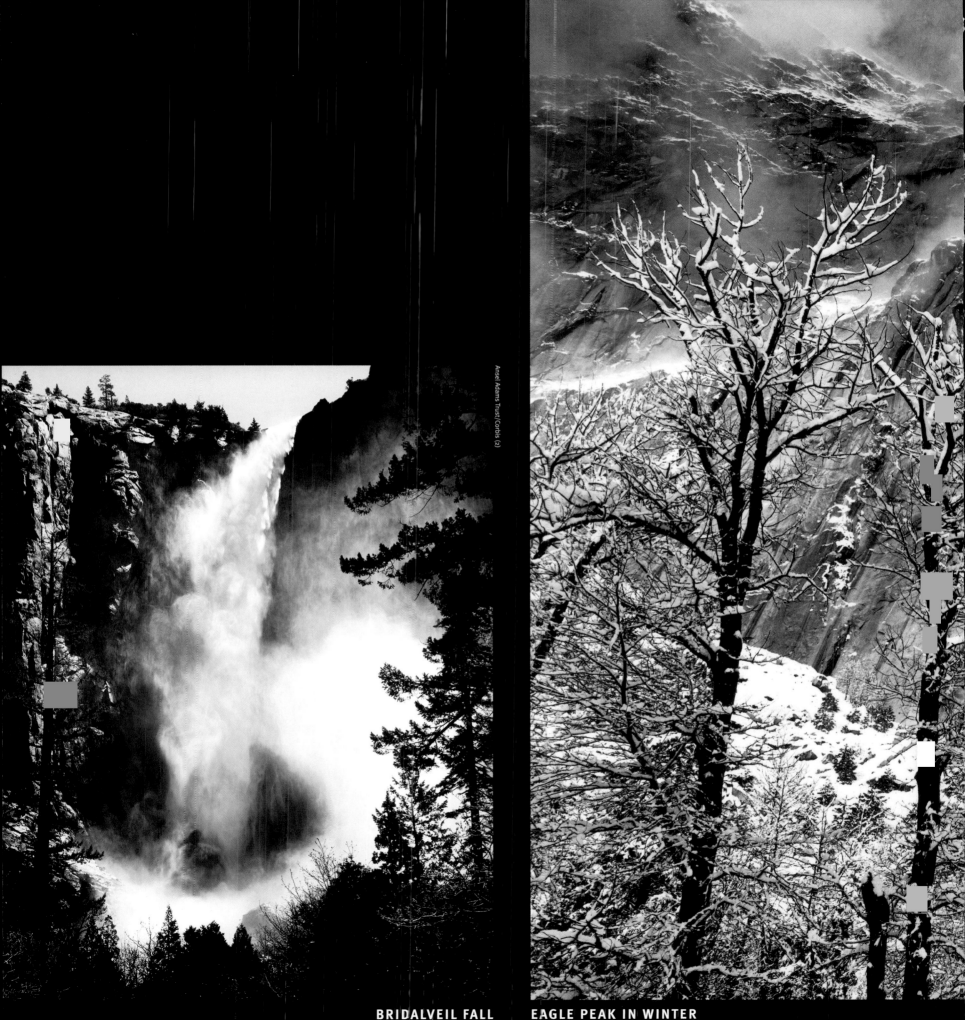

BRIDALVEIL FALL EAGLE PEAK IN WINTER

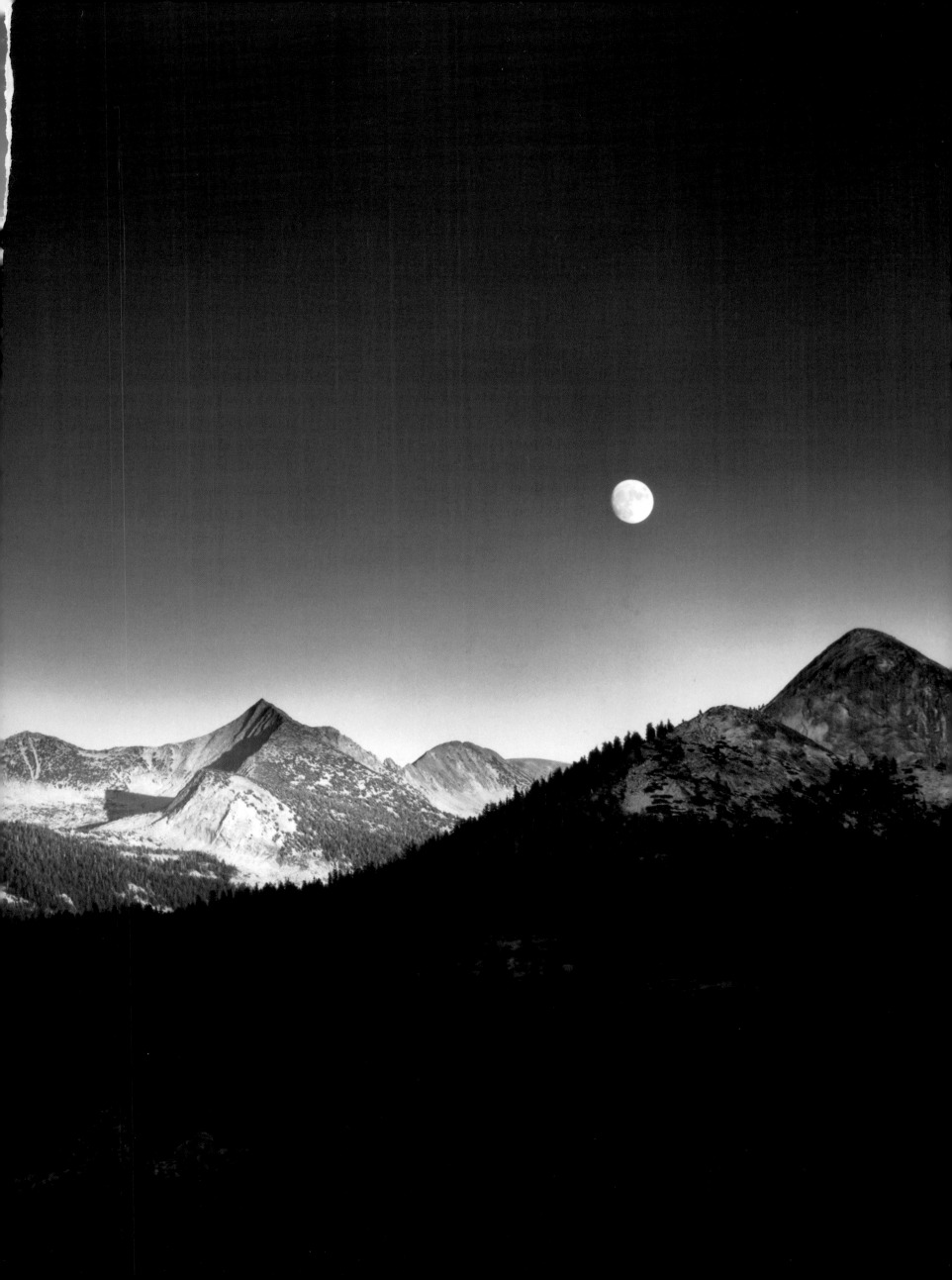

Ansel Adams Trust/Corbis

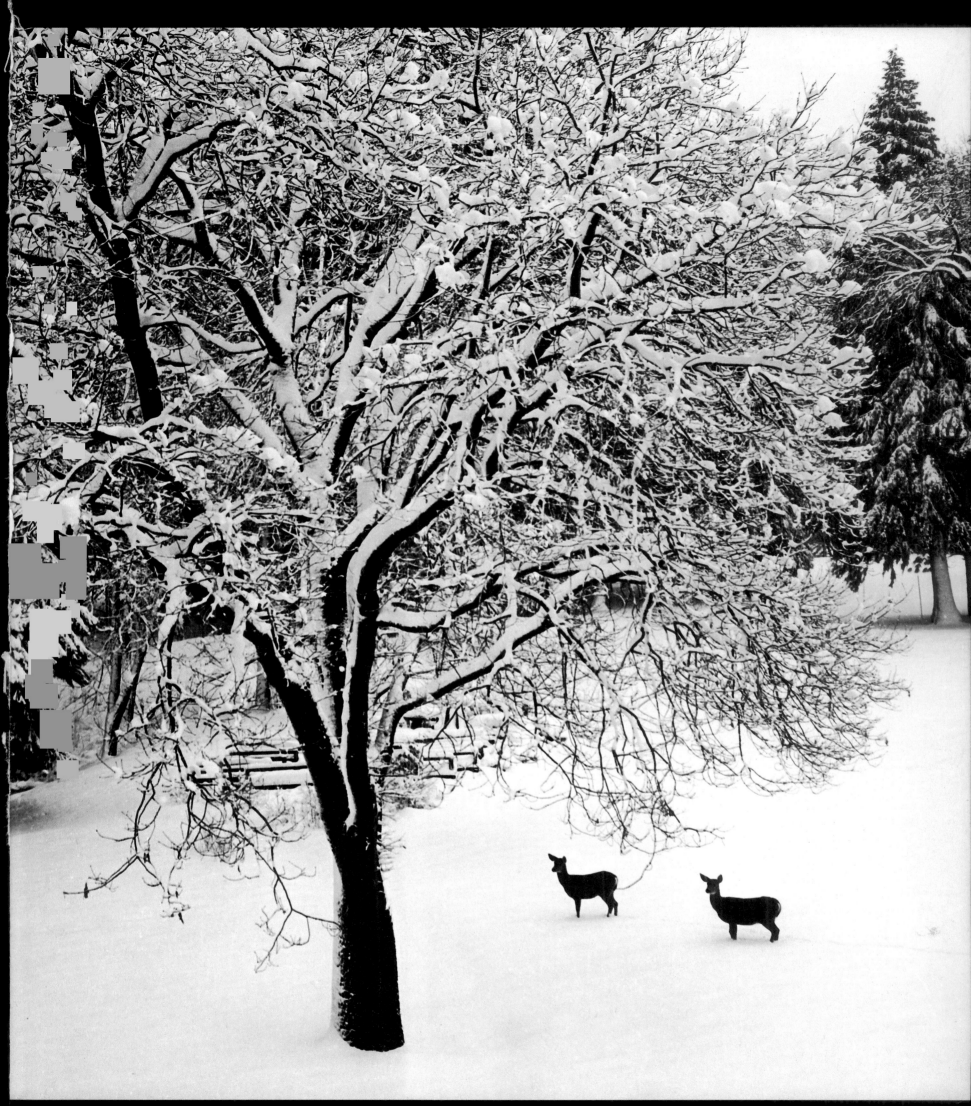

CALIFORNIA BLACK OAKS IN THE AHWAHNEE MEADOW

Ansel Adams

YOSEMITE

HE IS THE FOREVER DEAN of nature photography, and while his dramatic, iconic imagery was made in many places throughout the American West, it is Yosemite that was his home and his greatest subject.

Adams was born to comfortable means in San Francisco in 1902, and from the age of 12 was schooled by private tutors. He had a gift for the piano, and considered a concert career, but his plans took a fateful turn in 1916 when his parents took him to Yosemite and gave him a Box Brownie camera with which to record the sights. He became an avid mountaineer, recording several first ascents in the Sierra Nevada, and an even more accomplished chronicler of the natural wonders he found. In 1927 he hiked to Half Dome with a large-format camera and made 12 glass plate negatives that proved to him that, through photography, he could produce "an austere and blazing poetry of the real."

Adams met Virginia Best in Yosemite Valley. They wed there and settled there, Adams having already articulated his dream to Virginia in a letter: "I want a little studio—acoustically correct, and with wall space for my prints. And a suitable workroom as well . . . I want my friends about me and green things—and the air of the hills." Of the valley itself, he once said, "No temple made by man can compare." Adams died in 1984, his pictures having forcefully proved his point.

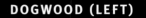
DOGWOOD (LEFT)

Santa Catalina Island

An hour's ferry ride from Los Angeles County, Santa Catalina is a rocky, 75-square-mile isle inhabited by not quite 4,000 people but beloved by countless thousands more. Its city, Avalon, which nestles with its back to the hills and faces crescent-shaped Avalon Bay, was first developed as a resort destination way back in 1887 during an early Southern California real estate boom. In the 1920s William Wrigley Jr. poured his time, energy and money into Catalina; he built the famous art deco dance hall the Casino, and he made sure his Chicago Cubs baseball team spent spring training on the island each year. His promotional efforts assured Catalina's status as a Californian focal point of fun and frolic. Movie stars came to Catalina, and movies themselves: In the '20s *The Vanishing American* was filmed there, and a dozen bison were imported for that shoot. They were left behind, and today more than 200 of their descendants roam the plains of the island's interior. As nearly 90 percent of the island is now owned and overseen by a conservancy, the land behind Avalon will remain naturally splendid forever, and the view of the harbor from the city itself (above) is eternally lovely. It confirms the words of the Four Preps' 1958 hit "26 Miles (Santa Catalina)": "It's the island of romance, romance, romance . . ."

W hen the Spanish Crown decided to go colonizing in California in the 1700s, Friar Junipero Serra, a native of the island of Majorca, was chosen to lead missionary efforts among the Native Americans there—build churches, make converts. The selection of Friar Serra proved to be inspired. At 55 years of age he founded his first mission in San Diego in 1769, and eight others before he died in 1784 at Mission San Carlos Borromeo. The one known as the Jewel of the Missions was established in 1776 here, at San Juan Capistrano. The Serra Chapel, believed to be the oldest church still standing in California, is where the good friar himself said Mass. And there is more within the Mission's adobe walls: 10 acres of lush gardens and fountains, the Padres Quarters, the Industrial Area, the Soldiers Barracks, the Cemetery and the Great Stone Church all can be visited, and in sum provide a spiritually uplifting view of what life was like when Friar Serra walked this way. This is not just a museum, however. Mass is still said in Serra Chapel; the worship in this cloistered mission is still very real.

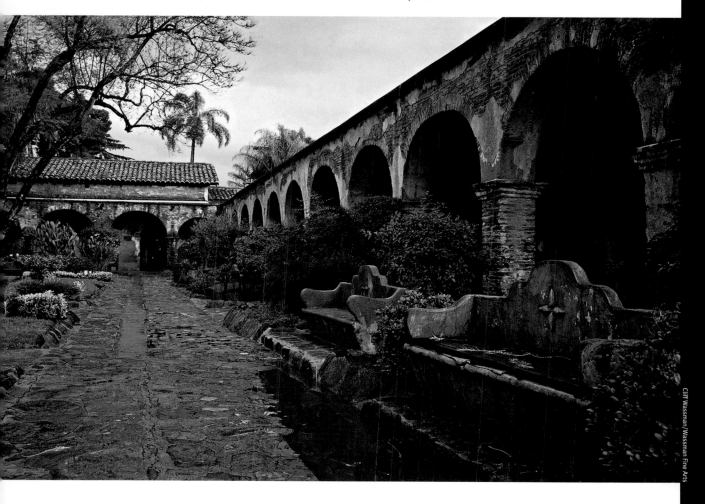

Cliff Wassman/Wassman Fine Arts

Robert Landau/Corbis

Mission
San Juan Capistrano
CALIFORNIA

Joshua Tree
CALIFORNIA

To many—perhaps too many—it is most familiar from the jacket of the U2 album. That's a fine photograph, certainly, but it's not what this place is about. Joshua Tree, which since 1994 has been a designated national park, seems like not much from the road. A swath more of desert. First-time visitors sometimes depart with a ho-hum feeling, as the sights don't immediately make you gasp in awe. But this is precisely the kind of place where each return venture permits a deeper understanding and appreciation for the setting and its life-forms. Walk gingerly amidst a garden of teddy bear cholla, careful to avoid their prickles. Listen to the wind whistling through the bone-dry air. Because this place grows on you, there can develop a personal response, an emotion, even an intimacy; you can fall in love with a place like this.

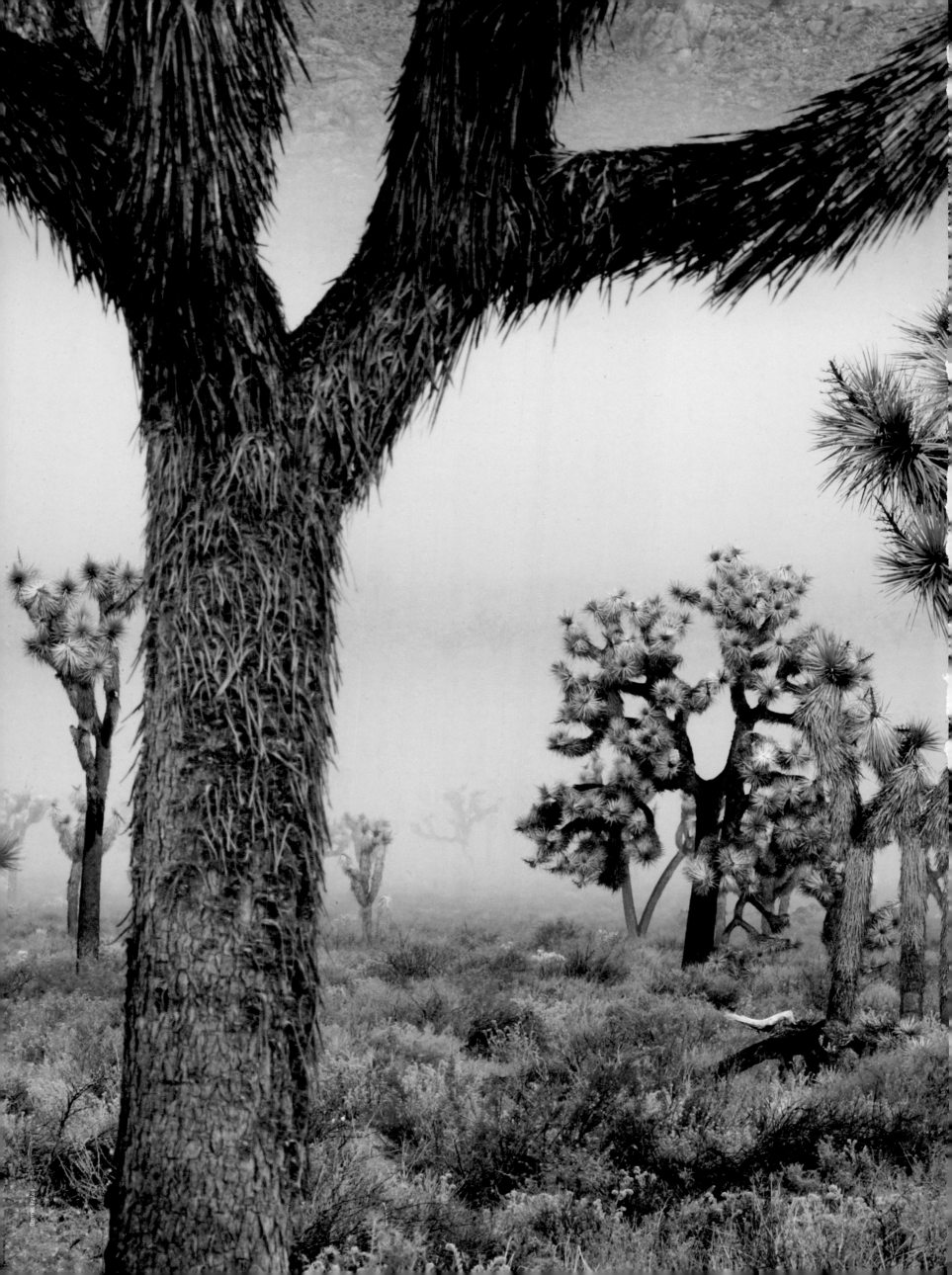

Balboa Park
CALIFORNIA

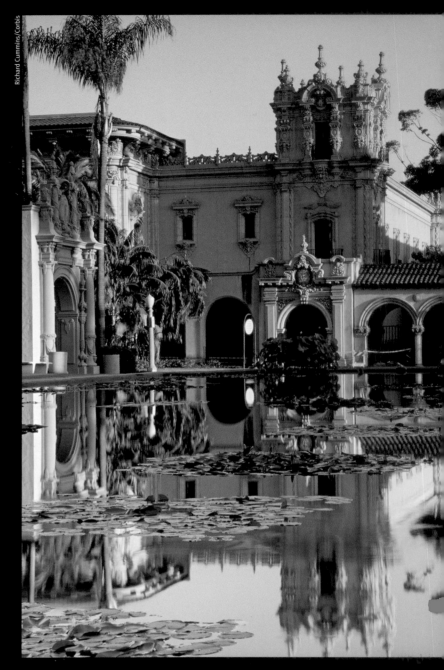

Some parks are just parks, and some are a little more involved—maybe a carousel or some such. And then there is San Diego's Balboa Park, the nation's largest urban cultural park and one that features something for everyone. Stroll the park's 1,200 acres of grounds in the routinely temperate and sunny local climate and consider the feast that surrounds you. There are 15 major museums here—art, science, natural history, air and space, you name it—and renowned performing arts venues, including the Old Globe Theatre and the Spreckels Organ Pavilion outdoor stage. The gardens alone—the cactus garden, the Japanese Friendship Garden, Palm Canyon and more than a dozen others—would be enough to make any park proud, as would the Botanical Building set just behind the Lily Pond (above). The Balboa Park Carousel has a handsome, hand-carved menagerie, and a miniature railroad runs through four acres of the park. Dining al fresco is all but required here, as is a trip to the jewel in Balboa Park's considerable crown: the San Diego Zoo. Home to more than 4,000 rare and endangered animals from more than 800 species and subspecies, all coexisting in an incomparably attractive setting, this is one of the world's finest zoos. It's in one of the world's finest parks.

Despite its ominous name, Death Valley is extraordinarily beautiful, a place of color and contrast, a world of wonder. The parched desert basin is filled with canyons, streaming sand dunes, multicolored rock layers and snow-topped mountain peaks—covering more than 3,337,000 acres in all. Death Valley is filled as well with lore and legend, much of it evoking human trial. The forty-niners who crossed the valley on their way to the California gold fields found it deeply inhospitable; it was they who gave the valley its chilling name (even though only one of their number died here). Temperatures can reach 130 degrees in summer and can fall below freezing on a winter's night. As that spread indicates, Death Valley is a realm of extremes. Its highest point is the summit of Telescope Peak at 11,049 feet, and its lowest, the salt lake at Badwater, is 282 feet below sea level—the very lowest point in the western hemisphere. Some do call the valley home: the native Timbisha Indians, for example, who have lived here more than a thousand years, not to mention the 900-plus kinds of plants and hundreds of animal species that have adapted to the harsh environment. For visitors, there is no better time to enjoy the valley than at sunrise or sunset, when the sky is streaked with vibrant colors, or at night when the air is clear and the stars are bright. It's enough to make you forget the name.

Death Valley

It is perhaps the most jaw-droppingly beautiful place in America, and it is a constant study in contrasts—different flora, fauna and geologic types coexisting. First and foremost throughout this coastal stretch of central California, there is the meeting of mountain and sea. The Santa Lucias rise across the highway from the rocky Pacific coast in dramatic fashion. Consider Cone Peak: At 5,155 feet elevation yet only three miles inland, it has the steepest coastal incline in the Lower 48. The narrowness—the tightness—of the mini-universe that is Big Sur creates microclimates, and here redwoods grow not far from cactus. There are cliffs and huge rocks along the coastline but also tiny beaches tucked away. When you drive a hundred or so miles down Big Sur along famous Route 1, you are hard-pressed to keep your eyes on the winding road; as you cross Bixby Bridge, 260 feet above the crashing ocean waves, you are aloft in your car. The shadings of Big Sur extend even to its human denizens. Perhaps only 1,500 people live in the area permanently, but this population includes folks of several different stripes: descendants of long-ago settlers; artists and writers and other creative types following in the footsteps of Henry Miller and Jack Kerouac, who came this way; Hollywood gods and goddesses, reminiscent of those who once partied nearby at Hearst's San Simeon. Nothing else is remotely like Big Sur, a place scarcely to be believed.

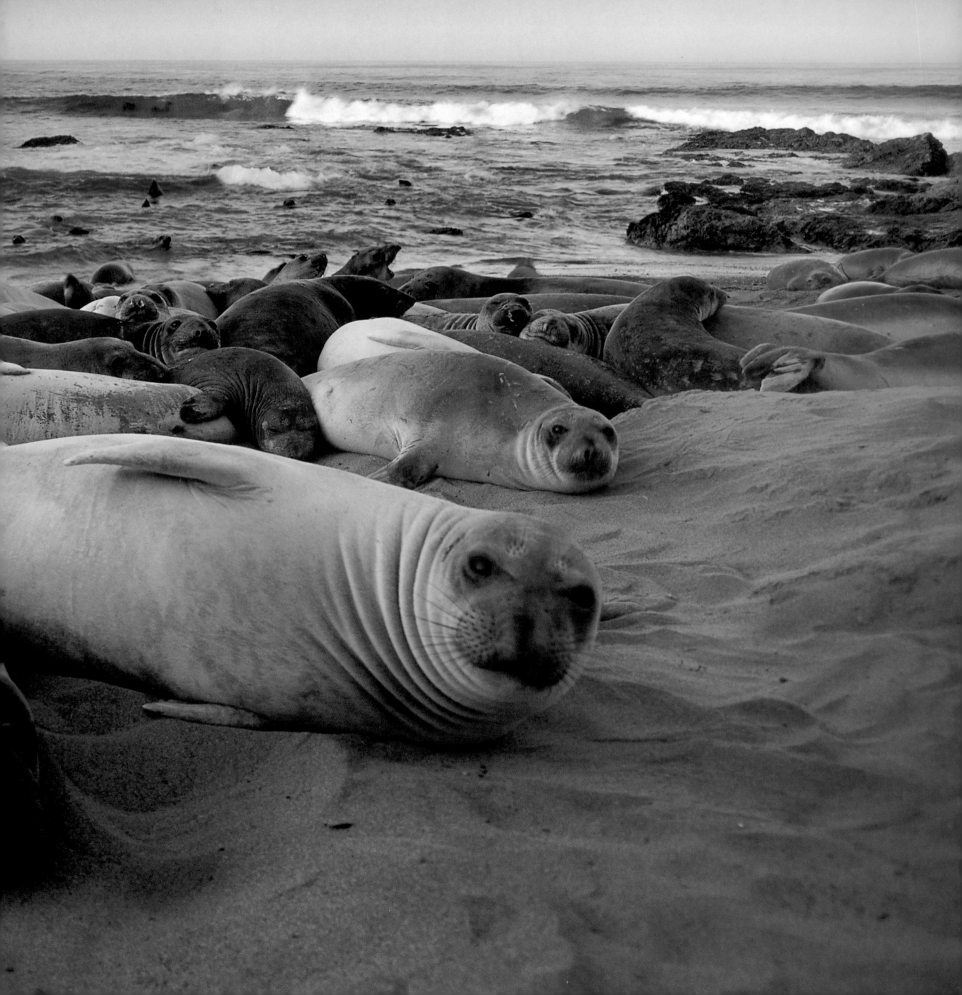

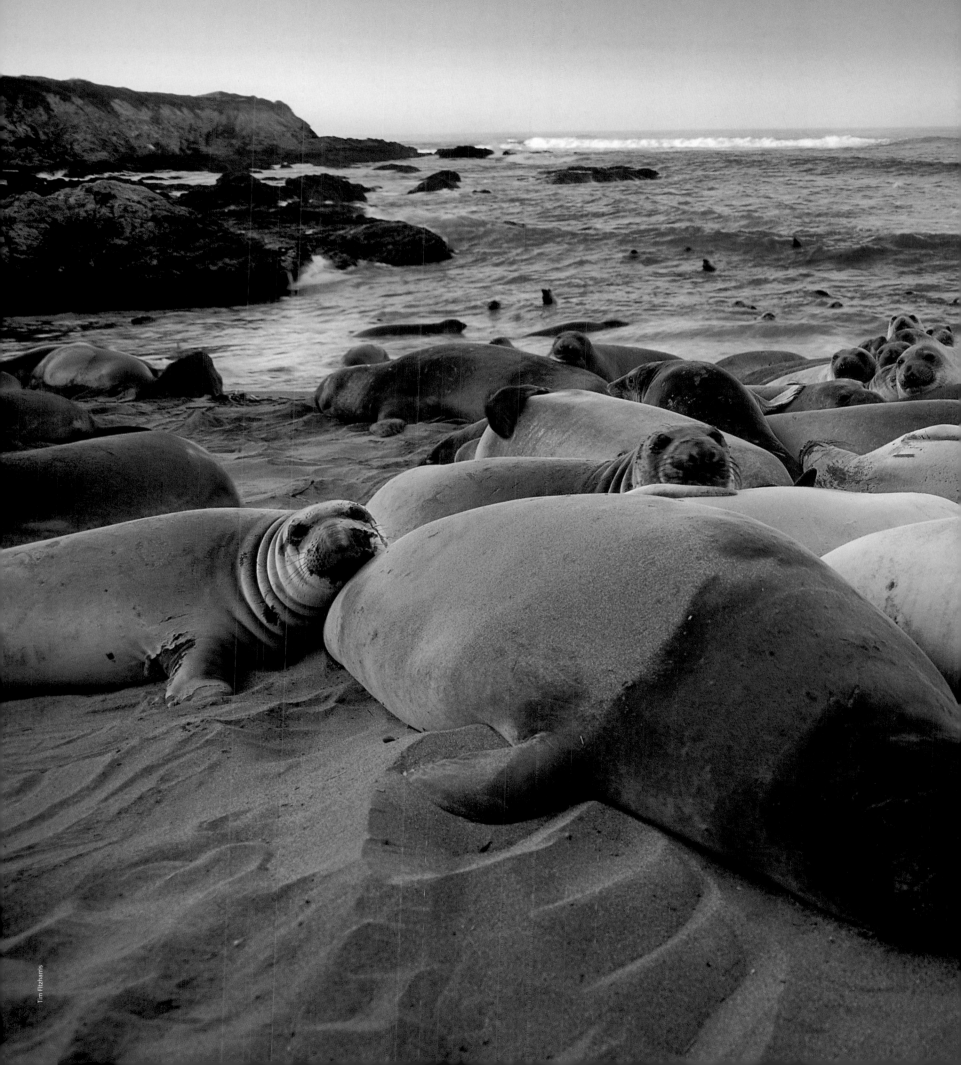

Big Sur
CALIFORNIA

Tim Fitzharris

E ast of San Francisco in central California there is a strange and awe-inspiring natural realm that is as diverse and exciting as the city itself. This is Yosemite, a place of grace and grandeur, so obviously special it was knighted a national park way back in 1890. The mountains here are the Sierra Nevada; the great naturalist John Muir, upon viewing them, declared this a Range of Light. Indeed, there are everywhere dramatic shadows and vibrant slashes of sunshine—deep greens, brilliant yellows and stark grays intermixing. There are big mountains here: Mount Dana (13,053 feet, second highest in Yosemite), Mount Gibbs (12,764) and Mammoth Peak (12,016) sitting side by side and making a sublime horizon. There are trails to the top of all three, as there are to the summit of Yosemite's most famous formation, Half Dome. Half of this granitic giant's 8,842 feet of altitude rises straight and stunningly from the valley floor. While all views in Yosemite are spectacular, the one from Glacier Point is perhaps the most famous vantage in the West; from atop the cliff a visitor beholds waterfalls, distant mountains and the neighboring Half Dome. Finally, there is, as we see here blazing in the setting sun, magnificent El Capitan.

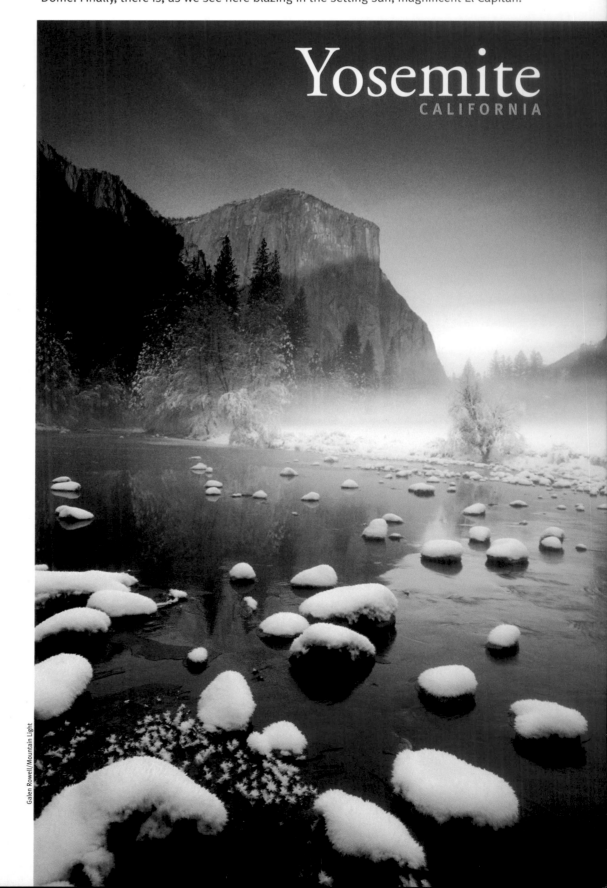

Yosemite
CALIFORNIA

San Francisco
CALIFORNIA

The voice you hear in your head just now belongs to Tony Bennett, and if you've ever visited the city by the bay then you too, certainly, have left your heart in San Francisco. It is a jewel of a city, romantic and alive, funky and quirky, cultured and classy and a little kooky—as in "Hey, man, that's kooky." The Beats came alive here (and you must visit City Lights Bookstore and the bar across the street, Vesuvio), and, somewhat later, so did the hippies, up at the corner of Haight and Ashbury. There's fine dining in elegant hotels and fine dining in electric Chinatown and fine dining at a fine restaurant that puts garlic in everything—*everything*. San Francisco is often seen as outré, but the fact is, it has something for everyone. Serious surfers brave the breakers here, and nature lovers stroll the Presidio. Sightseers have an on-high view of the Golden Gate Bridge and beyond (above), and history buffs are rewarded at every turn, whether they want to learn more about the great earthquake of 1906 or the grisly doings out on Alcatraz, which was a remote exile for yesteryear's criminals but is a short ferry ride into the bay for today's tourists. San Francisco is as

This is one of the greatest courses in the world, regarded by many as the most scenically sensational of them all. And adding to its beauty is this: It is open to the public. Yes, the green fees are princely, but the experience of playing Pebble is worth a king's ransom. Located on the Monterey Peninsula 120 miles south of San Francisco, the course opened for business in 1919, not as the product of one of the recognized genius architects of the game, but of Jack Neville and Douglas Grant, two amateur golfers hired by Samuel F.B. Morse (grand-nephew of the Morse code inventor) to come up with a layout. They were clearly greensward savants, for their creation was and remains brilliant, employing the land and the contours of the peninsula to perfect effect for challenging play and constantly invigorating views. We choose to highlight the links here, not least to tip the cap to all the beautiful golf courses in America, but there is much in the area around Pebble to delight the non-golfer as well. Nearby are Cannery Row (made famous by Steinbeck), the abundantly charming Carmel, and the Lone Cypress Tree. A circuit of the 17-mile drive is enough to convince any visitor to the region: This is an American Valhalla.

Pebble Beach Golf Links
CALIFORNIA

THE Redwoods
CALIFORNIA

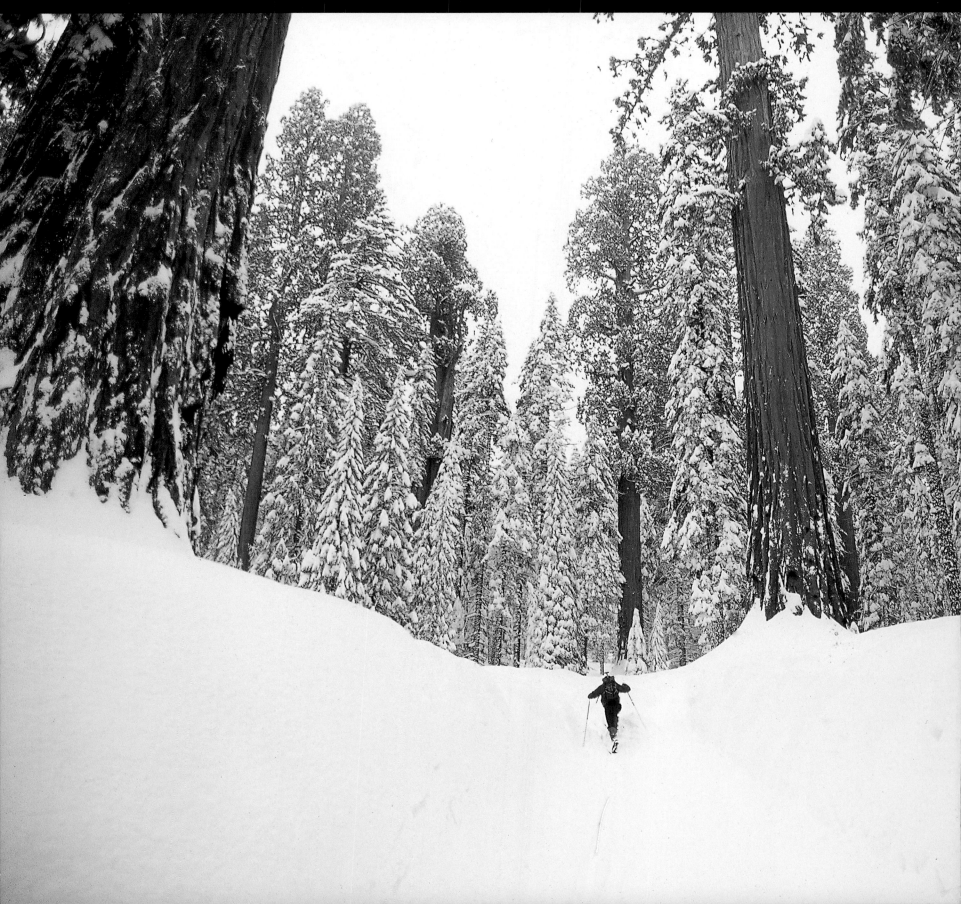

They can live for 3,000 years and surpass 300 feet. Think of what that means: The oldest redwoods in California today were mature trees well before Christ was born. But consider as well, the earliest records of redwoods in the state bring us back to 20 *million* years ago. This is a hallowed tree; these are hallowed forests. Of the three species known as redwoods, California is home to two: the coastal redwood and the giant sequoia. (The scene above is in Sequoia National Park, a preserve on the western flank of the Sierra Nevada Range established back in 1890. There is also, north of San Francisco, Redwood National Park.) The sequoia is generally stouter than the redwood (if you can call a tree that ranges up to 311 feet "stout"), while the redwood, which can reach nearly 370 feet in height, is generally leaner (if you can call a tree with a base of up to 22 feet in diameter "lean"). The world's three tallest trees are within a mile of each other on the northern California coast, and 20 of the world's 37 largest sequoias are in the park.

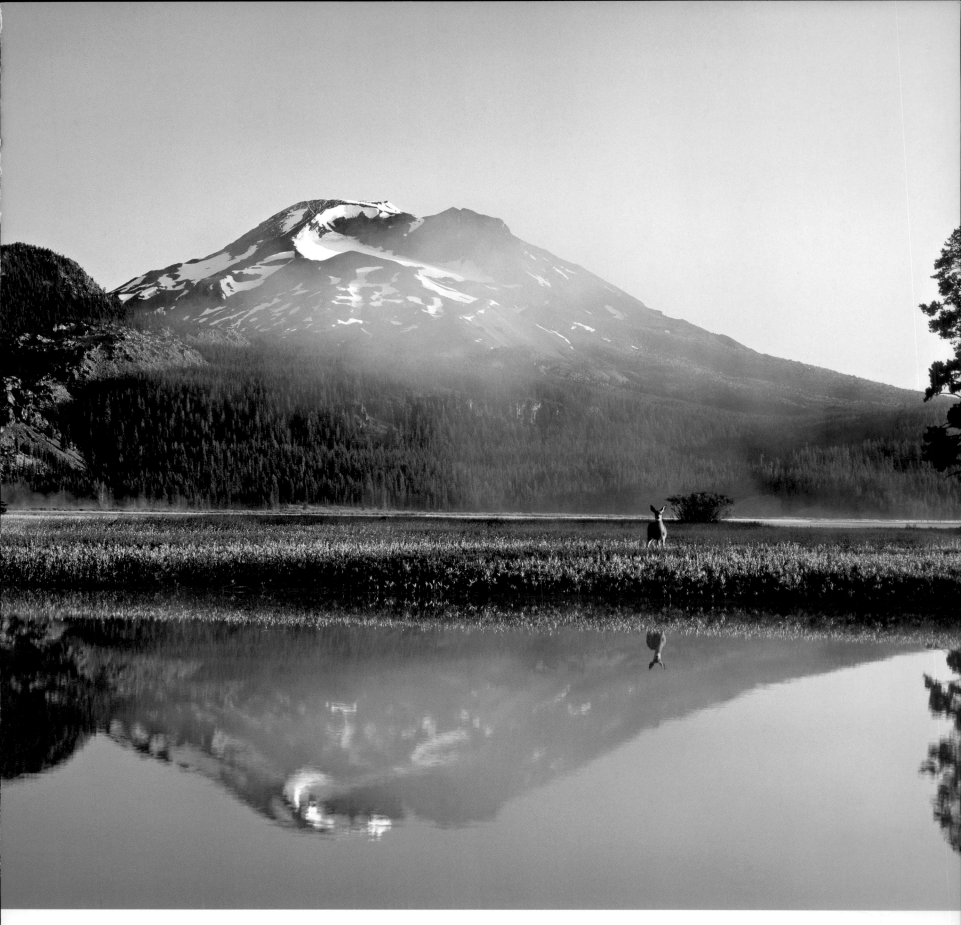

Cascade Lakes
OREGON

It's always sunny in this part of the world. Well, perhaps not always—but an average of nearly 300 days a year are sunny in central Oregon, since, as said earlier, the Cascade Mountains just to the west form an effective barrier against wet air from the Pacific. The sunshine serves to add glitter to a region already resplendent in natural beauty, as it reflects off distant glaciers and dozens of near-at-hand lakes and ponds. How best to drink it all in? Starting from Bend is a fine idea, climbing into the Deschutes National Forest and then past the 9,065-foot, conical Mt. Bachelor, in winter a world-class ski area and a summit from which you can see to California and Washington. As you drive on and then turn south, the lakes arrive in profusion: Sparks (above) and Devils and Hosmer and Lava and Little Lava and Cultus and Crane Prairie (actually, a reservoir) and Davis and Odell and Crescent . . . It's a land o' lakes—and sunlight. In days gone by, Kit Carson came this way, and no doubt was delighted. You will be too.

Oregon Wine Country

OREGON

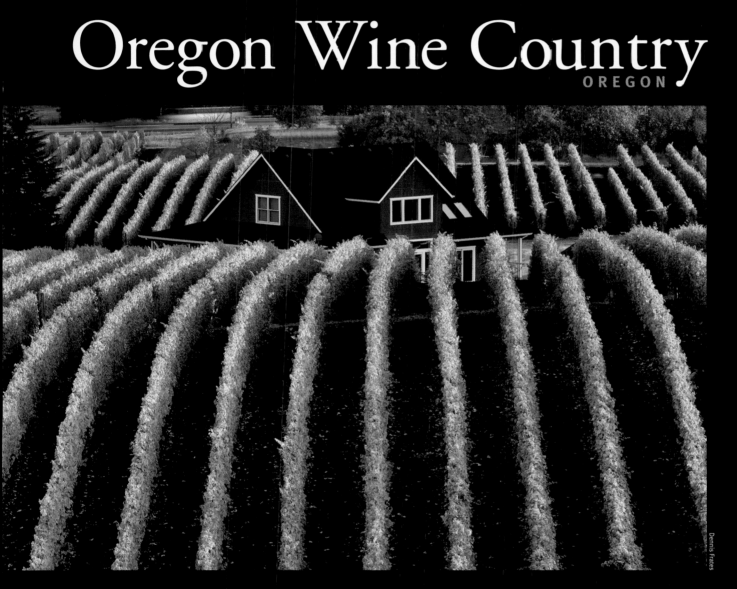

Dennis Frates

Craig Tuttle/Corbis

Many have said that Oregon's wine country is what somewhere else "used to be," and what that means is that it isn't yet overdeveloped, isn't yet too touristy, isn't yet "mega." In fact, most of the more than 300 wineries now operating in the state are quite small, many of them family operations producing fine artisanal wines that are shared with visitors in tasting rooms. You'll find them tucked away on back roads in the lush, rolling Willamette Valley, which stretches a hundred miles from Portland to Eugene. It is here, in the relatively cool climate between the Cascades and the coast, where pinot noir thrives. In southern Oregon there are wineries in high mountains; in the Columbia River Gorge there are wineries in the benchlands. There are 15 approved wine regions in the state in all, each with its own personality, but all of them welcoming.

John McAnulty/Corbis

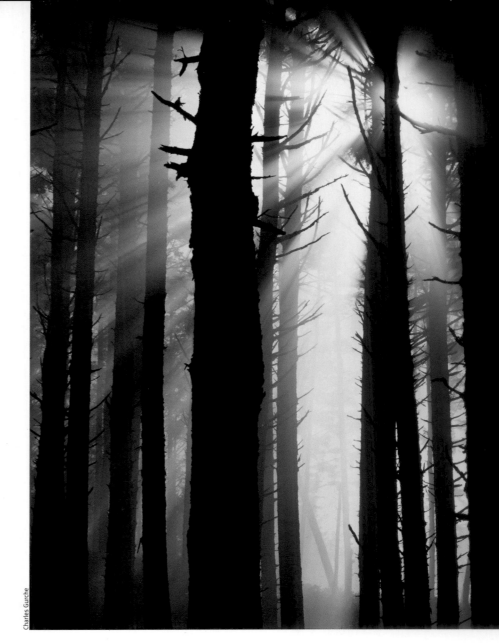

Charles Gurche

Umpqua
National Forest
OREGON

The Cascade mountain range, which keeps central Oregon sunny and dry by intercepting Pacific Ocean moisture, is, as you might expect, rather wet on its western slopes. This is not necessarily a bad thing, as towering waterfalls and frothing rivers only add to the character of a region that is already fascinating for all its signs of ancient volcanic action. There is a 172-mile scenic byway called the Rogue-Umpqua that spends much of its time in the Umpqua National Forest, which covers nearly a million acres along the western slopes of the Cascades. Three attractions not to be missed: Colliding Rivers Viewpoint, where the North Umpqua and Little rivers crash head-on into each other; Watson Falls, at 272 feet the highest in southern Oregon, and the star of the "Highway of Waterfalls"; and Crater Lake National Park, a short side trip off the byway to a clear lake sitting placidly in the mouth of a volcano that last blew 6,800 years ago. There are three wilderness areas in the National Forest, as well as the North Umpqua Wild and Scenic River, which is everything that its designation promises.

The Columbia River Gorge is a realm of waterfalls, with a half-dozen or more plunging at least a hundred feet, and many other smaller ones. And then there is Multnomah Falls, the second-highest year-round waterfall in the country—which cascades 620 feet from its origin high on Larch Mountain. To build up to your experience of Multnomah, drive 20 minutes east from Troutdale on the Historic Columbia River Highway and take in the near-constant drama of this mighty stream. Multnomah itself can be appreciated from below, of course, and then there is a 1.2-mile paved hiking trail to its top. The Benson Footbridge, built in 1914 by Italian stonemasons to replace a wooden structure, actually allows you to cross the falls between the upper and lower cataracts. After your exercise, repair to the Lodge, a handsome manse with views of the falls that dates to 1925. In the walls of the Lodge, which is open to the public and has a fine restaurant on its second floor, is represented every kind of stone to be found in the Columbia River Gorge. It's a stolid, strong, impressive edifice, much in keeping with the feel of this place. Multnomah Falls sends a chill, never more so than in winter when much of its flow freezes into a gigantic, rock-hugging icicle.

Multnomah Falls
OREGON

Mount Rainier
WASHINGTON

The undisputed focal point of the country's fifth-oldest national park is also the fifth tallest peak in the Lower 48: majestic Mount Rainier, a classic stand-alone pinnacle whose ice cap on a clear day dominates the Seattle skies. Its name was born in 1792, when British explorer Capt. George Vancouver, in the fashion of the time, named it after his friend Rear Adm. Peter Rainier. The massive mountain reaches a height of 14,410 feet despite being so close to the sea, and accounts for more than a quarter of the national park's 378 square miles; it's a huge hunk of rock. And ice: It is the most heavily glaciated peak in the contiguous states, with 35 square miles of snow and ice. Of its 25 active ice sheets, the largest is the Emmons Glacier, which alone has a surface area of 4.3 square miles. The lower areas of the park are famous for radiant wildflower displays, and surrounding are lush old-growth forests. For a long time, Rainier was regarded as a dormant volcano. Now, however, studies suggest that the old cone may once again breathe fire. Look out below.

Just off the far northwestern corner of the contiguous United States, there is a generous sprinkling of isles in the Pacific that have a special magic. There are more than 450 in all in this archipelago, when the tide is high, but fewer than 75 are inhabited. Of those, the Canadian ones are called the Gulf Islands, and those belonging to Washington State are called the San Juans. Four of the American islands are accessible by ferry, many others by sea kayak or sailboat. There are rugged, hilly places with tall firs and pines and eagles soaring overhead. In the ocean waters, orcas leap. In every season, but particularly in the cooler ones, the San Juan Islands are romantic retreats, where life can be contemplated in blessed peace. On Orcas Island, the largest of the San Juans, a walk to the top of half-mile-high Mount Constitution is rewarded by views of the archipelago and the sea beyond. Down below—back at the ranch—a fireplace, a hot drink and a good book await. The San Juan Islands are a short hop from Seattle, and a world away.

THE San Juan Islands
WASHINGTON

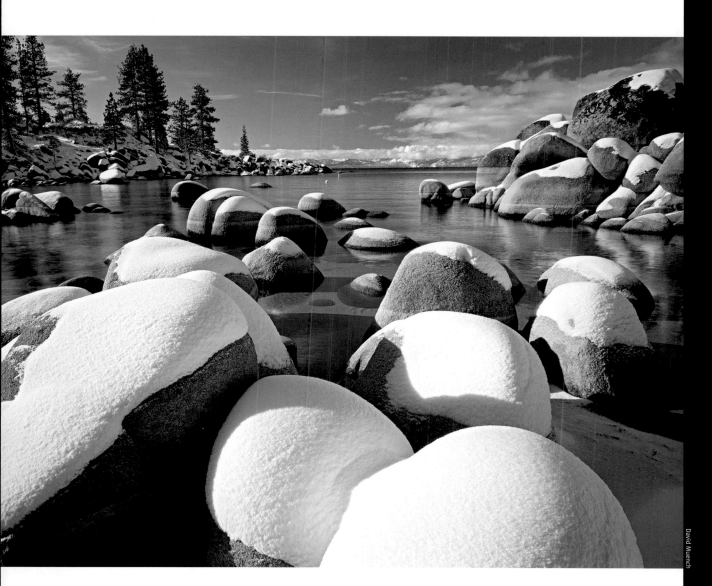

David Muench

Lake Tahoe
NEVADA AND CALIFORNIA

It is a stupendous lake, and more. The freshwater body of water itself, which sits on the border between the two states, is in the record books: With depths in excess of 1,600 feet in some places, it's the second deepest lake in the U.S. to Oregon's Crater Lake, and the 11th deepest on the planet. It is, as well, one of the highest lakes in the country, sitting at 6,229 feet above sea level. And it's also one of the very largest, with 192 square miles of surface area. But those are statistics, which can't tell the story of Tahoe's beauty, or that of the surrounding alpine region. Ski any one of the dozen ski areas in Tahoe—including Heavenly Mountain, California's largest, and Squaw Valley, host of the 1960 Winter Olympics—and be stunned by the summit views. Take a boat out on the lake in the summer, dine at any one of the many lakefront restaurants, and be blown away by the sublimity of it all. That said, Lake Tahoe has suffered from too much use and too little protection down the decades, and its water quality has greatly changed since the 1960s. Efforts are ongoing to preserve Lake Tahoe, and it would be a natural shame if they did not succeed.

Harald Sund

Yet another national park in Utah—the very first one there, in fact, having been established back in 1919—and yet another that cannot be ignored. Zion's name is entirely apt, as it is taken from a word that may be interpreted as "utopia" or "sanctuary." Zion National Park is a destination of the spirit, a getaway of canyons and plateaus, of domes, waterfalls and elaborate gullies. Sandstone cliffs soar to 3,000 feet while, below, the Virgin River pursues its endless quest amidst hanging gardens of columbine. Visitors to Zion are stunned by the dizzying vortex of colors and the striations on rock that have created such wonders as Checkerboard Mesa and Double Arch Alcove. The famed Watchman, a monolithic peak, watches over all. The park's location at the junction of various geographies assures an immense variety of plants and animals. In Zion's 229 square miles there are more than 900 species of flora, the richest diversity in Utah, plus nearly 300 kinds of birds, almost 50 species of reptiles and amphibians, 78 species of mammals and eight of fish. There is everything here from the Zion snail to the desert tortoise to the Mexican spotted owl.

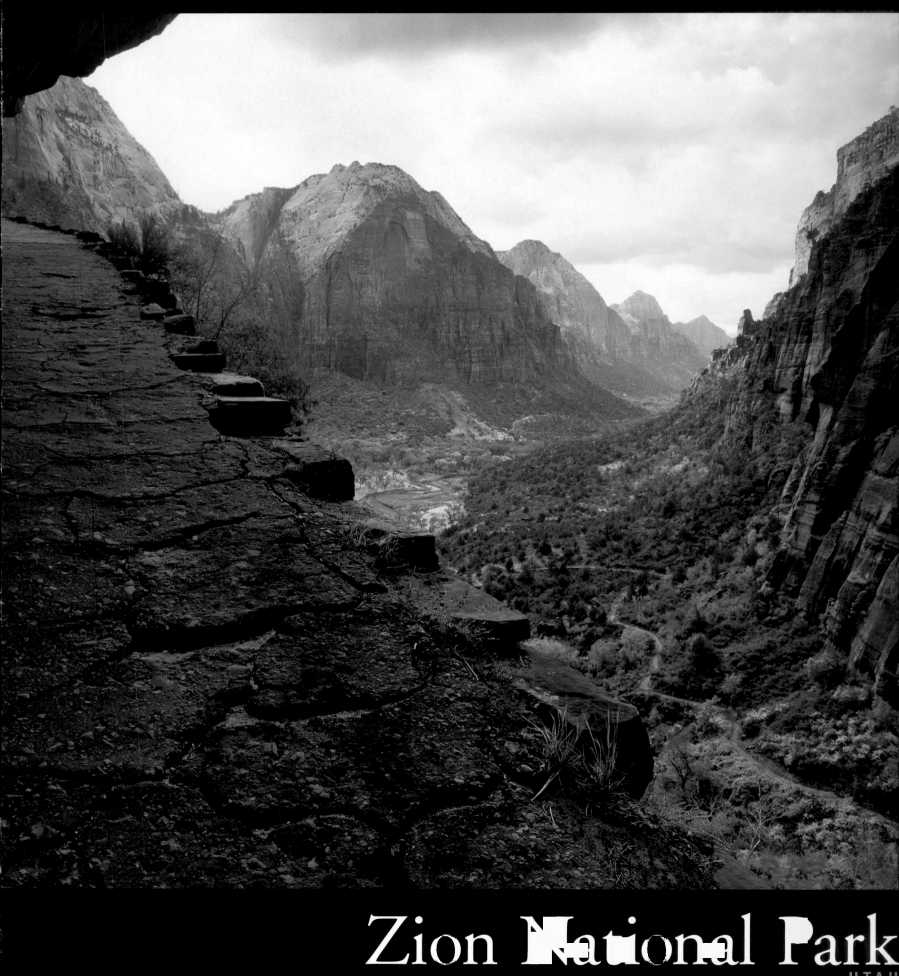

Zion National Park
UTAH

THE Arches
UTAH

As we have seen, there are natural arches elsewhere in Utah—in Canyonlands, in Monument Valley. But if arches are your thing, this is your place. A national park called, fittingly, Arches was established in 1971 around an area that contains the greatest density of these formations in the world, more than 2,000 natural sandstone arches in all. Millions of years of geologic history can be read in the vibrant shadings of different layers of rock. As alluring as the landscape is, there are other reasons to visit Arches, not least to experience a unique climate. The area is in what's called "high desert"—it's in a region ranging from 4,085 to 5,653 feet in elevation—where there can be a daily temperature fluctuation of as much as 50 degrees. That can be fun on a short-term basis, and some few have tried it for the longer haul. A disabled Civil War veteran named John Wesley Wolfe, for one, ran a ranch here with his son Fred in the late 1800s, and his hyper-rustic log cabin, root cellar and corral can be seen in the park.

Wally Pacholka

Dennis Frates

Bryce Canyon
UTAH

Many have tried to express what they feel as they gaze upon this scene. "Red rocks standing like men in a bowl-shaped canyon," was how the native Paiute Indians described the fantastical formations that fill Bryce Amphitheater. When the state of Utah's citizenry promoted the area as a park for federal protection in 1919, they called it the Temple of the Gods. More prosaically, the natural statuary is known as a collection of hoodoos—hooded specters haunting the canyon. By whatever name, these singular, signature features of Bryce Canyon never fail to elicit awe, and all who have beheld this artwork—rendered by millions of years of erosion, a panorama still in progress—have been profoundly moved by it.

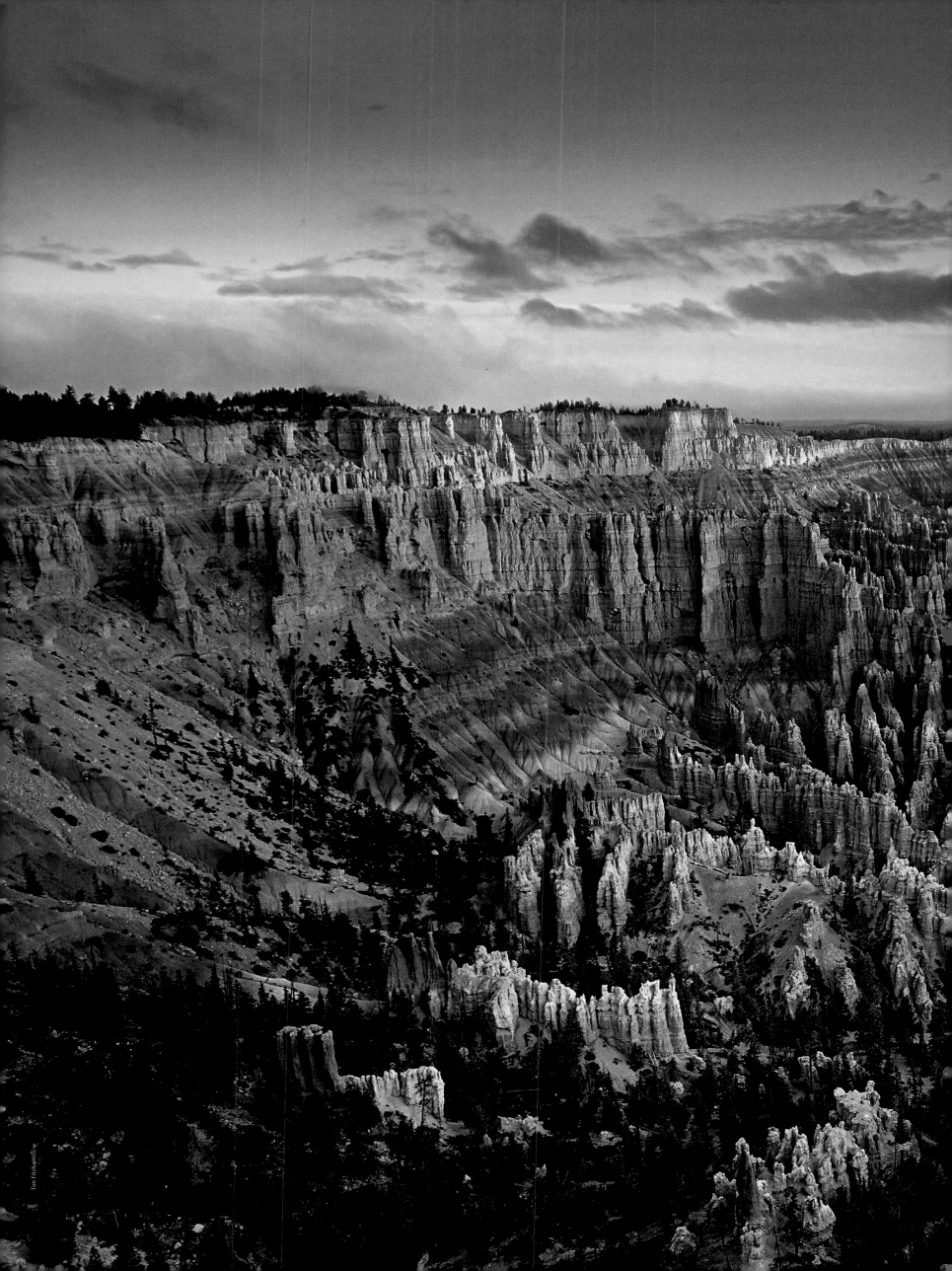

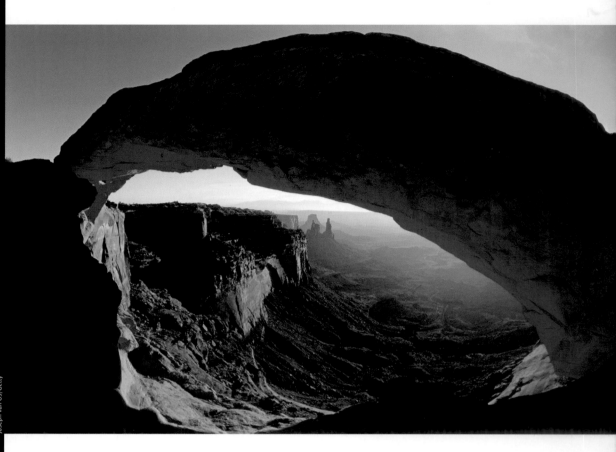

Joseph Van Os/Getty

Paul Chesley/Getty

Canyonlands
UTAH

The area of Utah now called Canyonlands was first chanced upon by human hunter-gatherers some 10,000 years ago. It was many moons later, in 1869, that John Wesley Powell began a three-month exploration of the Green and Colorado rivers, which converge here. The landscape had an impressive effect on Powell, as he recorded in his diary: " . . . rock—cliffs of rock; plateaus of rock; terraces of rock; crags of rock—ten thousand strangely carved forms." It is a terrain of sedimentary sandstone molded through time into mesas, buttes and canyons bounded by sheer walls. While there are four distinct areas, there is throughout a shared element of primitive desert that is characterized by cactus, cottonwood and coyote. The light is always at work at Canyonlands, which was made a national park in 1964, then expanded to its present size of 527 square miles in 1971. Above: Mesa Arch.

Monument Valley

You know this place, or think you do. Those buttes. That weird outcropping. Those red-hued arches. *Didn't I see that somewhere?* Well, sure you did: In all those westerns (no fewer than 10 John Ford films were set here; his usual star, John Wayne, should have built a second home); in all those other movies (from *Easy Rider* to *Forrest Gump* to *Thelma & Louise*); in all those Marlboro Man ads. The camera is drawn to this place, as it is to Arizona's Red Rock region, for good reason: Nothing else looks quite like this. It is the iconic,

mythic West writ by the imagination—and yet it is real. The shale-and-sandstone shapes you've seen over and over, usually with horses galloping past, have names: the East Mitten and West Mitten buttes, the Totem Po.e rock spire and the Thumb. And they can be visited at the Monument Valley Navajo Tribal Park. Yes, it is a cruel irony that the valley lies in its entirety within the boundaries of the Navajo Nation Reservation—an irony since Native Americans usually came off worse than poorly in the western epics set in this thunderous land.

Two billion years ago, events conspired to create the incomparable Grand Canyon—a realm for which the word "awesome" might well be reserved. Tectonic mayhem, water, erosion and "deposition," the formation of rock from sundry materials, began to converge in a mysterious, endless arabesque. Then 60 million years ago, two geological plates collided. A huge plateau was upthrust, and the Colorado River began its exquisite sculpture. "The Grand Canyon is carven deep by the master hand," wrote Donald Culross Peattie poetically about what happened next and is still happening today. "[I]t is all time inscribing the naked rock; it is the book of earth." After six million years of this natural history, we have a canyon 277 miles long and a mile deep. Nowhere else exists such a profound record of time's passage, indelibly etched in the exposed rock of canyon walls. People come from around the world to peer into this space, and when first confronting it, many typically dissolve into a preverbal state. There are so many stupendous elements—constantly in flux owing to the shifting sun—that the mind struggles to process them. Awesome, simply and inarguably awesome.

THE Grand Canyon
ARIZONA

Red Rock Country
ARIZONA

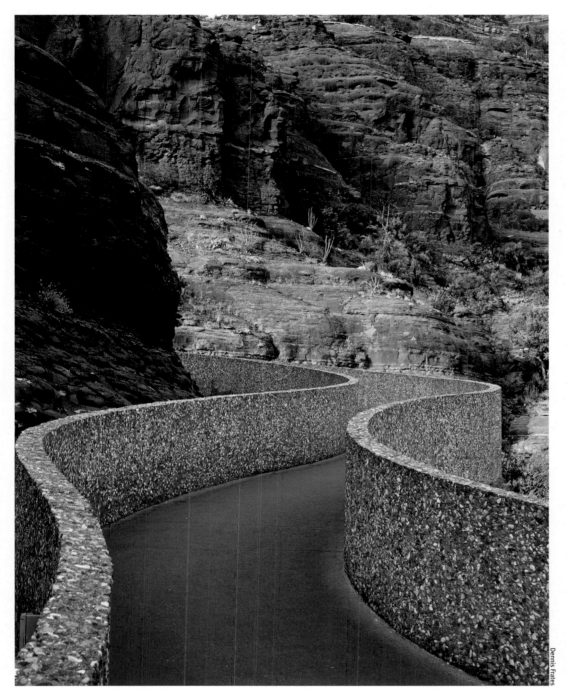

Dennis Frates

Hiroyuki Matsumoto/Getty

Sedona, Arizona, and its environs mean many different things to different people. To the golfer the area means world-class courses in a hard-to-beat setting and climate. To the writer of westerns or the film director of same, it means a physically perfect place in which to situate desperados and their pursuers. To the artist or photographer it means landscapes that must, simply must, be rendered on canvas or film. To the outdoors-inclined, it means paradise. The Conconino National Forest is nearly 2 million acres of pine-covered plateau cut by deep canyons and bordered on its southern flank by the magnificent Mongollon Rim, a thousand-foot-high cliff that stretches across central Arizona. From lowest to highest within the forest, elevations range from 2,600 feet to 12,633; the scenic variety therein can only be imagined. All around you are the red rocks: buttes, pinnacles, mesas and more canyons that are, interestingly, the remains of ancient wetlands. The desert has had its way with these formations, and today they blaze in the noonday sun—impossibly beautiful to behold.

to descend into that cave; those were his first steps to becoming a legend. For years he couldn't convince his friends and neighbors of the awesomeness of what was down there, but eventually enough folks followed him and confirmed what Jim was claiming. More than a century later, he is still regarded as the most significant explorer in the history of the caverns. In 1923,

the Carlsbad Cave National Monument was created by Congress, and seven years later the underground marvel's status was upgraded to Carlsbad Caverns National Park. Today the park contains 113 caves, and some of them—the Big Room, the Hall of the White Giant, Spider Cave—have become famous cathedrals of the caving community: the Yankee Stadiums of the underworld.

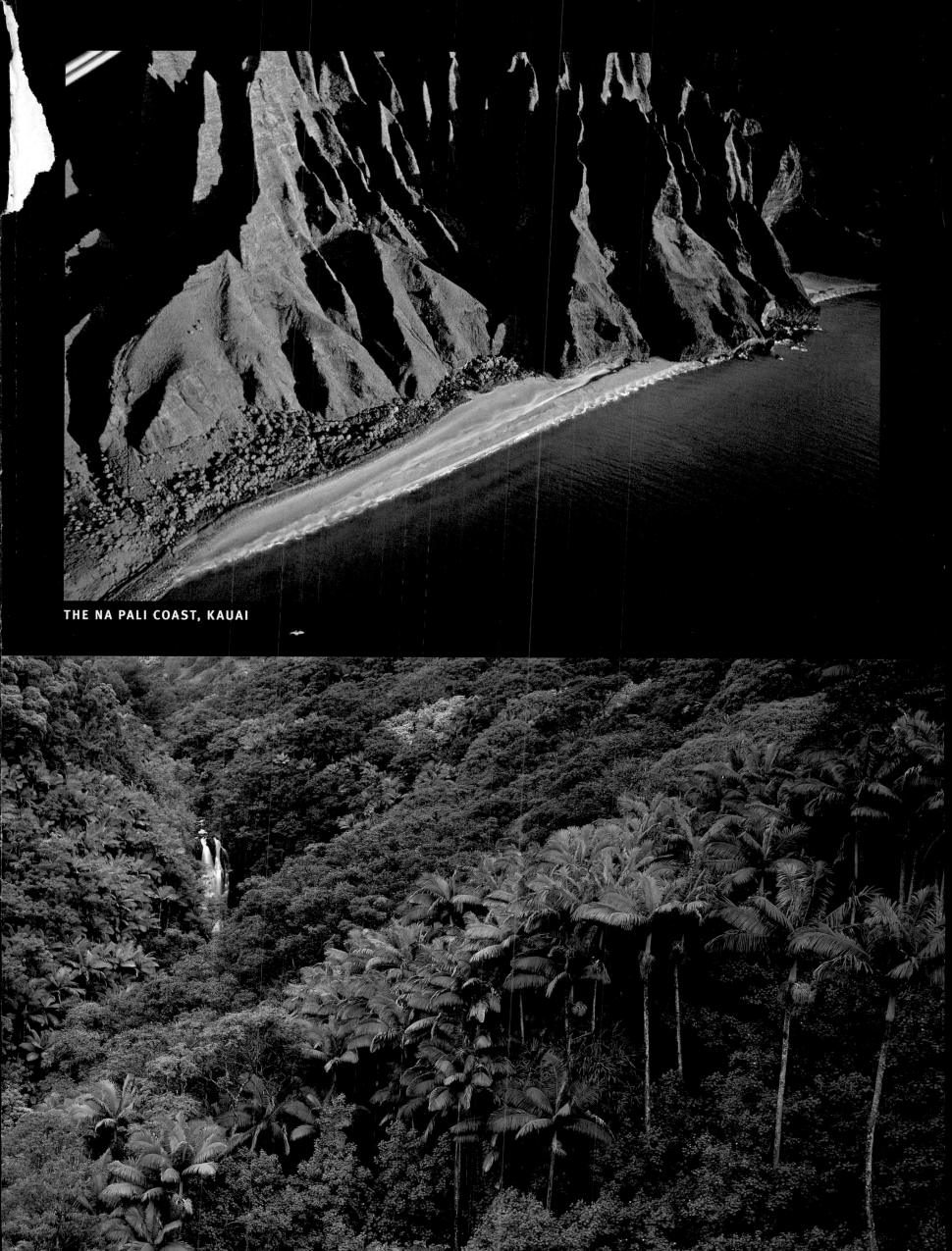

THE NA PALI COAST, KAUAI

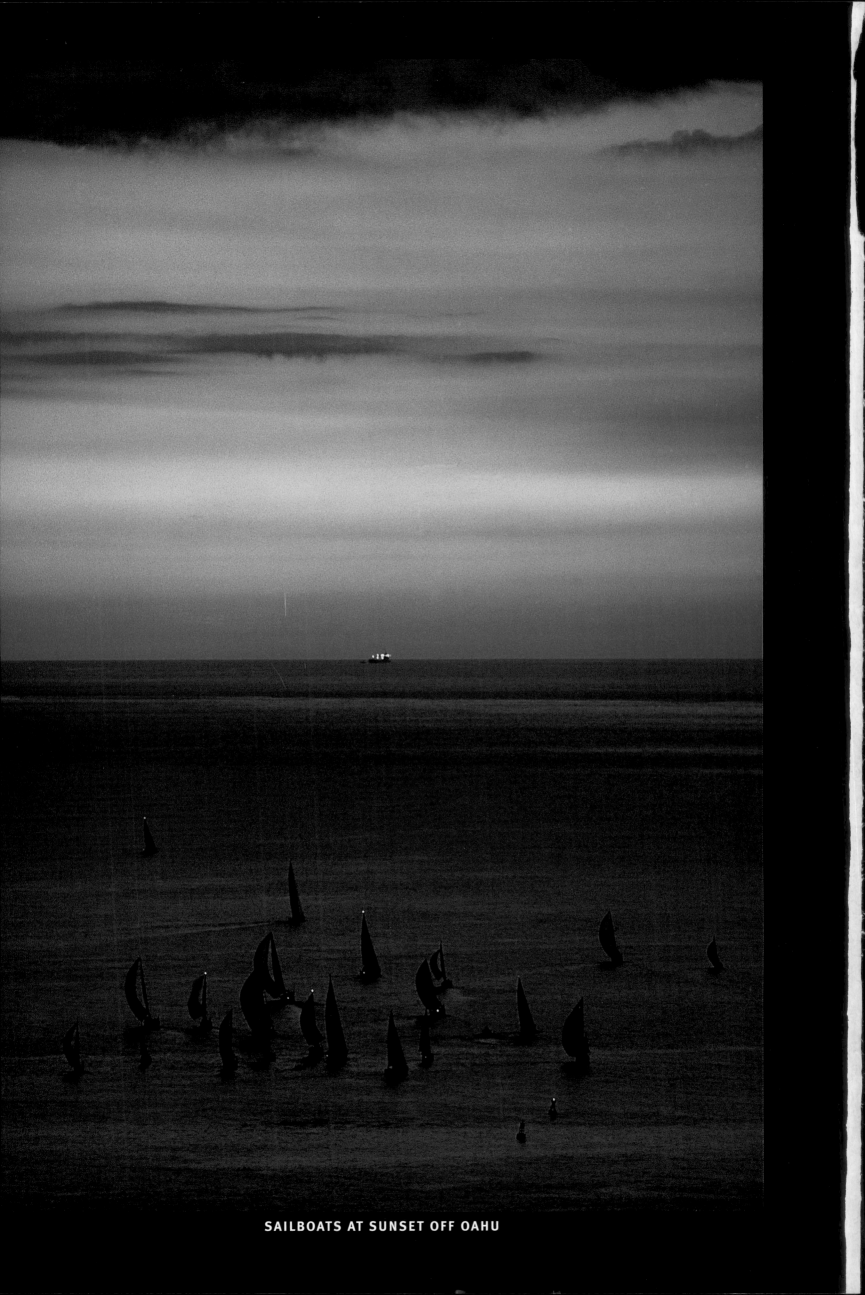

SAILBOATS AT SUNSET OFF OAHU

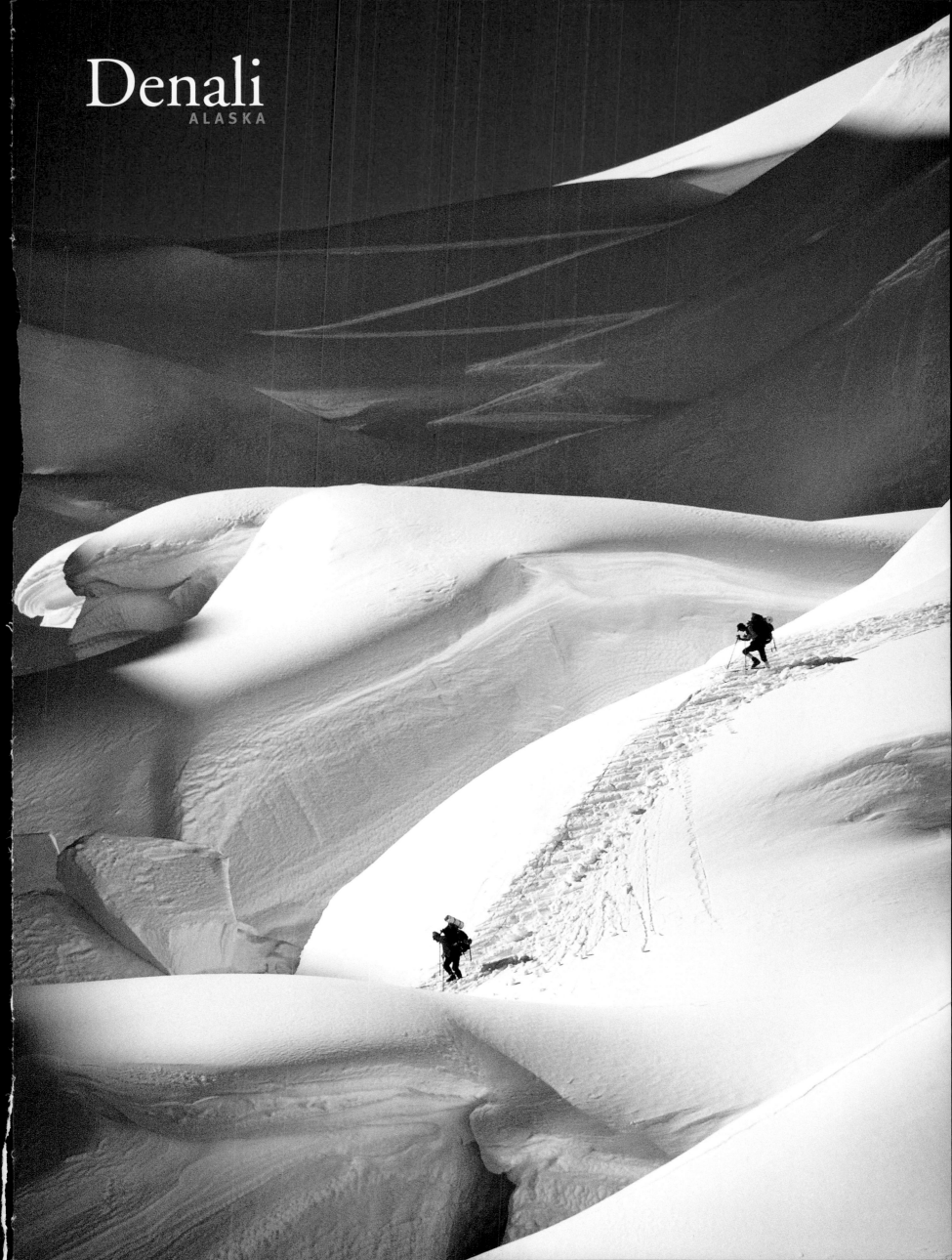

Denali
ALASKA

THE Big Island's Volcanoes
HAWAII

The isles that constitute our 50th state rose from the sea as the product of tremendous volcanic activity. That activity is ongoing today; in fact, the very youngest Hawaiian volcano, Loihi, remains active on a submarine level, yet to emerge above sea level. On the island of Hawaii itself, better known within the collective as the Big Island, there exist five major shield volcanoes in varying stages of their life cycle. The oldest of them is Kohala, located to the north, which emerged from the Pacific Ocean more than a half-million years ago and is now extinct, having last erupted 120,000 years ago. Mauna Kea, the tallest mountain in Hawaii, is considered dormant but not extinct, having last blown approximately 4,500 years ago—and retaining the potential to do so again. Hualalai hasn't erupted since 1801 but also may revive one day, a disquieting notion since the Kona International Airport exists on top of one of its old lava flows. Then there is Mauna Loa, the world's largest volcano, which, like Mauna Kea, is glaciated in its upper reaches. It has erupted 33 times since 1843, most recently in 1984, and will probably do so again. On its flank is Kilauea, the world's most active volcano, spewing continuously since 1983 and creating, for tourists, a spectacular show as it sends molten lava cascading into the sea. These are the ultimate fireworks.

Kenai Fjords
ALASKA

A glacier is in essence a river, if a slow-moving one. Active bodies of ice, these massive, grinding flows leave behind ponds and lakes, canyons and valleys. Much of the topography of the upper half of North America has been shaped by glaciers, which are the earth's most powerful practitioners of erosion. The fjords of Kenai in south central Alaska are long valleys that were etched by glaciers and now are filled with seawater. Into them juts Kenai Peninsula, and there, near the town of Seward, is a land where the ice age persists. There is a national park here, and Exit Glacier is the only part of that park accessible by road. An easy stroll from your car delivers you to the base of an impressive, active glacier. Bears, whales and the ice worm call the land of the fjords home—and so do these huge rivers of ice.

It is just as well that the governor of the Alaska territory, Thomas C. Riggs, went unheeded when he stated in 1919, "Katmai National Monument serves no use and should be abolished." Yet it is not unreasonable that he might have said it, considering the circumstances of the monument's founding (the monument is now a national park). The Valley of Ten Thousand Smokes is an astonishing 40-square-mile ash flow deposited by the Novarupta Volcano, and it runs to 700 feet deep. That was the original reason for preserving this part of Alaska: so folks could bear witness to this extraordinary flow. Could bear witness to ash. Today, Katmai National Park is home to five still-active volcanoes in the valley, and home as well to grizzlies and sockeye salmon that rely on the River Lethe. Better appreciated now than Riggs' declaration are the words of Gilbert E. Blinn, Katmai's first superintendent: "It is a land of uncrowded spaciousness, a place where people can experience wilderness on its own terms without the distraction of hordes of other visitors. It is a place where time and change are measured by the sun, the tides and the seasons rather than clocks and calendars."

This is America's Everest. In fact, when you consider that Denali, still called by many Americans Mount McKinley, rises from 2,000-foot lowlands to a summit height of 20,320 feet—a vertical climb of more than 18,000 feet—they certainly can be mentioned in the same breath, for that is a far greater ascent than even Everest's (in fact, about half again greater). Furthermore, with its Alaskan latitude and usual extreme cold, Denali is a dangerous mountain. Acute mountain sickness is common in climbers here, climbers who need to confront five large glaciers as well. Denali means, in the Dena'ina language, "the great one," and it certainly is that. When we talk of humans on the mountain, we are talking of summer, of course, not forbidding winter, when sunlight is less than scant, and the cold is unbearable. In the national park that surrounds the mountain, even during the seasons of darkness there are residents who are on their own, to survive or not, to prey and be preyed upon. The denizens of Denali include the King of Predators, Griz, who can reach 35 mph and tear apart a half-ton moose in no time; the visitor wants to avoid a wounded *Ursus arctos horribilis*, or one with her cubs. The Denali food chain descends through 37 species of mammal, down to pikas, hoary marmots, ground squirrels and snowshoe hares. Meadows below Denali's twin peaks nurture a large moose population, while the high country harbors Dall sheep, kin to the bighorn. Denali: seemingly forbidding, yet full of life.

Katmai
ALASKA

When comparing parts of paradise, we are inevitably forced to split hairs and make unsupportable claims. But it can be argued that of the Hawaiian islands, Kauai is the fairest of them all, and that among the many splendors of Kauai, the Na Pali Coast, up in the northwest of the island, is the most splendiferous. Pali means cliffs, and the wall of jagged rock rising from secluded beaches to sudden heights of up to a thousand feet creates an ongoing series of deep, narrow valleys and canyons, through which flow streams, and down which cascade waterfalls. A walk along the Kalalau Trail, which traverses five valleys on its way to Kalalau Beach, is 11 miles of the most outstanding hiking in the world. The soundtrack of the pounding Pacific ebbs and flows in the background as the trail goes up and down. The magic of the Na Pali Coast is lost on no one who visits. Hollywood did visit, and filmed part of the movie *South Pacific* there. The scouts took one look and said, yes, this is Bali Hai.

St. John
U.S. VIRGIN ISLANDS

Planeloads of tourists don't alight on the balmy Caribbean island of St. John—there's no airport. And the ferry from St. Thomas takes 20 minutes, just long enough to keep down the crowds and lend St. John an air of serene seclusion. The lack of development is intentional: Roughly two thirds of this island—7,000-plus acres of land—lies within Virgin Islands National Park, which was established in 1956. The hills and valleys are sumptuous; the beaches are some of the world's finest. In 1962, Congress expanded the boundaries of the national park to include 5,650 acres of underwater lands. The principal intention was to preserve the fragile coral gardens, but an ancillary benefit, of course, was to save for tourists the beautiful seascapes just below the surface. All of the diving around St. John is world-class, and even for those without tanks, the 650-foot-long snorkeling trail at Trunk Bay is transcendent. St. John has the rhythms of Caribbean life and many of the rare jewels of the natural world. Strange to end our LIFE 100 with a place outside the 50 states? Not so strange, with this.

HAWAII

IT SEEMS A SIMPLE EXERCISE, an equation that is not complex: making a beautiful picture of a beautiful place. And yet, so few are capable of accomplishing this at a level approaching the expert. We are constantly looking at photographs of places we've visited and saying to ourselves, "I remember it as so much *more* than that."

Not so with the landscape photography of Michael Melford. He has accepted the challenge of trying to capture on film many of the world's most dauntingly dramatic scenes, and has succeeded brilliantly. The reaction one has when looking at a Melford photograph is quite like the reaction one experiences from the top of the mountain itself, surveying the valley below. The applicable word is: Wow.

There is poetry in these pictures, but, interestingly, when Melford first picked up a camera, he was an engineering student at Syracuse University, planning for a future in the technical arts. Very quickly he determined that photography was the "perfect marriage" of the techno side of his nature and a creative side that was seeking an outlet. After establishing himself in New York City in 1979, he got an assignment from LIFE, and soon after became a contributing photographer. His talent for rendering a landscape proved his ticket to the wider world. Shooting for LIFE, *National Geographic* and other magazines, he has been everywhere, seen almost everything. He has published books on the Big Sky Country of the American West and on Alaska; he has a considerable life list of national parks in the U.S., and another of far-flung continents from Australia to Asia to Africa. "Of course, shooting the job is great, but actually being in the location is the real prize," says Melford.

And a prize above all others is being anywhere in our 50th state. "Telling someone that Hawaii is beautiful and special seems so incredibly obvious, a little like asking someone if they would like to win the lottery," Melford says. "But it's just undeniable: Hawaii is the dream island, the incarnation of that fantasy we all have of the ideal spot on earth. I've been so lucky to have shot there a number of times, and even more fortunate in that I've been asked to photograph some of the less-traveled sites. When I shoot, it's always about 'the light.' I like natural light, so I'm really at the beck and call of Mother Nature. Well, Mother Nature and Hawaii have a really good relationship—the light there is consistently magical.

"I do hope I'll be asked to go there to shoot again . . . and again, and again. It's that wonderful."

A SEA TURTLE OFF MAUI

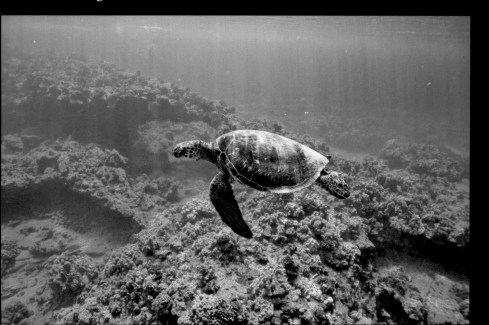

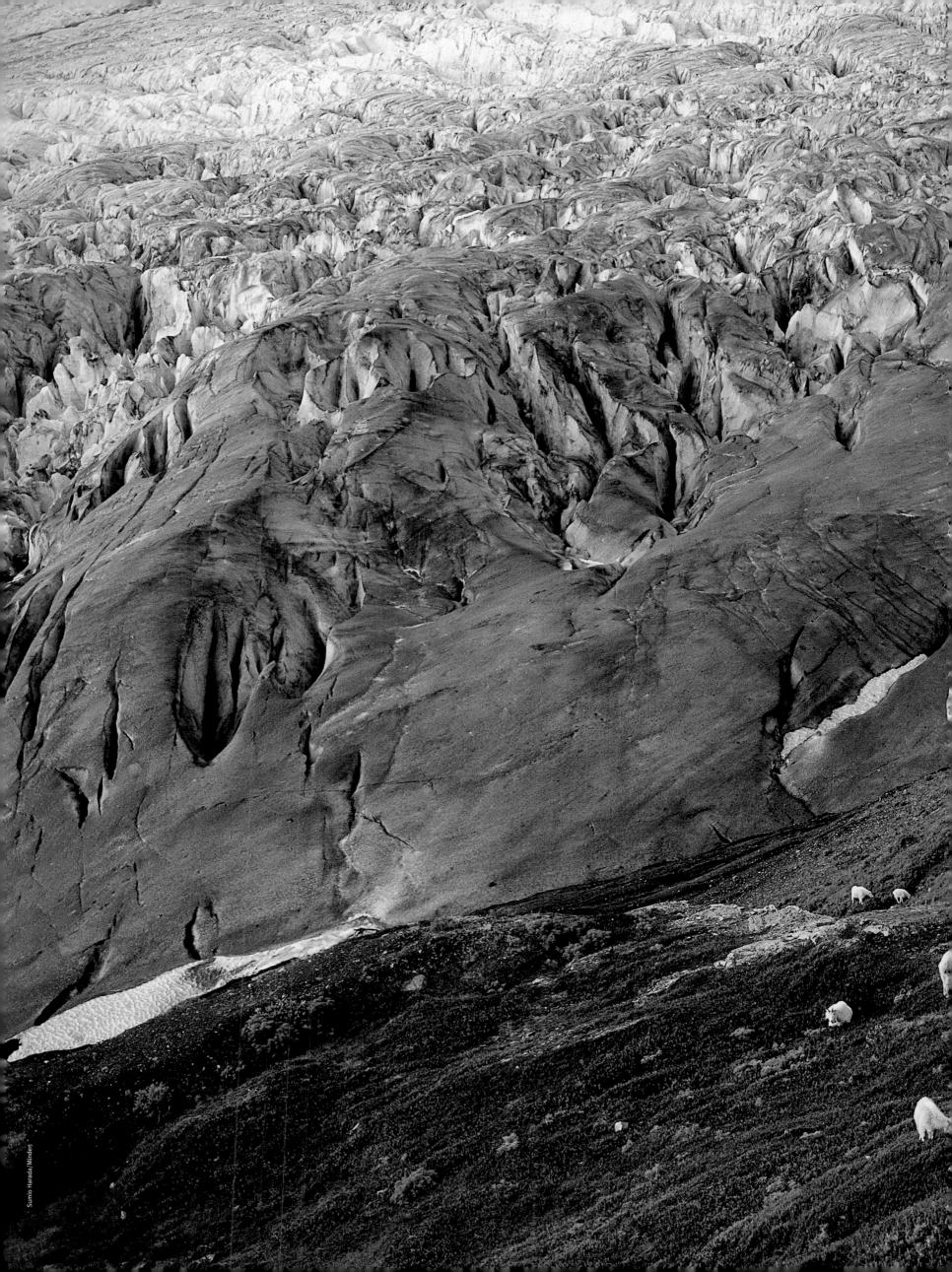

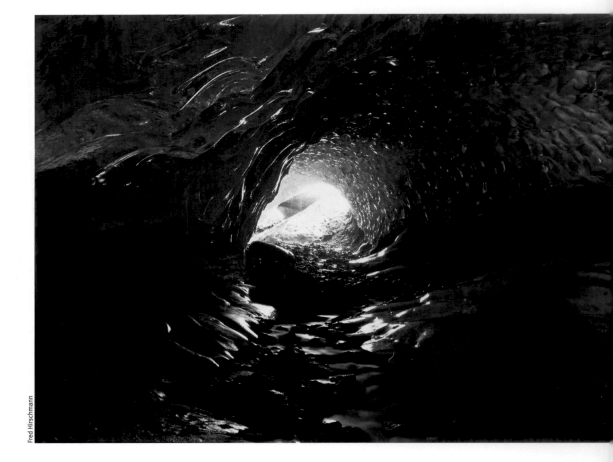

In 1980, after a decade's debate over who was entitled to the Last Frontier—developers? Native Americans? All citizens? Small critters and big beasts?—the U.S. Congress' compromise took shape in a piece of legislation called the Alaska Lands Act. Under the law's stipulations, the already extant Denali, which increased in size to 6,028,091 acres, was joined in one fell swoop by seven other enormous parks. Set aside were 573,000 acres in the Kenai Fjords, 1,750,000 acres in the Kobuk Valley, 4,045,000 acres around scenic Lake Clark, 8,500,000 acres in the mountainous north called Gates of the Arctic, a whopping 13,188,000 acres of mountain and glaciers called Wrangell-St. Elias National Park, 4,090,000 acres surrounding volcanic Mount Katmai in the southwest and 3,280,198 acres in the south called after the body of water there, Glacier Bay. This region boasts steep snowcapped mountain ranges as well as deep fjords; it is a most dramatic study in contrasts. Glacier Bay affords a superb opportunity for studying the generation of flora and fauna in the wake of retreating glaciers. Consider: As recently as 250 years ago, a glacier thousands of feet thick filled what is now a 65-mile-long fjord. In Glacier Bay you can learn—you can *see*—how the physical world takes shape.

QT Luong/Terra Galleria

Fred Hirschmann

Glacier Bay
ALASKA

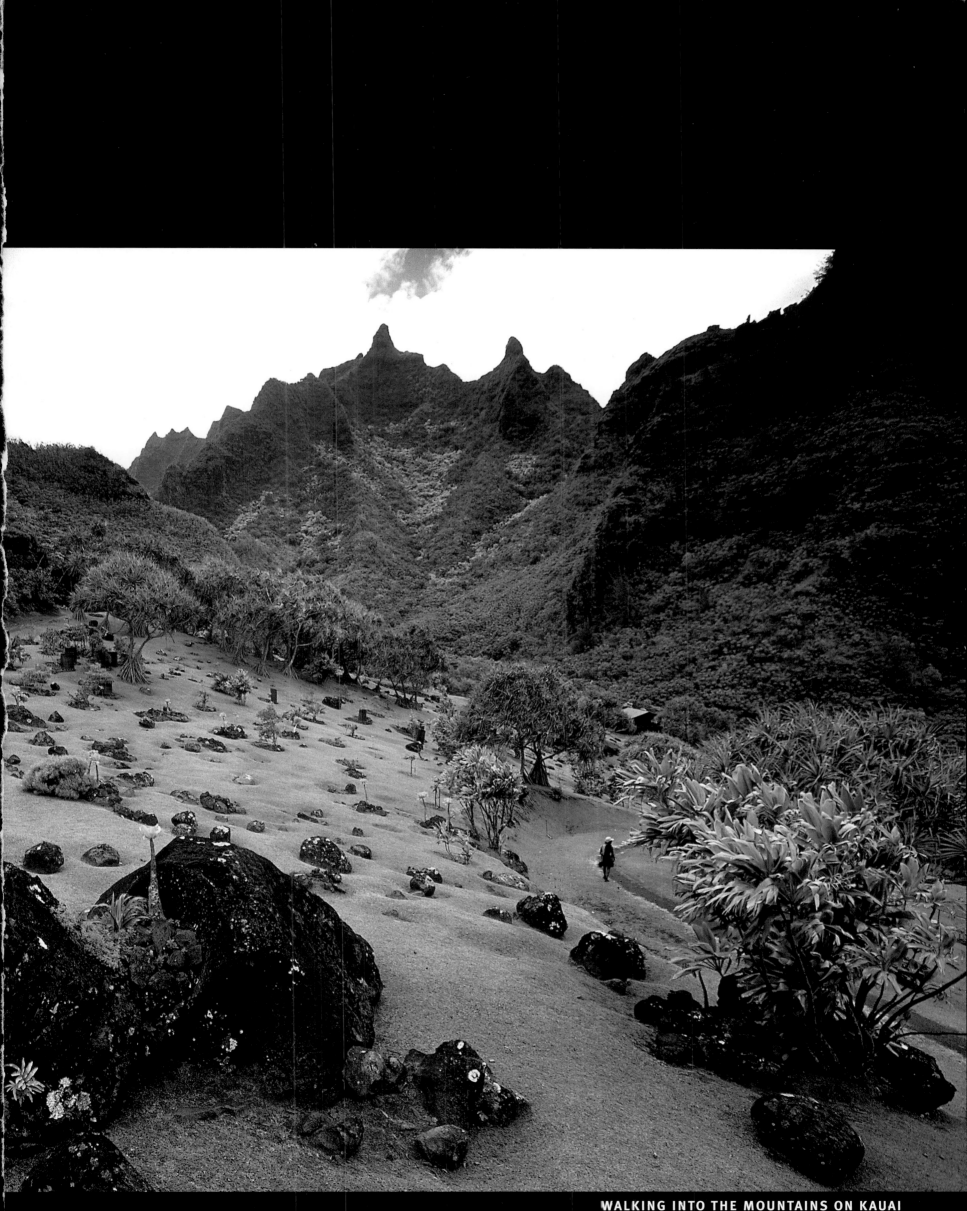

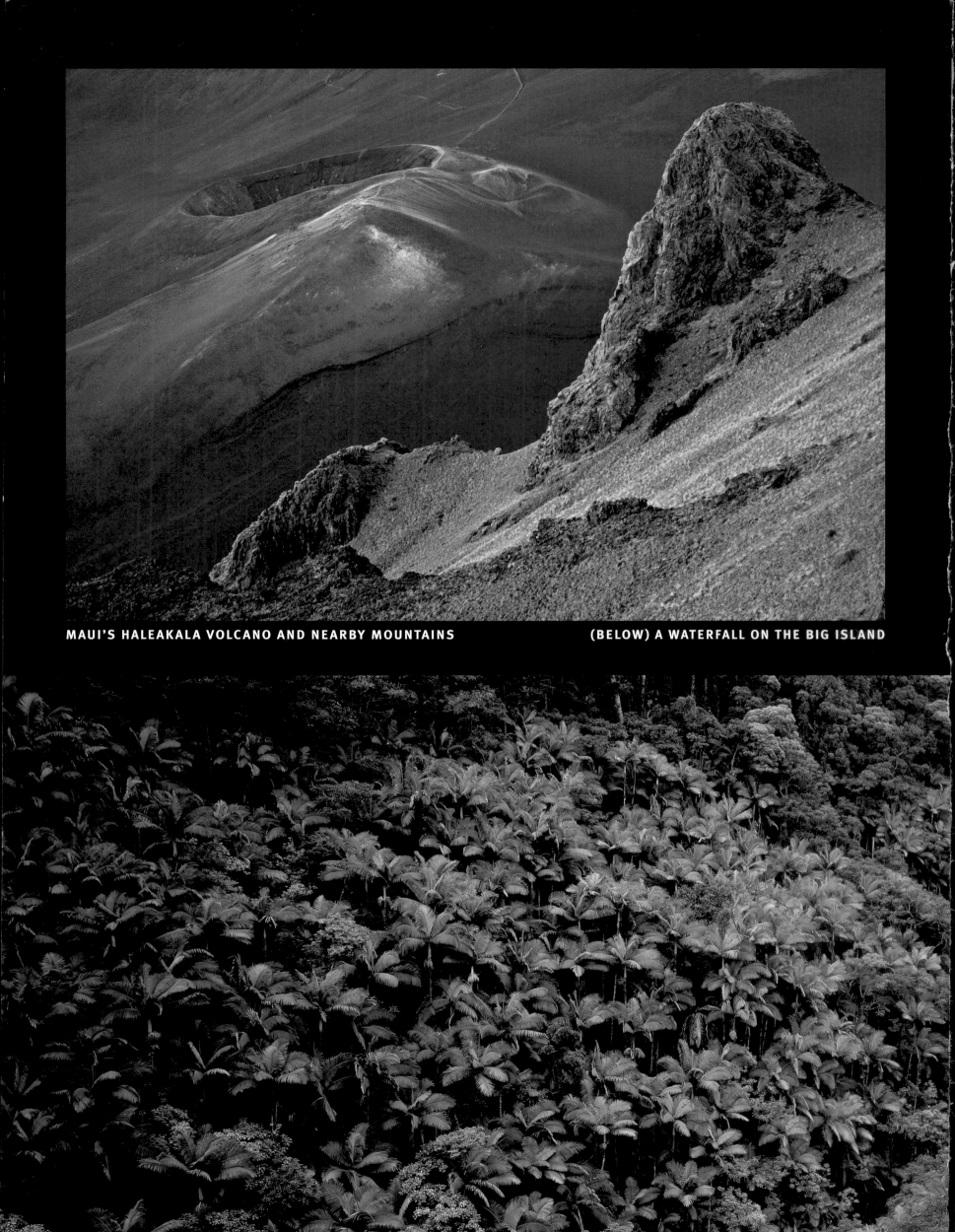

MAUI'S HALEAKALA VOLCANO AND NEARBY MOUNTAINS (BELOW) A WATERFALL ON THE BIG ISLAND